SUSHI ART
COOKBOOK

The Complete Guide to Kazari Sushi

KEN KAWASUMI

TUTTLE Publishing

Tokyo | Rutland, Vermont | Singapore

What is Kazari Sushi?

A *morikomi* mixed sushi arrangement that celebrates the spring season.

I coined the term "Kazari Sushi"—literally "decorative sushi"—to describe traditional or decorative sushi made into artful shapes with various methods, including *saikuzushi* layered sushi, *nigirizushi* sushi nuggets, *chirashizushi* scattered sushi, and *oshizushi* pressed sushi. Even a single roll or serving will be a welcome addition to a dish, and these festive sushi rolls are a great way to celebrate by incorporating seasonal or event-based themes. As an innovative way to enjoy sushi, it's certain to be a much-appreciated epicurean delight for both the chef and the guest.

A Note for Sushi Professionals

Kazari Sushi will enhance your menu offerings for seasonal events and celebrations. Making an entire platter of decorative sushi for a party may be too time-intensive; still, creating, for example, a single roll featuring the Chinese character for "celebrate" will yield four impressive slices. By placing one slice in the center of each five-serving platter, you can embellish twenty servings' worth of sushi. A panda design may be great for kids, and a flower motif could complement a wedding or anniversary celebration. For an older person's birthday, the Chinese character for "crane" might be appropriate. These decorative additions will be cause for much fanfare and commemorative photo-taking. Kazari Sushi is a great way to elevate any occasion.

Sharpening Your Skills

Kazari Sushi can range from easy to complex. Start with a simple roll and gradually work your way up in skill level.

Attempting a difficult design from the outset could result in an outcome that is less than ideal, which may be discouraging. Begin with basic skills such as rolling a circle, making a mountain, and forming curved contours. As you practice the various types of sushi, they will become second nature.

Layered sushi and other creative sushi expressions require just a few extra steps that sushi chefs are already using on a daily basis. Whenever you have a few spare moments, experiment with ingredients on hand and test out different flavor combinations as you acquire new skills.

Kawasumi-Style Kazari Sushi

Some sushi chefs may wonder whether making Kazari Sushi or layered sushi will negatively affect their bottom line, or whether the lack of seasonal ingredients in these rolls will diminish their appeal. Others may exclaim, "Sushi should be simple!"

I believe in upholding the culinary traditions of Japanese sushi in the form of decorative sushi that can be easily prepared in restaurant facilities. First and foremost, though, my aim is to amaze and delight my customers with a meal that's delicious.

To achieve this, preparations and proper steps are important. Calculate the consumption time, select ingredients that will hold up over longer periods, maintain the temperature of the sushi rice, and add the raw ingredients at the end. Keeping these factors in mind will ensure that your sushi creations look and taste wonderful. And experiencing this unique creative expression of sushi will make customers and sushi makers alike into fans of Kazari Sushi.

My ultimate goal is for Kazari Sushi customers to declare it beautiful and tasty. In that sense, I am still learning and developing my own form of decorative sushi. Feedback from users of this book, and learning about their creations, will help me to continue developing my skills. These days it's easy to acquire fresh seafood and sushi-specific cooking supplies, so the enthusiastic home cook will have no trouble delving into the Kazari Sushi techniques. I hope this book will bring joy to everyone involved in the creation process, from those who make it to those who consume the edible art.

Ken Kawasumi
Director of Kawasumi Kazari Sushi Association

Contents

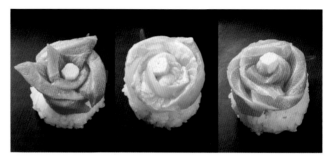

Before You Begin

The decorative and creative techniques for creating Kazari Sushi rolls featured in this book are intended for professional sushi chefs, as well as aspiring sushi chefs and home cooks interested in Kazari Sushi methods.

Fundamentals

Basic Techniques for Making Kazari Sushi Rolls

Unlike typical sushi rolls, Kazari Sushi rolls with designs tend to be larger, with intricate details that require particular techniques. From preparing the ingredients to cutting the rolls, this section contains all the key information you'll need.

How to Prepare the Ingredients

Prior to starting, gather all the ingredients in the required amounts. You need to be able to focus on the construction of the rolls without running the risk of missing ingredients or having insufficient amounts. The basic measurement of the nori used in the book is a half-sheet; that is, a sheet of nori cut in half lengthwise (the width will be approximately 4 inches / 10.5 cm). Always cut the other ingredient lengths to correspond to this nori length. It's a good idea to keep a mixture of water and vinegar nearby for your hands and kitchen knives. The water and vinegar mixture keeps your hands and knife from sticking to the rice.

Sushi Rice

Refer to page 8 for a basic sushi rice recipe. For Kazari Rolls, specific coloring ingredients are mixed in with the rice to give it different hues. Depending on the ingredients, the distribution and intensity of the color will vary, so pay attention as you blend the coloring ingredient with the rice, adjusting the amount of the coloring ingredient accordingly. Furthermore, due to the way certain rolls are crafted, the design may not show up as well when there is not enough rice in the rolls, so make sure to prepare more rice than the recipe or instructions call for.

Ingredients used for coloring sushi rice			
Red	*oboro* flakes; *tarako* salted pollock roe; *mentaiko* spiced roe; *tobiko* flying-fish roe; *umeboshi* paste; very finely grated beetroot (use a Microplane or mini-grater), salted and squeezed to remove excess moisture	**Brown**	*ami no tsukudani* (tiny shrimp simmered in soy sauce) or other *tsukudani* variations (see page 10); Kanpyo Simmered Gourd (see page 10); *tori soboro* Simmered Ground Chicken (see page 10)
Yellow	chopped Japanese Omelette; *takuan* pickled daikon; tumeric; very finely grated carrot (use a Microplane or mini-grater) seasoned with salt and lemon, then squeezed to remove excess moisture	**Black**	black sesame seeds; *yukari* (dried shiso powder); kombu *tsukudani*
Green	*aonori* laver flakes; minced *nozawana* pickled mustard greens; spinach or other greens briefly blanched in boiling salted water, squeezed dry, and finely chopped	**White**	*bettarazuke* white pickled daikon; white sesame seeds; *kamaboko* fish cake; *surimi* artificial crab; smoked tofu

Thoroughly mix the coloring ingredients into the sushi rice so that the color is evenly distributed. Add a little at a time and gradually increase it while gauging the color. Make sure not to crush the rice grains as you mix in the coloring ingredient.

Measure the designated portions of rice in advance, lightly pressing the required amount into a ball and set aside. This way you will not need to stop in the midst of assembling a roll to measure out the other portions of the rice.

Preparing the Nori Seaweed Sheets

The Kazari Rolls featured in this book are all based on a half-sheet of nori; that is, a full 8 x 7½ inch (21 x 19 cm) sheet cut lengthwise. If you purchase pre-cut half sheets that measure 4 x 7½ inches (10.5 x 19 cm), omit the lengthwise cut. Where ½ of a half sheet is specified, this is a half-sheet cut in half crosswise; "⅔ half-sheet" indicates a half-sheet cut crosswise to two-thirds of its original length. Prepare all nori pieces by cutting them to the required size before starting to construct the rolls.

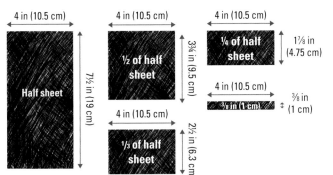

Prepare accurately cut nori pieces. A ruler or cutting board with printed measurements is handy for precision work.

If the instructions call for 1½ sheets of nori, you will be attaching the two pieces of nori together, using a bit of mashed rice as "glue," to create an extended piece.

Useful Equipment and Tools for Making Kazari Rolls

Here is a list of helpful tools and equipment for measuring, weighing, decorating, etc.

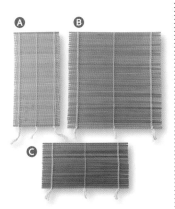

Various sushi mats

A Half-sized mat specifically used for making Kazari Rolls, which generally use half-sheets of nori.
B Standard sushi mat.
C Mat for making thin rolls (*hosomaki*). Find one that is easiest for you to use.

Cutting board with printed measurements

With printed measuring lines in ¼-inch or 1-cm increments, this cutting board is useful for cutting nori and shaping sushi rice.

Digital scale

It's best to use a digital scale for measuring ingredients accurately. Some models have a "tare" function that allows you to subtract the weight of the packaging. Select one that can measure in ounces to the hundredth place, or in 1-gram units.

Nori punches

This is a convenient tool to cut various shapes like eyes and mouths out of nori. If you're lucky enough to live near a large Japanese market, you might find nori punches there, near other bento supplies. Nori punches can also be purchased online.

Ruler

Helpful for measuring things like the size of ingredients and the height of sushi-rice "mountains." A 6-inch (15-cm) ruler is sufficient.

Bamboo skewers

Bamboo skewers are very handy for placing nori pieces or other small design elements used as a finishing touch for Kazari Rolls. The thinness of the skewers makes them easier to use than chopsticks.

Craft scissors

Craft scissors, usually smaller than the average kitchen scissors, are useful for detailed cutting.

Unlike conventional sushi, Kazari Sushi tends to be more involved, which may require more equipment and supplies. Proper maintenance and extra attention to detail are necessary at all times. Here are a few best-practice pointers to deliver delicious sushi safely and easily.

Handling the Ingredients

In addition to using typical sushi ingredients, Kazari Sushi incorporates processed ingredients such as *kamaboko* fish cake as well as fresh produce. Store each ingredient in a designated container and keep them separate. Make sure to securely close the container lids. Some ingredients need to be refrigerated, frozen or kept in a cool, dark place. Be aware of the expiration dates and try to use up the ingredients as soon as possible.

TIPS

- Store raw foods, processed goods and fresh produce separately.
- Do not mix ingredients in containers or use tools on more than one type of ingredient (e.g., don't use a knife to cut raw fish and then use it to cut processed food).
- Wipe off any moisture or condensation and wrap ingredients in paper towels, cloth or plastic wrap to prevent leaking
- When Kazari Rolls include raw seafood as well as other types of ingredients, prepare the ingredients in separate containers
- Keep raw ingredients in the refrigerator until you are just about to use them.

Practice Good Hygiene

While constructing Kazari Rolls, your hands will frequently get dirty from adding color to sushi rice or from working on small, detailed elements. Consistently wash your hands, and when you handle raw foods, make sure to rinse your hands thoroughly before moving on to the next step. The same goes for knives and cutting boards. Diligent hygiene maintenance is vital. Remember also to systematically work on ingredients by type, such as simmered components, raw components, etc. Always use latex kitchen gloves if you have any cuts or injuries on your hands. Regularly replace hand towels and the water and vinegar mixture used for wetting hands and knives. To work as efficiently and quickly as possible, prepare well, be conscious of how you handle food and equipment, and keep honing your skills.

TIPS

- Keep your hands and equipment clean.
- Have designated cutting boards and tools for different tasks.
- When cooking with gloves, do not use the same gloves for different tasks unless you wash your hands (and gloves) between steps.
- For more involved dishes, try to add raw ingredients at the end and plan your steps accordingly.
- Work quickly and do not leave completed dishes at room temperature for prolonged periods.

Sushi rice does not stick to embossed gloves, so these are handy for sushi-making. Do not use your cooking gloves for other tasks.

Maintaining Your Equipment

Equipment and tools require a few steps in addition to cleansing. They must be free of moisture and fully dry; they need to be disinfected and sterilized. Sushi mats will get moldy if they are not dried thoroughly after washing. Sponges and washcloths for dishwashing should be kept separate from those used for food preparation. Wring out as much water as possible after each use.

TIPS

- As soon as you are done using a piece of equipment or a tool, wash and dry it.
- Clean the sushi mat with a dishwashing scrubber and dry it thoroughly.
- Change hand towels frequently; bleach or disinfect after each use.
- Verify that the refrigerator and freezer temperatures are accurate; keep the handles clean.
- Keep sponges and scrubbers clean.

Rolling Techniques

Since the beauty of Kazari Rolls lies in the balance of their composition and design, most of the rolls are not formed by simply rotating the sushi mat from front to back. Instead, the sushi mat and sushi is turned to the side, and the shape is adjusted by looking at the cross-section and contents at the open end of the roll. Carefully following each step of the assembly instructions (e.g. the layering order of ingredients, how to spread the sushi rice) will yield superior results.

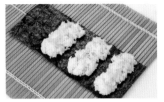 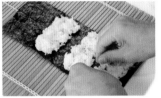 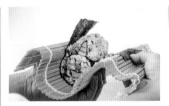

To spread sushi rice across a larger nori surface, divide the required amount of rice into multiple equal-sized portions and lay them on the nori with a little space between each portion. Then fill in the space by gently spreading each portion to create one big even surface of rice. Sushi rice mixed with coloring ingredients tends to be more difficult to spread, so this technique works particularly well for tinted sushi rice.

To begin rolling, hold the sushi mat in one hand with the palm curved. Keep an eye on the elements to make sure the shapes are not getting distorted or shifted, and apply pressure evenly and firmly from both sides of the sushi mat.

Once the ends of the nori have overlapped and the roll is closed, adjust the shape. Turn the sushi mat and view from the side as you adjust the shape with both hands. This is particularly essential for rounded and raindrop-shaped rolls.

To accurately shape and cut ingredients used as design elements to precise sizes, such as strips of sushi rice (Smiley Face Rolls on page 33) or "mountains" of sushi rice (Tulip Rolls on page 40), a cutting board with printed measurements is very helpful.

For a semicircle or square roll, place the roll on a dry cutting board once the nori has sealed the roll closed. Place the sushi mat on top and press to form the desired shape.

As you refine the shape with the sushi mat, place the palm of your hand or a clean cloth over the opening of the roll to keep it flat and to prevent the fillings and contents from popping out.

Cutting Techniques

The Kazari Rolls in this book are generally sliced into four pieces. Clean cuts are essential for the design to show up clearly. Use a very sharp knife, and dampen the blade with a mixture of water and vinegar before slicing through the roll with small back-and-forth sawing motions. After making each cut, place the knife on a stable surface and wipe the blade thoroughly with a cloth before dipping it in the vinegar water again.

Dip the tip of the kitchen knife into the water and vinegar mixture and quickly stand the knife upright to allow the liquid to flow down the blade. Then press a cloth to the blade to wipe off excess moisture.

Insert the kitchen knife into the roll as if to barely slice the surface. Use small sawing motions to gently cut through the rest of the roll.

After each slice, wipe down the blade with a cloth, then dip it in the water and vinegar mixture again.

Basic Recipes

The following recipes are staple items used in many Kazari Sushi rolls. In many cases, only a small amount of a given ingredient is called for, but leftovers can be refrigerated or frozen for later use. Plan ahead—if you're making sushi for a party or large group, try to make rolls with common ingredients in order to minimize waste.

Making Delicious Sushi Rice

When enjoying sushi, the freshness and preparation of the toppings tend to take center stage, but the sushi rice that forms the foundation is vital to the overall taste. For Kazari Rolls in particular, sushi rice is often the star, so be extra mindful of starting with and making the best possible sushi rice. Let's begin with rice basics.

As the foundation of Kazari Sushi, properly prepared sushi rice is the most essential basic ingredient. Use rice designated specifically for sushi, and use only rice vinegar in the sushi seasoning. Don't use any metal in preparing seasoned sushi rice. Turn the rice out into a ceramic, wooden, or plastic bowl, and use a wooden or plastic rice paddle to mix the seasoning into the rice. Have an assistant fan the rice with newspaper as you mix in the seasoning. The finished rice should be glossy and able to readily clump together, with a mild, "moreish" flavor.

Cooking Sushi Rice

Although the rice used is specific to sushi, the cooking steps don't differ all that much from preparing regular rice. The main difference is that sushi rice is cooked with slightly less water to yield firmer rice. The instructions below are for using a rice cooker. If preparing sushi rice on the stovetop, follow the instructions on the package.

1 Measure the correct amount of uncooked rice into a bowl or container. Add plenty of water to wash the grains, then drain. Don't swish the rice around too vigorously, as it may break the rice grains. Rinse several times, draining the water completely each time.
2 Let sit in a strainer for about 15 minutes to allow the water to drain.
3 Pour the washed rice into the rice cooker and add an equal amount of water (1 cup of rice = 1 cup of water). If possible, let the rice soak for 10 to 20 minutes before cooking.
4 Once the rice is cooked, allow it to steam in the covered pot or rice cooker to fully absorb all the water.

TIP

Newly harvested rice contains more moisture. If you're using "new crop" rice, reduce the amount of cooking water by about 10 percent. The amount of soaking time needed will depend on the season: it will be shorter in the summer and longer in the winter.

Making Seasoned Vinegar

Seasoned vinegar for sushi is made by dissolving salt and sugar into rice vinegar. Always prepare the seasoned vinegar in advance. You can adjust the proportions of ingredients to suit your own tastes and those of your guests, as well as the type of sushi you are making. The tables on the opposite page provide measurement guidelines.

Adding the Seasoned Vinegar

The rice needs to be warm to fully absorb the seasoned vinegar, so it's important to add the mixture as soon as the steaming step is complete. Gently fold in and evenly distribute the seasoned vinegar without crushing the rice grains. Conventional rice cookers include the steaming step with the cooking time, so you can add the seasoning as soon as the rice is done cooking.

TIPS

- Let the cooked rice steam for about 20 minutes in the rice cooker or covered pot before adding the seasoned vinegar.
- Use a wooden rice paddle to gently mix the rice and seasoned vinegar.
- Quickly and evenly distribute the vinegar to coat every grain of rice.
- Cool with a fan when the rice vinegar has been thoroughly mixed in.
- Once the sushi rice is ready, transfer it to a wooden bowl or rice tub and cover with a tightly wrung out damp cloth to retain the rice's moisture. Use within 4 hours.

Sushi Rice Guidelines

It's best to make the seasoned vinegar in advance so that the salt and sugar can fully dissolve and enrich the flavor. The tables below show how you can vary the quantities of salt, sugar and rice vinegar (combined in advance and added after the cooked rice has finished steaming) to achieve slight variations in flavor suitable for different types of sushi. The plastic measuring cup included with most rice cookers is 1 *go*, a traditional measure for dry rice equivalent to ¾ cup or 180 g.

Mild Sushi Rice					
For nigiri sushi, spherical sushi, everyday sushi, and sushi with strongly flavored ingredients such as vinegared or marinated fish					
Uncooked Rice	**Water**	**Salt**	**Sugar**	**Rice Vinegar**	**Yield**
¾ cup / 180 g	¾ cup / 180 ml	⅔ teaspoon	2 teaspoons	5 teaspoons (25 ml)	about 1½ cups / 300 g
1½ cups / 360 g	1½ cups / 360 ml	1½ teaspoons	4 teaspoons	3 tablespoons plus 1 teaspoon (50 ml)	about 3 cups / 600 g
3¾ cups / 900 g	3¾ cups / 900 ml	1 tablespoon	3 tablespoons	8½ tablespoons (125 ml)	about 7½ cups / 1.5 kg

Standard Sushi Rice					
Perfect for any type of sushi, including rolled sushi					
Uncooked Rice	**Water**	**Salt**	**Sugar**	**Rice Vinegar**	**Yield**
¾ cup / 180 g	¾ cup / 180 ml	⅔ teaspoon	2⅓ teaspoons	5 teaspoons (25 ml)	about 1½ cups / 300 g
1½ cups / 360 g	1½ cups / 360 ml	1½ teaspoons	5 teaspoons	3 tablespoons plus 1 teaspoon (50 ml)	about 3 cups / 600 g
3¾ cups / 900 g	3¾ cups / 900 ml	1 tablespoon	4 tablespoons	8½ tablespoons (125 ml)	about 7½ cups / 1.5 kg

Sweet Sushi Rice					
Typically used in western Japan, as well as for pressed sushi. Kids like it, too!					
Uncooked Rice	**Water**	**Salt**	**Sugar**	**Rice Vinegar**	**Yield**
¾ cup / 180 g	¾ cup / 180 ml	⅔ teaspoon	1 tablespoon	5 teaspoons (25 ml)	about 1½ cups / 300 g
1½ cups / 360 g	1½ cups / 360 ml	1½ teaspoons	2 tablespoons	3 tablespoons plus 1 teaspoon (50 ml)	about 3 cups / 600 g
3¾ cups / 900 g	3¾ cups / 900 ml	1 tablespoon	4⅔ tablespoons	8½ tablespoons (125 ml)	about 7½ cups / 1.5 kg

Strong Sushi Rice					
Best for vegetable sushi and in sushi where the rice is featured prominently					
Uncooked Rice	**Water**	**Salt**	**Sugar**	**Rice Vinegar**	**Yield**
¾ cup / 180 g	¾ cup / 180 ml	⅔ teaspoon	2⅓ teaspoons	2 tablespoons (30 ml)	about 1½ cups / 300 g
1½ cups / 360 g	1½ cups / 360 ml	1½ teaspoons	2 tablespoons	4 tablespoons (60 ml)	about 3 cups / 600 g
3¾ cups / 900 g	3¾ cups / 900 ml	1 tablespoon	4 tablespoons	9 tablespoons (135 ml)	about 7½ cups / 1.5 kg

Kanpyo Simmered Gourd

Dried *kanpyo*, which looks a bit like fettuccine, is available in Asian markets. It can often be found precooked in the refrigerated or deli section of a Japanese market, but you can also make your own by following this recipe.

1 oz (25 g) dried *kanpyo*
Salt for rubbing (about 2 teaspoons)
½ cup (120 ml) sake
2 tablespoons soy sauce
1 tablespoon sugar

1 Wash the dried *kanpyo* under cold water, then rub all over with salt. Without rinsing, cover with cold water and soak overnight (alternately, pour boiling water over and let stand 10 minutes), then drain.
2 Combine the sake, soy sauce and sugar in a small saucepan and place over medium-low heat. Stir to dissolve the sugar and then add the drained *kanpyo*. Simmer for 5 minutes, then remove from heat and let stand for 30 minutes.
3 Drain and use. Makes about 4 ounces (120 g) simmered *kanpyo*.

Japanese Omelette

If you're lucky enough to live near a large Japanese market, you can probably find premade Japanese omelette near the sushi case. It's not too hard to make your own, though.

2 eggs
1 teaspoon sugar
1 teaspoon soy sauce
1 teaspoon mirin
Pinch salt

1 Combine all ingredients in a bowl and whip with a fork or chopsticks to blend. Have a piece of paper towel handy before you begin cooking.
2 Add a little oil to a medium skillet over medium-high heat. Holding the paper towel with cooking chopsticks, spread the oil over the pan surface. When the oil is hot, pour in just enough of the egg mixture to make a thin layer. When the egg just begins to set, use the chopsticks to roll it over to the side of the pan.
3 Add a little more oil, spreading it with the paper towel. Again add egg to make a thin layer, lifting the cooked egg so the new mixture goes underneath. When it begins to set, roll the previously cooked egg up with it and push the roll to the side.
4 Oil the pan again and repeat, rolling the previously cooked egg together with the new each time, until you have used all the egg mixture (5 to 7 times, depending on pan size).
5 Remove from heat and transfer to a clean cutting board. When cool, cut into bars of the size specified in the recipe.

Simmered Ground Chicken

This flavorful ingredient is called *tori soboro* in Japanese and consists of ground chicken that is stir-fried and then simmered in sweetened rice wine, soy sauce and ginger until dry.

1 tablespoon vegetable oil
8 oz (250 g) ground chicken
1 tablespoon sake
2 tablespoons sugar
1 tablespoon mirin
2 tablespoons soy sauce
1 tablespoon grated ginger, with juice

1 Add the oil to a skillet over medium heat. When hot, add the chicken and cook until it is almost cooked through, stirring and breaking up into small pieces.
2 Add the sake, sugar, and mirin, and stir well. Add the soy sauce, continuing to stir and break the chicken up into small pieces. When the meat is thoroughly broken up, add the grated ginger and juice, and continue cooking until all liquid is absorbed. Remove from heat and set aside to cool. Leftover meat may be frozen for future use.

Tsukudani Sweet Soy and Mirin Simmered Ingredients

The recipes in this book call for *ami no tsukudani*, which are tiny shrimp simmered in a sweet soy sauce. This can often be found in the refrigerated or deli section at a Japanese market. There are many variations, however: *tsukudani* can also be made with dried baby sardines (*chirimenjako*), shredded simmered kombu, hijiki or wakame seaweed, chopped clams, or other ingredients. This recipe makes about ½ cup (100 g).

2 tablespoons mirin
2 tablespoons sugar
2 tablespoons soy sauce
½ teaspoon thinly shredded ginger
½ cup (150 g) small dried shrimp, dried baby sardines, kombu, wakame or other ingredient, soaked or simmered until tender, then drained well
1 teaspoon toasted white sesame seeds

1 Combine the mirin, sugar, soy sauce and ginger in a small saucepan over medium heat. Stir until sugar dissolves, then add your chosen ingredient.
2 Continue to cook, stirring constantly, until the sauce thickens and the items are soft, then remove from heat and stir in the toasted white sesame seeds.
3 Chop the *tsukudani* finely before adding to the sushi rice.

Ingredients and Substitutions

The following ingredients are staples in Kazari Sushi because of their versatility, color, and flavor. If you don't have an Asian market nearby, try looking for these items on the internet.

Aonori laver flakes *Aonori* is deep green, with a mild seaweed flavor. These fine flakes are available in Asian markets. If you can't obtain *aonori*, use very finely chopped parsley leaves instead.

Bamboo leaves Available online and in Asian markets, fresh bamboo leaves are used decoratively in sushi presentations. Substitute fresh herbs for cut bamboo leaves if necessary.

Bettarazuke white pickled daikon White pickled daikon is not dried before pickling, so it has more moisture than the more common *takuan*. It has a sweet, fresh taste. You can find it with other pickled vegetables at larger Asian markets or online. If *bettarazuke* is not available, use an equal amount of finely minced sweet pickled white onion (drain well before adding to rice).

Cheese kamaboko cylinders These sticks of fish paste mixed with mild cheese can be found at larger Asian markets. They're about ¾ inch (2 cm) in diameter. Similarly proportioned sticks of *surimi* or packaged cheese sticks can be substituted if necessary.

Fish sausage A pink variety of *kamaboko* that comes in tubes about an inch (2.5 cm) in diameter. Look for it in the refrigerated area of large Asian markets. Substitute precooked hot dogs if necessary.

Green tobiko flying-fish roe *Tobiko* may be mixed with wasabi and other coloring agents to make it green. It can be found in the refrigerated or frozen section of many Asian markets. If unavailable, mix 1 tablespoon finely chopped parsley stems with ¼ teaspoon of wasabi paste as a substitute.

Ikura salmon roe These large orange fish eggs are probably the easiest to find of the varieties of fish roe used in Kazari Sushi. You can find "red caviar" at gourmet specialty shops, even if they don't specialize in Asian food.

Japanese cucumber Smaller than English cucumbers, Japanese cucumbers have thin skins and undeveloped seeds, and are entirely edible. Substitute skinned and deseeded English cucumbers if necessary.

Kamaboko fish cake This cooked fish paste comes in many shapes, sizes, and colors. The *kamaboko* called for in these recipes is white, and it comes in a half-moon shape (like a tube cut in half lengthwise). If unavailable, try using smoked tofu cut to the specified size and shape instead.

Mentaiko spiced pollock roe *Mentaiko* (and related *tarako*) is usually sold intact in the ovum of the fish. *Mentaiko* is marinated in a chili-pepper sauce, which imparts a spicy flavor and bright red color. Substitute very finely chopped sun-dried tomatoes cured in olive oil with a pinch of crushed or powdered red peppers.

Mirin rice wine This Japanese cooking wine is widely available, but in a pinch, use an equal amount of sake with ⅓ the amount of sugar added (e.g., 1 tablespoon sake plus one teaspoon sugar). Sweet sherry may also be substituted.

Mitsuba A Japanese herb with a distinctive flavor, *mitsuba* can be found in the produce section of a Japanese or Asian market. If it's unavailable, flat-leaf parsley may be substituted.

Nozawana pickled mustard greens These tangy, salty pickled greens complement rice extremely well. If you can't find *nozawana*, add 2 table-spoons salt to 1 quart (1 liter) water, bring to a boil, and blanch 2 ounces (60 g, or 2 cups) fresh spinach leaves for 30 seconds. Drain and squeeze to remove as much moisture as possible before arranging on the sushi rice. If stems are called for, thin Swiss chard or spinach stems, blanched in heavily salted water and drained well, can be used as a substitute.

Oboro whitefish flakes *Oboro* (also called *denbu*) consists of fluffy flakes or granules made from dried whitefish seasoned with sake and mirin. As *oboro* flakes are often colored pink, they may be mixed with sushi rice to give it a pink tint. Store unused *oboro* in the freezer. If you can't obtain *oboro*, try substituting a small amount of finely grated beet (use a Microplane if possible). Grate ⅓ cup (50 g) raw beet and season with ¼ teaspoon of salt, stir to mix and let stand 5 minutes, then drain and use as needed. You can store the grated beet in a tightly closed container in the refrigerator for a week. Use ¼ teaspoon of beet per ½ cup (100 g) of sushi rice.

Pickled ginger Sweet and warming, pickled ginger is thinly sliced ginger root that has been pickled in seasoned vinegar. If store-bought pickled ginger is unavailable or not preferred, you can prepare your own (see pages 8–9 for seasoned vinegar information).

Tarako salted pollock roe Commonly (and erroneously) called "cod roe," *tarako* is Alaska pollock roe that's been treated with salt. It has a rich taste and fine texture, and a pinkish-orange color. If you can't

find it in the fresh or frozen section of your Asian market, you can substitute an equal quantity of very finely chopped smoked salmon.

Takuan pickled daikon Yellow in hue, *takuan* is made from daikon radishes that are dried before pickling. It is a bit chewier than *bettarazuke* in texture, and makes a loud crunching sound when it is eaten. One of the more widely available Japanese pickled vegetables, it can be found in the macrobiotic section of most health-food stores, as well as at Asian supermarkets. If you can't find it, substitute chopped pickled carrots or cauliflower from a pickled Italian vegetable mix—drain well before adding to the sushi rice.

Tobiko flying-fish roe *Tobiko* is an orange-colored mild-tasting roe that pops pleasantly on the tongue. It can be found fresh or frozen at many Asian markets. If you can't obtain it, mixing the sushi rice with finely grated carrot will give it the desired orange tint. Grate ⅓ cup (35 g) of carrot with a Microplane or fine grater. Sprinkle ½ teaspoon salt and 1 teaspoon lemon juice over and stir well to blend. Let stand 5 minutes then squeeze well to remove as much moisture as possible. Mix into the rice.

Umeboshi plum paste This tangy, deep-purple paste is available in tubs, bottles or tubes in the refrigerated section of Asian markets. If kept refrigerated, the paste has a long shelf life.

Wasabi paste Most commercial preparations of this green, sinus-opening condiment contain a blend of mustard seed powder, horseradish powder, water and food coloring. Japanese brands are more likely to contain actual wasabi root. If you can't find the paste, you can prepare your own using wasabi powder (follow package instructions).

Yamagobo pickled burdock root
Pickled burdock root can be found in Asian specialty markets; it is usually a pinkish orange in color. If you can't find it, peel or whittle a 4-inch (10.5-cm) length of carrot down to pencil diameter and boil in well-salted water until just tender (2 to 3 minutes).

Yukari dried shiso powder Red shiso, or perilla, is a deep-red leaf used to impart color to *umeboshi* pickled plums, among other things. The dried leaf is powdered and mixed with salt to create a tart seasoning called *yukari*, which gives rice a purple hue. If you can't find *yukari*, substitute an equal amount of *umeboshi* paste or finely chopped *umeboshi* pickled plums.

Basic Sushi Rolls and Simple Shapes

The *hosomaki* thin roll is the basis for most of the rolls in this book. Master this roll first before proceeding to more complicated rolls. Layered rolls incorporate traditional sushi rolling techniques and produce beautiful designs that are as captivating to the modern eye as they were in times past. Carefully follow each step for best results.

Basic Thin Rolls
- **Round Rolls**
- **Square Rolls**
- **Triangle Rolls**
- **Raindrop Rolls**
- **Jewel Rolls**

Thin Roll Arrangements
- **Flower Rolls**
- **Cherry-Blossom Rolls**

Layered Rolls Made with Thin Rolls
- **Seven Treasure Rolls**
- **Peach-Blossom Rolls**
- **Plum-Blossom Rolls**

Layered Rolls Made with Cut Thin Rolls
- **Coin Rolls**
- **Seven-Part Star Rolls**
- **Four Seas Rolls**
- **Water Chrysanthemum Rolls**

Basic Thin Rolls (Hosomaki)

The thin roll is important to master, as it is the basic foundation of most varieties of Kazari Sushi. It's important to keep in mind the uniformity of the shape of the roll, the centering of the filling, and the density of the rice—that is, gently compressed without being crushed. You can easily apply the techniques to variations, including round, square, and triangle-shaped rolls.

Round Rolls with Kanpyo Simmered Gourd Maru-maki

Kanpyo Simmered Gourd is used in many Kazari Rolls, especially those featuring curved lines, like kanji character rolls. It's tasty and versatile, and stands on its own while also partnering well with other ingredients. This simple thin roll is a mainstay in sushi restaurants, and is a great vegetarian sushi option as well.

MAKES 24 ROUND PIECES

1¾ cups (350 g) prepared sushi rice

2 sheets nori, cut in half lengthwise to make 4 half-sheets

4 strips of Kanpyo Simmered Gourd (see page 10), cut to the length of the nori (7½ in / 19 cm), approximately 3 oz (90 g)

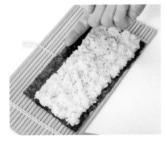 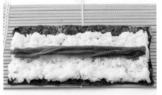

1 Place a half-sheet of nori horizontally on a sushi mat. Without crushing the rice grains, gently spread a fourth (about 7 tablespoons) of the sushi rice across the nori, leaving about ¾ inch (2 cm) of space at the back edge of the nori and an even narrower space at the front. Use your finger to make a shallow lengthwise channel across the center of the rice, where the filling will be placed. Lay one-fourth of the *kanpyo* strips across the rice in this depression.

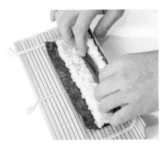

2 Making sure not to shift the nori, lift up the front of the sushi mat and curl the front edge of the mat toward the back in one smooth motion.

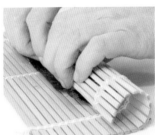

3 Tighten the sushi mat around the nori and filling. Pull the mat toward you, continuing to roll the mat so that the empty nori at the far end of the sheet closes the roll. Use the mat to adjust the shape, forming a cylinder of even thickness. Remove the sushi mat. Repeat to make 4 rolls in all.

4 Use a very sharp knife dipped in vinegar water to cut each roll in half, then cut each half into thirds to make 6 pieces, wiping the blade clean after each cut.

Square Rolls with Tuna Kaku-maki

Tekka-maki, or tuna roll, is one of the two most popular thin rolls (the other is *kappa-maki*, cucumber roll—in fact, if you like, you can use a thin-skinned Japanese or English cucumber in place of tuna in this recipe). Cut the four sides of the tuna very straight to make even-sided bars with a square cross-section. This will help make the square shape of the roll clearer.

MAKES 24 SQUARE PIECES

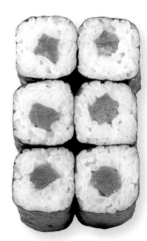

1¾ cups (350 g) prepared sushi rice

2 sheets nori, cut in half lengthwise to make 4 half-sheets

4 rectangular bars of sushi-grade tuna (around 2 oz / 60 g each), cut to 7½ x ⅜ x ⅜ in (19 x 1 x 1 cm)

2 teaspoons prepared wasabi paste

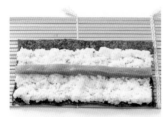

1 Place one half-sheet of nori horizontally on a sushi mat. Without crushing the rice grains, gently spread one-fourth (about 7 tablespoons) of the sushi rice across the nori, leaving about ¾ inch (2 cm) of space at the back edge of the nori and a narrower space at the front. Use your finger to make a shallow lengthwise channel across the center of the rice, where the filling will be placed.

2 Gently smear ½ teaspoon of the wasabi across the rice along the central channel. Lay the tuna on top of the wasabi.

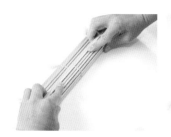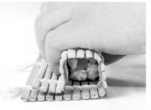

3 As when making a round roll, lift up the front of the sushi mat and curl it toward the back in one smooth motion, making sure not to shift the nori and filling as you do so. Then place your index fingers on the center of the sushi mat to create a flat side that is parallel to one side of the square filling, pressing down gently. Repeat for the other three sides so that the roll is clearly square. Remove the sushi mat. Repeat to make 4 rolls in all.

4 Use a very sharp knife dipped in vinegar water to cut each roll in half, then cut each half into thirds to make 6 pieces, wiping the blade clean each time.

NOTE: *The amount of wasabi used can be varied according to your tastes or your guests' desires. Many sushi restaurants in the US, knowing that their customers will mix wasabi together with soy sauce for dipping, do not put wasabi into their rolled sushi. Traditionally, however, the wasabi is incorporated into the roll, so pieces of rolled sushi are gently dipped into plain soy sauce. Only when eating* sashimi *(raw fish served without rice) do customers add their own wasabi to taste.*

Triangle Rolls Sankaku-maki

If you'd like more variety in this simple roll, you can sprinkle toasted sesame seeds over the cucumber, or add a smear of wasabi or *umeboshi* paste. When rolling the sushi, try to be sure the triangle of the cucumber wedge is aligned with the triangle shape of the roll.

MAKES 24 TRIANGULAR PIECES

1¾ cups (350 g) prepared
 sushi rice
2 sheets nori, cut in half
 lengthwise to make
 4 half-sheets
1 Japanese or English
 cucumber at least 7½ in
 (19 cm) long

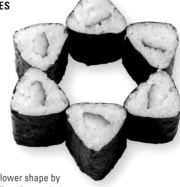

You can create a star or flower shape by arranging six triangular slices into a circle.

1 Remove the ends of the cucumber and cut it to the same length as the nori. Slice the cucumber in half lengthwise. Lay one half face-down on the cutting board and slice lengthwise to make three triangular wedges. Repeat with the other half.

2 Place one half-sheet of nori horizontally on a sushi mat. Without crushing the rice grains, gently spread one-fourth (about 7 tablespoons) of the sushi rice across the nori, leaving about ¾ inch (2 cm) of space at the back edge of the nori and a narrower space at the front. Use your finger to make a shallow lengthwise channel across the center of the rice, where the filling will be placed. Lay one cucumber wedge in the channel, peel side down.

3 Taking care not to shift the nori and cucumber slice, lift up the front of the sushi mat. With a pinching motion, roll the mat to form a triangular shape, pressing gently as you tighten the mat. Remove sushi mat. Repeat to make four rolls in all.

4 Use a very sharp knife dipped in vinegar water to cut each roll in half, then cut each half into thirds to make 6 pieces, wiping the blade clean each time.

Raindrop Rolls Shizuku-maki

When making a teardrop roll, be sure to place the filling toward the back of the roll, rather than in the middle. As you form the roll, it is helpful to hold the sushi mat in one hand and look at the roll from the side as you adjust the shape.

MAKES 24 TEARDROP-SHAPED PIECES

1¾ cups (350 g) prepared sushi rice

2 sheets nori, cut in half lengthwise to make 4 half-sheets

½ cup (130 g) *tobiko* flying-fish roe

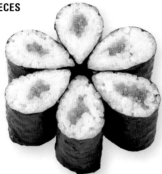

A roll sliced into six pieces can be arranged to make a flower shape.

1 Place one half-sheet of nori horizontally on a sushi mat. Without crushing the rice grains, gently spread one fourth (about 7 tablespoons) of the sushi rice across the nori, leaving about ¾ inch (2 cm) of space at the back edge of the nori and a narrower space at the front. Use your finger to make a shallow lengthwise channel across the rice toward the back, where the filling will be placed. Arrange 2 tablespoons of the *tobiko* in this channel to make a narrow line across the length of the rice.

 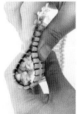

2 Taking care not to shift the nori and filling, lift the front of the sushi mat and use the same rolling method as the round roll (page 13). Keep pressing and rolling all the way, then lift up the sushi mat and adjust the shape into a teardrop shape while viewing the roll from the side. Remove the sushi mat. Repeat to make 4 rolls in all.

3 Use a very sharp knife dipped in vinegar water to cut each roll in half, then cut each half into thirds to make 6 pieces, wiping the blade clean each time.

Jewel Rolls Magatama-maki

When making a teardrop roll, be sure to place the filling toward the back of the roll, rather than in the middle. As you form the roll, it is helpful to hold the sushi mat in one hand and look at the roll from the side as you adjust the shape.

MAKES 32 COMMA-SHAPED PIECES

1¾ cups (350 g) prepared sushi rice

2 sheets nori, cut in half lengthwise to make 4 half-sheets

½ cup (80 g) pink *oboro* fish flakes

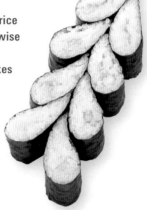

1 Place one half-sheet of nori horizontally on a sushi mat. Without crushing the rice grains, gently spread one fourth (about 7 tablespoons) of the sushi rice across the nori, leaving about ¾ inch (2 cm) of space at the back edge of the nori and a narrower space at the front. Use your finger to make a shallow lengthwise channel across the rice toward the back, where the filling will be placed. Arrange 2 tablespoons of the *oboro* flakes in this channel to make a narrow line across the length of the rice.

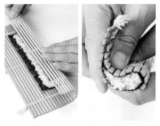

2 Using the same method as the Raindrop Rolls (left), lift the entire sushi mat, turn to the side and adjust the shape to form a comma-shaped roll. Remove the sushi mat. Repeat to make four rolls.

3 Use a very sharp knife dipped in vinegar water to cut each roll in half, then cut each half into four pieces, wiping the blade clean each time.

Thin Roll Arrangements

Create whimsy with simple arrangements of sliced thin rolls. To ensure that each sliced piece has the same shape, spread the rice evenly on the nori and turn the sushi mat to look at the roll from the side as you adjust the shape. Slice the roll with care to avoid disturbing the fillings, and try to make each slice uniform in thickness.

Flower Rolls Hana-maki

For this vibrant arrangement, orange *tobiko* flying-fish roe is added to the sushi rice to give it color; the cucumber pieces provide an extra pop of brightness. Positioning the cucumber pieces at the pointed end of the teardrop-shaped rolls looks lovely because when the pieces are arranged they form the center of the flower.

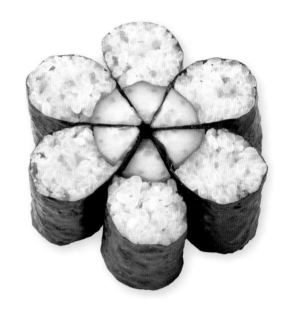

MAKES 24 PIECES, OR 4 FLOWER ARRANGEMENTS

1⅓ cups (275 g) prepared sushi rice
2 sheets nori, cut in half to make 4 half-sheets
4 tablespoons *tobiko* flying-fish roe
1 Japanese or English cucumber at least 7½ in (19 cm) long

1 Combine the *tobiko* with the prepared sushi rice. Divide into four equal portions.

2 Remove the ends of the cucumber and cut it to the same length as the nori. Slice the cucumber in half lengthwise. Lay one half face-down on the cutting board and slice lengthwise to make three triangular wedges. Repeat with the other half.

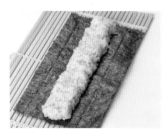

3 Place a sheet of nori horizontally on the sushi mat, and spread one-fourth of the *tobiko* rice (about 5 tablespoons) across the center of the nori to a height of just over an inch (3 cm).

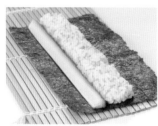

4 Place a piece of cucumber at the upper edge of the *tobiko* rice (toward the back of the roll). Press the cucumber against the rice, and leave a ⅜-inch (1-cm) space between the edge of the nori and cucumber.

5 Making sure not to shift the contents, lift and wrap the front of the sushi mat so that the front edge of the nori just meets the edge of the cucumber. Tighten.

6 Unwrap the sushi mat, then gently continue to tilt and rotate the roll to encase the contents into the nori. Adjust the sushi mat so that the part of the roll with no cucumber is rounded; tighten.

7 Re-place the roll on the mat so that the rounded part is down and the cucumber wedge is at the top. Hold the mat in one hand and view roll from the side as you adjust the roll into a teardrop shape. Remove the sushi mat. Repeat to make four teardrop rolls in all.

8 Remove the sushi mat and use a very sharp knife dipped in vinegar water to cut the roll into 6 equal slices, wiping the knife clean each time. Arrange to form a flower, with the pointed end of each "teardrop" at the center.

Cherry-Blossom Rolls Sakura no Hana

This particular thin roll is sliced into cherry-blossom petals and arranged to form flowers. The distinctive notched petal shape is achieved by using the blunt edge of a kitchen knife to create a groove in the roll.

MAKES 24 PETAL-SHAPED PIECES

1¾ cups (350 g) prepared sushi rice
2 sheets nori, cut in half lengthwise to make 4 half-sheets
4 tablespoons pink *oboro* fish flakes

TIPS *Thoroughly mix the* oboro *into the sushi rice to distribute the color evenly. • Don't roll the sushi mat; use a folding motion instead. • Wrapping the roll loosely with the mat will help keep the nori from tearing. • Make the groove the same depth for each slice, being careful not to tear the nori.*

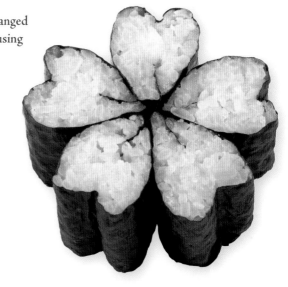

1 Combine the *oboro* with the sushi rice and mix gently to tint the rice evenly.

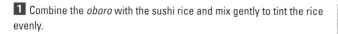

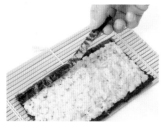

2 Cut a ⅜-inch (1-cm) strip from one sheet of nori. Place the remaining larger piece of nori horizontally on the sushi mat. Leaving ⅛ inch (3 mm) of space at the top and bottom edges of the nori, gently spread the sushi-rice mixture down the length of the sheet. Lay the ½-inch strip of nori across the back edge of the nori.

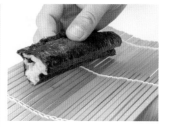

5 Reposition the roll on the mat once again so that it faces the other direction. Press the sushi mat to form the petal shape. Remove the sushi mat and cut off any excess nori that may be peeking out from the closed end. Repeat to make 4 rolls in all.

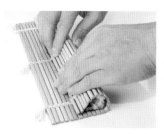

3 Fold the sushi mat over, pinching the end to form a triangular shape as you adjust the shape of the roll. Try not to press too tightly; this will help with forming the groove in step 4.

6 Use a very sharp knife dipped in vinegar water to cut the roll into 6 equal slices, wiping the knife clean after each cut. Arrange 5 slices into a cherry blossom.

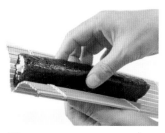

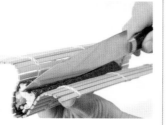

4 Reposition the roll on the sushi mat with the closed end (where the two edges of the nori meet) toward the bottom of the mat. Carefully press the back edge of a knife into the roll to make a groove.

Large-scale decorative sushi rolls can be made with multiple pieces and types of thin rolls that are wrapped together to form a larger roll. Rolls can be combined into an endless variety of designs, forming brilliant layered sushi creations. The key to a beautiful finish and professional-looking results is to carefully maintain uniform thickness and shape for each thin roll.

Seven Treasure Rolls

Four diamond-shaped thin rolls surrounding a filling (in this case, Japanese Omelette) comprise this large Kazari Roll. "Seven Treasures" refers to the pattern formed by the repeating circles called *shippou* in Japanese, which is considered a fortuitous design. Feel free to experiment with different fillings in complementary colors to make your own version.

MAKES 6 LARGE PIECES

1¾ cups (350 g) prepared sushi rice, divided into 4 equal portions
Nori: 4 half-sheets + 1 full sheet
1 bar (¾ oz / 20 g) sushi-grade tuna, cut into a bar 8 in (20 cm)
 long and ⅜ in (1 cm) on each side
8-in (20-cm) long Japanese or English cucumber, cut into 6
 lengthwise wedges
½ oz (15 g) *nozawana* pickled mustard greens
1 tablespoon *tobiko* flying-fish roe
Japanese Omelette (see page 10) cut into a bar 8 in (20 cm) long
 and ¾ in (2 cm) on each side

TIPS *Make each roll the same thickness and shape, and keep the position and color coordination of each of the four rolls in mind as you assemble them. • To assemble the entire roll, place the Japanese Omelette in the center. • The nori that wraps the omelette should touch the nori surfaces of the surrounding rolls. • As a final step, shape the entire roll into a square.*

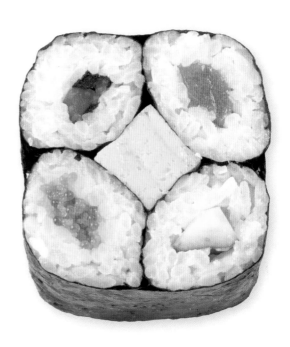

Nori Pieces

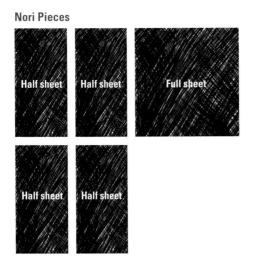

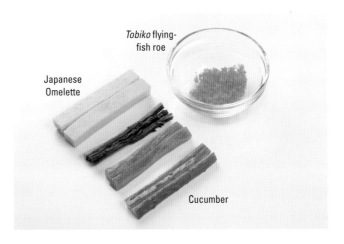

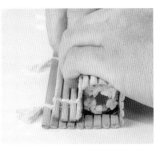
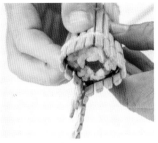

5 Place the omelette in the angled space created between the two rolls.

1 Make four separate square rolls (see page 13). For each roll, use a half-sheet of nori, one fourth of the sushi rice, and one filling (tuna, cucumber, pickled greens, or *tobiko*). As a final step for each roll, lift the sushi mat and press the entire roll into a diamond shape.

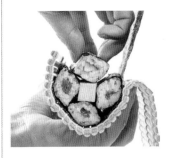

6 Arrange the remaining two rolls on top of the omelette, paying attention to the color of the filling. Make sure that one side of each of the four rolls is flush with one side of the omelette.

2 Make sure that all four rolls are the same thickness and shape. Flattening the sides into the diamond shape will make a space for the omelette.

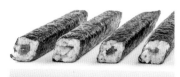

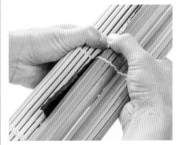

7 Use the sushi mat to finish rolling. Be sure the nori wraps around itself to seal the roll shut.

3 Place the full sheet of nori vertically on the sushi mat so that the short edge is parallel with the slats. Position one of the thin rolls at the front edge.

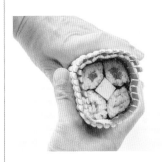

8 Press the sushi mat into a square shape. Remove the sushi mat and use a very sharp knife dipped in vinegar water to cut the roll into 6 equal slices, wiping the knife clean after each cut.

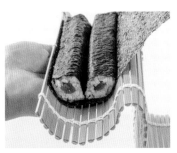

4 Holding the sushi mat in your non-dominant hand, place a second thin roll, with a contrasting-colored filling, next to the first.

Peach-Blossom Rolls Momo no Hana

Round rolls filled with pink *oboro*-tinted sushi rice form the petals for the peach blossom, and a slice of cheese *kamaboko* fish cake makes up the center. The arrangement is then wrapped in more sushi rice, resulting in an elaborate layered sushi roll. Because the center of the flower is round, it may be tricky to get it in the right place. Use the sushi mat to keep the shape together by pressing firmly.

MAKES 4 LARGE PIECES

1 cup (200 g) prepared sushi rice, divided
Nori: five ⅓ half-sheets + two 1-in (2.5-cm) wide strips, the
 length of a full sheet + 1⅓ half-sheets, "glued" together with a
 bit of rice to make an extended sheet
1 tablespoon pink *oboro* fish flakes
4-in (10.5-cm) cylinder cheese *kamaboko*
Five 4-in (10.5-cm) stalks *nozawana* pickled mustard greens
½ teaspoon toasted white sesame seeds
1 tablespoon finely minced pickled ginger

TIPS: *Make the round rolls equal in thickness to create a pleasing circular design. • Form the flower shape inside of the sushi mat, staggering each element as you build the roll. • Once the flower shape has been constructed, press it firmly together with the sushi mat and "tie" it together with the nori strips. • Spread the plain sushi rice in an even layer across the nori so that the design will appear uniform when the roll is sliced.*

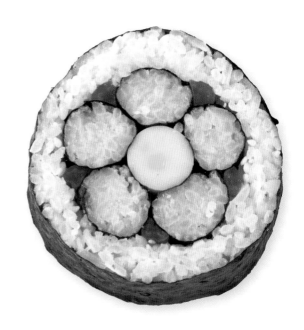

Nori Pieces

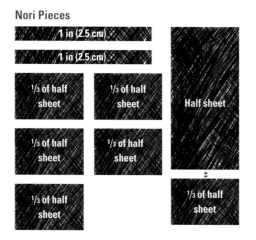

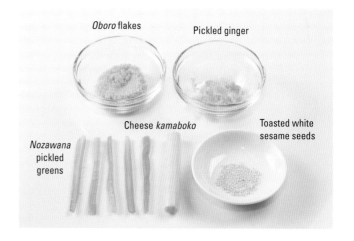

Oboro flakes

Pickled ginger

Cheese *kamaboko*

Toasted white sesame seeds

Nozawana pickled greens

1 In a small mixing bowl, combine ½ cup (100 g) of the sushi rice with the *oboro* flakes and mix gently until the rice is evenly tinted. Divide the now-pink rice into five equal portions.

 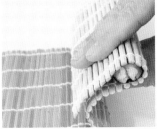

2 Place one of the ⅓ half-sheet nori pieces on the sushi mat with the long edge parallel to the slats. Form one portion of the pink rice into a cylinder and place it in the center of the nori. Use the sushi mat to wrap the nori around the rice. Repeat to make 5 rolls.

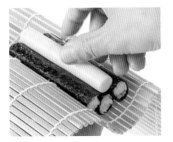 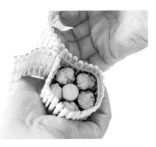

3 Hold the sushi mat in one hand and arrange three of the rolls from step 2 to form a half-circle. Place the cheese *kamaboko* in the hollow formed by the rolls. Balance the two remaining rolls on top of the cheese *kamaboko* and tighten the sushi mat around the entire construction, pressing them together.

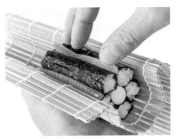

4 With the mat still in one hand, open it and place a stalk of pickled greens between each "petal," rotating the mat in your hand as you go to keep the "flower" together. Tighten the sushi mat around the entire roll once more and set aside.

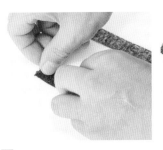 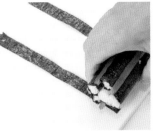

5 Smash a few grains of sushi rice at one end of the 1-inch (2.5-cm) nori strips and place them parallel to each other on a cutting board, set apart to match the width of the "flower." Carefully roll the "flower" onto the two strips of nori so that they wrap all the way around. Use the rice at the end as glue to secure the strips together. Set aside.

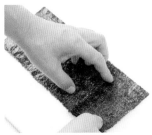 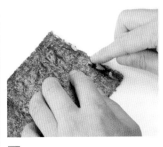

6 Lay the extended nori sheet on the sushi mat so that the short edge is parallel to the slats in the mat.

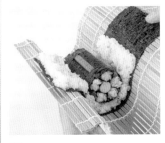 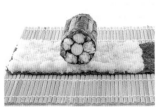

7 Spread the remaining ½ cup (100 g) of sushi rice evenly across the long nori sheet, leaving 2 inches (5 cm) of space at one end. Sprinkle the toasted white sesame seeds and minced pickled ginger evenly across the rice. Place the "flower" roll in the middle of the rice. Lift the sushi mat and slowly wrap the new layer of rice around the flower, using the empty nori at the edge to seal the expanded roll shut.

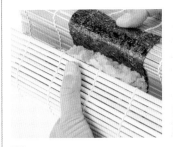 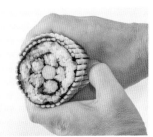

8 Roll the sushi mat all the way and compress it gently. Viewing the roll from the side, adjust the shape into a circle. Remove the sushi mat and use a very sharp knife dipped in vinegar water to cut the roll into 4 equal slices, wiping the knife clean after each cut.

Plum-Blossom Rolls

The construction method for the Plum-Blossom Rolls is the same as for the Peach Blossom Roll (page 20), but nori is added within the petals for additional detail. In keeping with this particular flower theme in look and taste, the red hue of the sushi rice is from *umeboshi* paste, which is made from pickled *ume* plums.

Mitsuba, a Japanese herb with a distinctive flavor, can be found in the produce section of a Japanese or Asian market. If it's unavailable, flat-leaf parsley may be substituted. In either case, blanch in boiling water for 1 minute, plunge into cold water, drain well, and then squeeze to remove as much moisture as possible.

MAKES 4 LARGE PIECES

1⅓ cups (275 g) prepared sushi rice, divided
Nori: five ½ half-sheets + two 1-in (2.5-cm) wide strips, the
 length of a full sheet + 1⅓ half-sheets, "glued" together with
 a bit of rice to make an extended sheet
1½ tablespoons pink *oboro* fish flakes
1 teaspoon *umeboshi* plum paste
4-in (10.5-cm) length pink pickled burdock root
1 bunch *mitsuba* (about 2 oz / 50 g) blanched, drained, and
 squeezed, cut to 4-in (10.5-cm) lengths
1 teaspoon toasted white sesame seeds

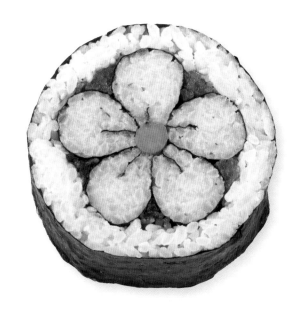

TIPS *Make the smaller rolls equal in size and thickness to produce uniform petals. • Form the flower shape inside of the sushi mat, pressing firmly around the mat to secure the shape. • Once the flower shape has been constructed, tie together with the nori strip. • Spread the sushi rice on the nori evenly for the design to show up clearly when the roll is sliced. • View the roll from the side to adjust the overall circular shape with the sushi mat.*

Nori Pieces

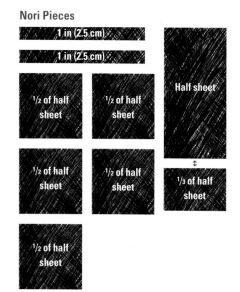

1 in (2.5 cm)

1 in (2.5 cm)

½ of half sheet

½ of half sheet

Half sheet

½ of half sheet

½ of half sheet

⅓ of half sheet

½ of half sheet

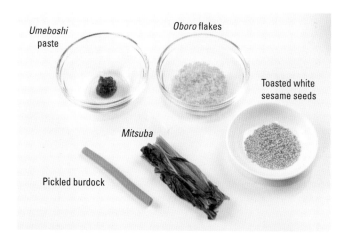

Umeboshi paste

Oboro flakes

Toasted white sesame seeds

Mitsuba

Pickled burdock

1 In a small bowl, combine ⅔ cup (130 g) of the sushi rice with the *oboro* and *umeboshi* paste. Gently mix until all ingredients are combined and the rice is a uniform pink. Divide into five equal bundles (about 5 teaspoons each), handling gently. Divide the *mitsuba* into 5 equal bunches. Cut a ⅝-inch (1.5-cm) strip from the shorter edge of each of the ½ half-sheets of nori.

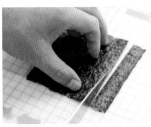

2 Lay one of these cut pieces of nori horizontally on the sushi mat and spread one portion of the *oboro* rice over it, leaving a space of about 3/16 inch (5 mm) at the top and bottom edges. Lay one of the ⅝-inch (1.5-cm) strips of nori across the upper edge.

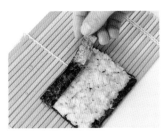

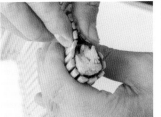

3 Lift up the front of the sushi mat and, being sure not to shift the contents, wrap the roll into a raindrop shape (see page 15). Repeat steps 2 and 3 with the other 4 quarter-sheets. Finally, trim about 3/16 inch (5 mm) from the closed tip of each raindrop roll.

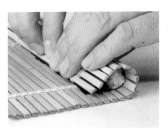

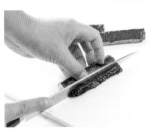

4 Hold the sushi mat in one hand. Placing one roll at a time, arrange three of the raindrop rolls to form a half-circle, with the tips facing in. Place the pickled burdock root in the hollow created at the center of the three rolls.

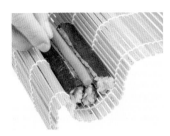

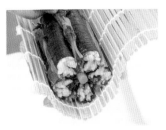

5 Add the last two raindrop rolls to complete the circle around the burdock root and wrap the sushi mat around the roll, pressing the rolls together firmly. Open the mat again and lay a strip of *mitsuba* between each "petal" of the flower, rotating the roll in the mat until all the *mitsuba* has been added. Roll the sushi mat closed again, compressing once more to make the roll perfectly round, and set aside.

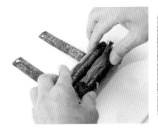

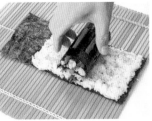

6 Lay the 1-inch (2.5-cm) nori strips parallel on a dry cutting board. The outside edges should be a little less than the width of the "flower" roll. Smash a couple grains of rice at the far end of each strip, then lay the "flower" on top of the nori strips and roll it so that it is held together by the strips, securing the ends together with the rice "glue."

7 Place the extended nori sheet on the sushi mat, aligning the short edges with the slats. Take ½ cup (100 g) of the remaining sushi rice and spread it evenly across the nori, leaving about 2⅜ inches (6 cm) empty at one edge. Sprinkle with the toasted sesame seeds. Place the "flower" in the center of the rice.

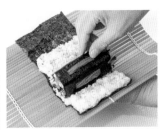

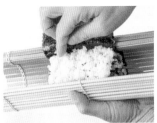

8 Pick up the sushi mat and hold it in one hand. Without closing the roll, curl your palm to wrap the rice around the flower. There should be about 2 tablespoons of sushi rice remaining; spread this over the top of the flower.

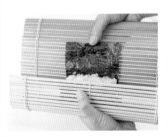

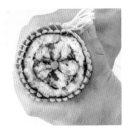

9 Wrap the mat around to complete the roll, sealing the nori to the outside of the roll. View from the side and adjust to make the roll perfectly round. Remove the sushi mat and use a very sharp knife dipped in vinegar water to cut the roll into 4 equal slices, wiping the knife clean after each cut.

Layered Rolls (Saiku-maki) Made with Cut Thin Rolls

Thin rolls that have been sliced lengthwise can be arranged to create elaborate designs and patterns. The Coin Rolls on this page and the Four Seas Rolls (page 28) may appear complicated, but once you've gone through the steps, they're a snap to make. If you take extra care while forming the building-block rolls, the beautiful designs will reveal themselves when the completed roll is sliced.

Coin Rolls

This roll is modeled after Edo-period coins called *kaneitsuhou*, which, like many coins of the era, were round with a square hole in the middle. First, one thin roll is wrapped within two other layers of rice and nori. This triple roll is then sliced in half and rearranged around a center filling of *kamaboko* fish cake before being wrapped in an extra-long piece of nori and sliced to reveal the elaborate pattern.

MAKES 4 LARGE PIECES

1¼ cups (250 g) prepared sushi rice
Nori: 1 half-sheet, cut to a 3⅛-in (8-cm) width along the long side
 + 1 half-sheet + 1 full sheet, cut to ¾ width along the long side
 + 1⅓ half-sheets, "glued" together with a bit of rice to make an extended sheet
2 generous tablespoons *tarako* salted pollock roe
4-in (10.5-cm) length *kamaboko* fish cake, cut into a bar shape
 ⅝ in (1.5 cm) on each side
1 teaspoon toasted white sesame seeds

TIPS *Spread the rice evenly over the nori, and shape the layered roll into a perfect circle. • When slicing the roll down the middle, take care to maintain the shape and don't squeeze or press hard. • Be sure to cut the* kamaboko *bar at exact right angles on all four sides. • Compress the sushi mat to secure the shape, then use the mat to finesse the final roll into a circle.*

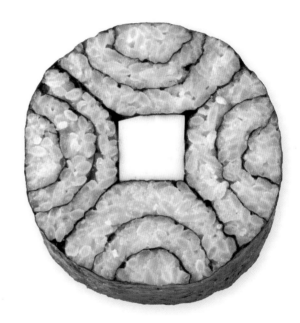

Nori Pieces

3⅛ in (8 cm)

Half sheet

¾ of full sheet

Half sheet

⅓ of half sheet

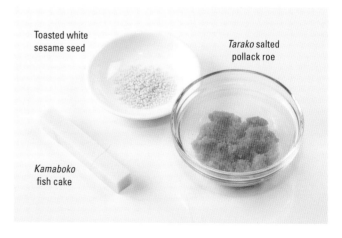

Toasted white sesame seed

Tarako salted pollack roe

Kamaboko fish cake

1 Place the *tarako* in a small bowl and break apart well. Add the sushi rice and stir, gently, until the roe is incorporated evenly throughout, tinting the rice. Divide the tinted rice into four parts: One ¼-cup (50-g) portion; one ⅓-cup (65-g) portion; one ½-cup (100-g) portion; and a 2-tablespoon portion.

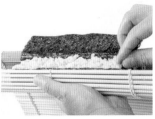

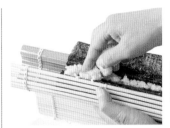

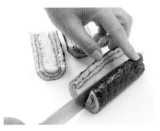

2 Place the 3⅛-inch (8-cm) nori sheet on the sushi mat so that the long edge is parallel to the slats. Roll the ¼-cup (50-g) portion of the rice into a cylinder the same length as the nori. Lay it in the middle of the nori and make a round roll, wrapping the mat around the roll and rotating it to make it perfectly even and circular. Set aside.

5 Hold the sushi mat in one hand and round out the bottom of the roll without closing it. Spread the last portion of rice over the top of the roll, then close the mat and finish the roll, sealing it shut with the nori at the end.

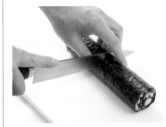

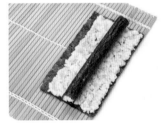 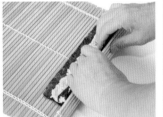

3 Place the half-sheet of nori on the sushi mat so that the long edge is parallel to the slats. Spread the ⅓-cup (60-g) portion of rice across the nori, leaving about ⅜ inch (1 cm) at the top edge. Place the first roll in the middle and use the sushi mat to wrap the second layer of rice and nori around it. Use the sushi mat to close the roll and make it into an even cylinder.

6 Dip a very sharp knife in vinegar water and cut the roll in half crosswise. Clean and re-wet the knife and cut each piece in half lengthwise to create 4 long pieces. Wipe the blade clean after each cut.

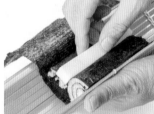 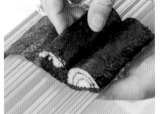

7 Place the extended nori sheet on the sushi mat with the short end parallel with the slats. With the sushi mat in one hand, place one of the pieces from step 6 cut-side-down along the front edge of the nori. Place another piece behind the first one. Balance the *kamaboko* between the two pieces, with the corner in the angle between them.

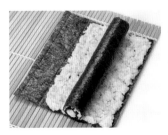

4 Place the ¾ sheet of nori on the sushi mat so that the long edge is parallel to the slats. Spread the ½-cup (100-g) portion of rice across the nori, leaving 2 inches (5 cm) of space at the top edge. Place the double roll in the middle.

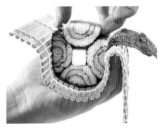 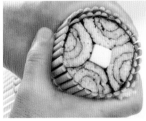

8 Keep holding the sushi mat in your hand and place the remaining two cut rolls on top of the *kamaboko*.

9 Wrap the nori around all the pieces, sealing the roll by compressing the sushi mat. Hold the mat in both hands and round out the shape. Remove the sushi mat and use a very sharp knife dipped in vinegar water to cut the roll into 4 equal slices, wiping the blade clean each time.

Seven-Part Star Rolls

Round rolls with different-colored fillings are sliced in half to create this layered design; the Japanese Omelette at the center adds a flourish. Change it up with different colors; you can also make 4 round rolls for a Nine-Part Star Roll.

MAKES 4 LARGE PIECES

¾ cup (150 g) prepared sushi rice, divided
Nori: three ½ half-sheets + 1 half-sheet
1 heaping teaspoon minced *nozawana* pickled mustard greens
1 heaping teaspoon pink *oboro* fish flakes
1 heaping teaspoon *tobiko* flying-fish roe
4-in (10.5-cm) length Japanese Omelette (see page 10)

TIPS *Cut the Japanese Omelette with a steady hand for a clean circular shape. • Make all the round rolls the same size, and do not flatten or distort their shape when cutting them lengthwise to create half-circle pieces. • Arrange the half-circles so pieces of the same color are not next to each other.*

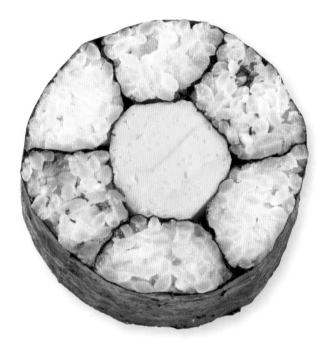

Nori Pieces

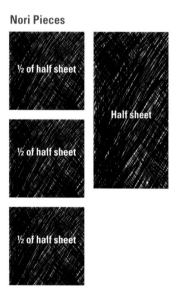

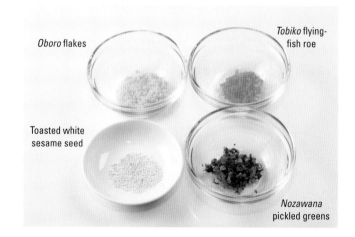

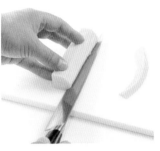

1 In a small bowl, combine ¼ cup (50 g) of the sushi rice with the pickled greens and the sesame seeds. Gently mix until evenly combined. In a second bowl, combine another ¼ cup (50 g) of the rice with the *oboro*, mix, and set aside. In a third bowl, do the same with the remaining ¼ cup (50 g) of rice and the *tobiko*. Carefully trim the Japanese Omelette into a cylindrical shape 1 inch (2.5 cm) in diameter.

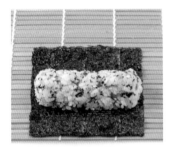
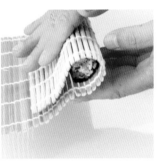

2 Place one of the ½ half-sheets of nori lengthwise on the sushi mat. Form the pickled greens rice into a cylinder as long as the nori, place in the middle of the mat and make a round roll. Rotate the roll back and forth inside of the sushi mat several times so that the roll is perfectly cylindrical.

3 Repeat step 2 for the pink *oboro* rice and the orange *tobiko* rice.

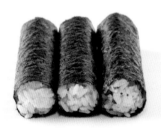

4 Dip a very sharp knife in vinegar water or wipe with a wet cloth. Cut the rolls from steps 2 and 3 lengthwise, wiping the knife clean after each cut.

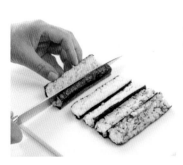

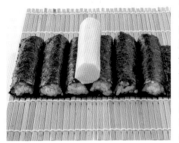

5 Place the half-sheet of nori on the sushi mat so that the short edge aligns with the slats. Starting at the front edge of the nori, arrange the half-rolls from step 4 in this order: *tobiko*, pickled greens, *oboro*, *tobiko*, pickled greens, *oboro*. Then center the omelette cylinder atop the rolls in the middle.

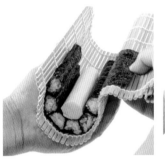
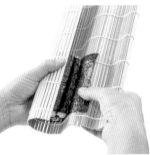

6 Holding the sushi mat in one hand, wrap it around to enclose the contents, making sure to keep the omelette in the center. Seal the nori and tighten.

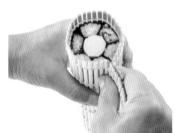

7 Shape the roll into a circle. Remove the sushi mat and use a very sharp knife dipped in vinegar water to cut the roll into 4 equal slices, wiping the knife clean each time.

Four Seas Rolls

Inspired by the verse "The quiet waves of the four seas" from the Noh chant "Takasago," this design incorporates motifs symbolizing peace, and is often used for celebratory occasions like weddings. Although complicated in appearance, it's quite easy to make. Even a single slice has panache; line up multiple slices for maximum impact.

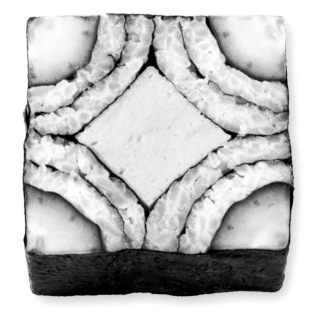

MAKES 4 LARGE SQUARE PIECES

¾ cup (150 g) prepared sushi rice, divided
Nori: ¾ half-sheet + 1 half-sheet + 1⅓ half-sheets, "glued" together with a bit of rice to make an extended sheet
2 tablespoons pink *oboro* fish flakes
4-in (10.5-cm) length Japanese or English cucumber, about 1¼ in (3 cm) in diameter
4-in (10.5-cm) length Japanese Omelette (see page 10), cut into a bar 1 in (2.5 cm) on each side

TIPS *The cucumber tends to slide off easily, so be sure to press it into the sushi rice before making the first roll. • Make sure the layers of sushi rice layers are of equal thickness to create well-defined wave patterns. • Hold the roll firmly to stabilize when cutting, and cut it into quarters as evenly as possible; this will help with balancing the sushi roll elements when creating the design. • As you wrap the completed roll, take care that the contents don't shift. • The size of the roll will vary depending on the diameter of the cucumber, so adjust the size of the nori accordingly.*

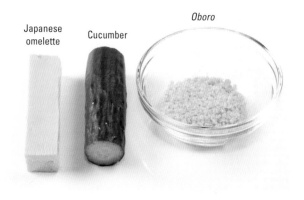

Japanese omelette Cucumber Oboro

Nori Pieces

¾ of half sheet

Half sheet Half sheet

⅓ of half sheet

1 In a small bowl, combine 7 tablespoons of the sushi rice with the *oboro*. Gently mix until the rice is evenly tinted. Set aside.

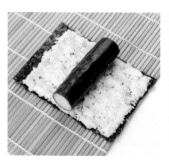
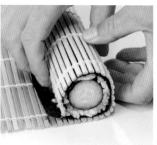

2 Place the ¾ half-sheet of nori vertically on the sushi mat so that the short edge is parallel with the slats. Spread the remaining 5 tablespoons of plain sushi rice across the nori, leaving ⅜ inch (1 cm) of space at the top edge. Lay the cucumber across the center of the rice, then use the sushi mat to wrap the rice around the cucumber, sealing the nori.

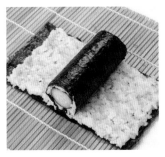 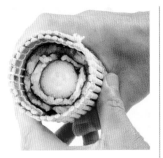

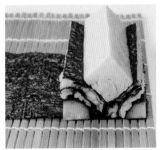 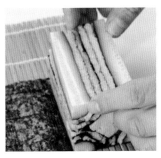

3 Place the half-sheet of nori vertically on the sushi mat so that the short edge is parallel with the slats. Spread the remaining 5 tablespoons of plain sushi rice across the nori, leaving ⅜ inch (1 cm) of space at the top edge. Lay the cucumber across the center of the rice, then use the sushi mat to wrap the rice around the cucumber, sealing the nori.

5 Place the extended nori sheet on the sushi mat with the short edge parallel to the slats. Place two of the quarter-rolls on the nori as shown in the photo. Place the Japanese Omelette in the v-shaped space between the rolls. Balance the other two quarter-rolls on top of the omelette.

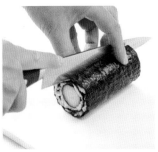 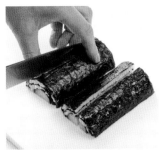

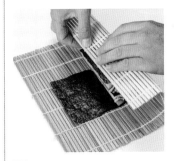 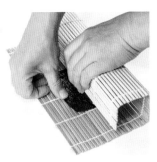

4 Dip a very sharp knife in vinegar water. Carefully slice the roll in half lengthwise and wipe the knife clean. Place the halved rolls face down, and cut each in half lengthwise again to make even quarters.

6 Begin to roll the mat, taking care to avoid shifting the contents. Form into a square shape, pulling the sushi mat toward you after the first rotation to secure the elements. Continue to roll, pressing against the mat so that the nori adheres to the filling. Adjust the shape as needed to make it into a square.

7 Remove the sushi mat and use a very sharp knife dipped in vinegar water to cut the roll into 4 equal slices, wiping the knife clean each time.

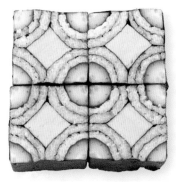

Arrange slices side-by-side for a dazzling display.

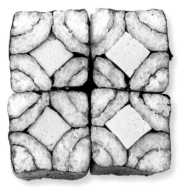

Try changing the color of the sushi rice or the size of the roll for a different design. You can also leave out the cucumber for a smaller, easier roll. Cut the omelette to ⅜ inch (1 cm) on each side, and reduce the amount of rice to 3½ tablespoons of plain sushi rice and 4 tablespoons of *oboro* rice.

Water Chrysanthemum Rolls

Evoking a chrysanthemum floating in a flowing stream of water, this is a traditional design that commemorates longevity. The flower petals are crafted from Japanese Omelette wrapped in nori to make them stand out; the nori and rice combine to create the effect of undulating waves and water. The petals could also be made with the method used for Raindrop Rolls (page 15).

MAKES 4 WATER CHRYSANTHEMUM PIECES

¾ cup (150 g) prepared sushi rice, divided
Nori: 3 half-sheets, cut crosswise to make 6 quarter-sheets
 + ⅔ half-sheet + 1⅓ half-sheets, "glued" together with a bit of
 rice to make an extended sheet
1 tablespoon pink *oboro* fish flakes
1 teaspoon *aonori* flakes
½ teaspoon toasted sesame seeds
Japanese Omelette (see page 10), cut into three ⅝ x 1 x 4-in (1.5 x
 2.5 x 10.5-cm) bars
4-in (10.5-cm) length pickled burdock root

TIPS *Cut the chrysanthemum petals into identical shapes. • Press nori-wrapped petals together firmly to hold the shape. • Roll the contents so that the flower shape and the layers of sushi rice seamlessly form into one design.*

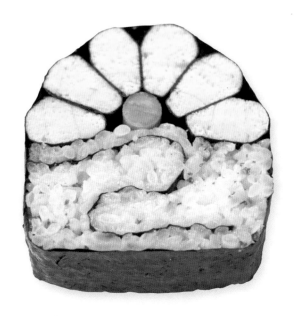

Nori Pieces

½ of half sheet
½ of half sheet
⅔ of half sheet
Half sheet
½ of half sheet
½ of half sheet
⅓ of half sheet
½ of half sheet
½ of half sheet

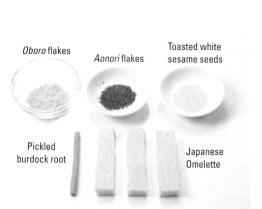

Oboro flakes
Aonori flakes
Toasted white sesame seeds
Pickled burdock root
Japanese Omelette

1 In a small bowl, combine ½ cup (100 g) of the sushi rice with the *oboro* flakes. Gently mix until the *oboro* is evenly incorporated. In a second bowl, combine the remaining 4 tablespoons of sushi rice with the *aonori* flakes and sesame seeds. Gently mix until all ingredients are distributed evenly.

2 Cut the omelette pieces lengthwise on the diagonal to form 6 triangular wedges of equal size. Trim the corners from the wide part of the wedge to round them into petal shapes.

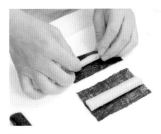 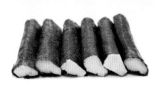

3 Wrap a quarter-sheet of nori around each of the "petals."

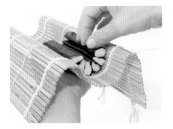 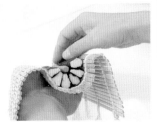

4 Holding the sushi mat in one hand in a curved shape, arrange the nori-wrapped petals with the narrow ends facing inward to form a semicircle about 2 inches (5 cm) in diameter. Place the pickled burdock root at the center. Compress the sushi mat without distorting the shape of the semicircle so that the "petals" stick together. Lay the semicircle flat-side down on a clean, dry surface.

5 Lay the ⅔ half-sheet of nori on a clean, dry cutting board. Spread half of the *oboro* rice evenly across the entire surface of the nori. Turn the nori over and spread the other half of the rice across the other side.

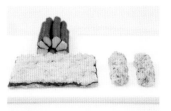

6 Roll half of the *aonori* rice into an 4-inch (10.5-cm) cylinder. Repeat with the remaining *aonori* rice.

7 Lift the short edge of the rice-covered nori and fold it into an "s" shape (the width of the "s" should be the same as the width of the "petals"). Shift the upper end (top of "s") to the right so that the shape is offset.

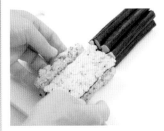

8 Insert an *aonori* cylinder from step 6 into the space at the lower right of the "s" formed in step 7. Insert the other *aonori* cylinder into the space at the upper left. This represents the "water" part of the roll.

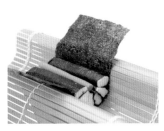

9 Lay the extended nori sheet over the flower "petals" from step 3 (make sure to align the center of the flower with the center of the nori piece). Flip the flower shape over and place it on the sushi mat. Gently press the mat to adhere the outer nori to the flower shape.

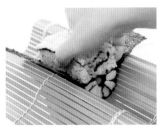 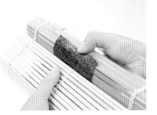

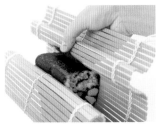

10 Turn the water shape from step 8 upside down and place it on top of the inverted flower shape. Close the nori over it and press the sushi mat to secure. Use the mat to shape the roll into a tall semicircle. Remove the sushi mat and use a very sharp knife dipped in vinegar water to cut the roll into 4 equal slices, wiping the knife clean each time.

CHAPTER 2
Amazing Decorative Sushi Rolls

No design is impossible when it comes to Kazari Sushi—you can make flowers, trees, animals, faces, characters, landscapes, words, symbols and more. This section introduces you to the methods and ingredients that will allow you to execute intricate designs easily. Once you're comfortable with the techniques, have fun creating your own designs!

Basic Kazari Sushi Rolls
- Smiley Face Rolls

Symmetrical Designs
- Clown Rolls
- Samurai Rolls

Rolls that Use Mountain Shapes
- Tulip Rolls
- Morning Glory Rolls

Using Ingredients in Cross-Section
- Bell Rolls
- Penguin Rolls
- Reindeer Rolls

Inside-Out Rolls
- Train Car Rolls
- Santa Claus Rolls

Rolls Featuring a "Branch" Made out of Kanpyo Simmered Gourd
- Sunflower Rolls
- Flowering Cherry Tree Rolls

- Persimmon Rolls
- Pine Tree Rolls

Adding "Ears" to Animal-Shaped Rolls
- Panda Rolls
- Bunny Rabbit Rolls

Rolls with Japanese Kanji Characters
- Rolls with Kanji for "Sun"
- Rolls with Kanji for "Origin"

Rolls with Kanji Characters Made out of Kanpyo Simmered Gourd
- Rolls with Kanji for "Celebration"
- Rolls with Kanji for "Long Life"
- Rolls with Kanji for "Good Fortune"

Novelty Rolls
- Sparrow Rolls
- Guitar Rolls

Landscape Rolls
- Mount Fuji Rolls
- Seashore Rolls

Let's start with a very simple face design. This roll requires only one full sheet of nori, and its compact size makes it easy to assemble. A thin roll sliced in half makes curved lines for the eyes, and other ingredients will add to the facial expression. The Smiley Face Roll incorporates all the basic techniques for making Kazari Rolls, including balancing design elements like the eyes and mouth, slicing a thin roll lengthwise, and blending ingredients. Once you've mastered the Smiley Face, challenge yourself to create a larger Kazari Roll.

Smiley Face Rolls

The following will show you how to cut a thin roll to form the curved lines of the eyes; shape Japanese Omelette into a half-circle; symmetrically place the eyes; and spread the sushi rice evenly. A version of this face is used for the Clown Rolls on page 35.

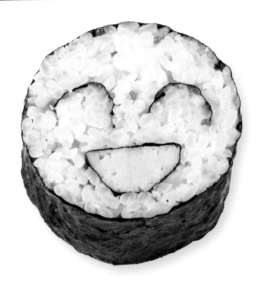

MAKES 4 SMILEY FACE PIECES

Scant ¾ cup (140 g) prepared sushi rice
Nori: 1 half-sheet, cut crosswise into thirds (only 2 of these ⅓ half-sheets will be used) + 1 half-sheet
1 tablespoon *tobiko* flying-fish roe
½ teaspoon toasted white sesame seeds
Japanese Omelette (see page 10), cut into a 1 x ⅜ x 4-in (2.5 x 1 x 10.5-cm) bar shape

TIPS *Distribute the coloring ingredients into the sushi rice evenly, but be sure not to over-mix the rice or break up the grains. • Divide the sushi rice into specified portions before assembly, and shape them into cylinders or strips that are the same length as the nori (approximately 4 inches / 10.5 cm) before placing them on the nori. • Nori has a tendency to shrink, so work quickly once you spread the sushi rice over it.*

Smiley Face Wrapped in an Egg Crêpe

You can substitute a thin layer of Japanese Crêpe instead of nori for the outer wrapping. Cut the crêpe to the same size as a half-sheet of nori (approximately 4 x 8 inches / 10.5 x 20 cm), and cover the sushi mat with plastic wrap before laying the crêpe down. Take care not to tear the crêpe when spreading the sushi rice.

Japanese Crêpe

2 eggs
2 teaspoons castor sugar
1 teaspoon *dashi* or water
Pinch salt
½ teaspoon cornstarch mixed with ½ teaspoon water

Mix all ingredients thoroughly until the sugar is dissolved. Pass through a fine sieve. Place a lightly oiled pan over medium-high heat. When hot, add about ¼ cup of batter, or enough to cover the bottom of the pan when swirled. Cook on one side only.

Nori Pieces

⅓ of half sheet

⅓ of half sheet

Half sheet

Toasted white sesame seeds

Tobiko

Japanese Omelette

1 In a bowl, combine the sushi rice with the *tobiko* and white sesame seeds. Gently mix until the roe is evenly distributed throughout the rice. Divide the *tobiko* rice into five portions: 2 tablespoons, ⅓ cup (65 g), 2 teaspoons, 5 teaspoons, and 2⅔ tablespoons.

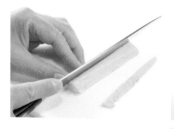

2 Lay the omelette flat on a cutting board. Carefully slice away the upper corners of the bar in an arc to make the omelette into a long semicircle. Wrap the omelette in one of the ⅓ half-sheets.

3 Shape 2 tablespoon of the *tobiko* rice into a 4-inch (10.5-cm) cylinder and place on the other ⅓ half-sheet of nori. Make a thin round roll.

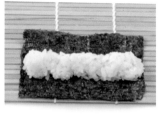

4 Dip a very sharp knife in vinegar water and cut the *tobiko* rice roll in half lengthwise.

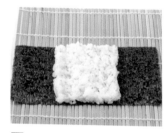

5 Assemble all the elements. Lay the half-sheet of nori on the sushi mat with the short edges parallel with the slats. Spread the ⅓-cup (60-g) portion of rice over the center of the nori, leaving a 2-inch (5-cm) space on either side.

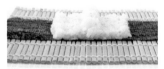

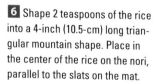

6 Shape 2 teaspoons of the rice into a 4-inch (10.5-cm) long triangular mountain shape. Place in the center of the rice on the nori, parallel to the slats on the mat.

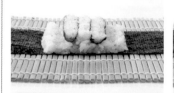

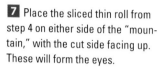

7 Place the sliced thin roll from step 4 on either side of the "mountain," with the cut side facing up. These will form the eyes.

8 Spread 5 teaspoons of the rice to cover the tops of the eyes and the "mountain."

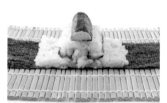

9 Center the nori-wrapped omelette (the mouth) from step 2 on top of the rice from step 8, with the rounded side facing up.

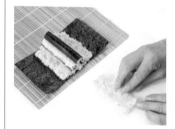

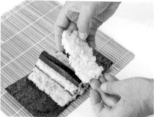

10 Shape a rectangular strip from the remaining 2⅔ tablespoons of rice to cover the mouth and eyes. Place on top of the construction from step 9.

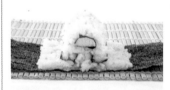

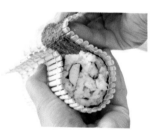

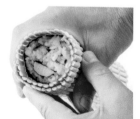

11 Lift up the sushi mat, pressing the roll into a circular shape, and seal the nori. Continue to adjust the shape to make a perfect circle. Remove the sushi mat and use a very sharp knife dipped in vinegar water to cut the roll into 4 equal slices, wiping the knife clean each time.

Symmetrical Designs

To create symmetrical designs, it's important to keep the left and right sides uniform when spreading or placing the sushi rice. Also, clearly mark the center so you know where to place the various elements for the best results. Accurately measure the sushi rice portions, and use consistent pressure when spreading the rice. Examples of symmetrical designs are Tulip Rolls (page 40), Penguin Rolls (page 46), and rolls with 日, the kanji character for "Sun" (page 66).

Clown Rolls

Form a symmetrical round roll for the face first, then add the hat. The overall roll will be a raindrop shape. Reverse the color of the face and surrounding sushi rice in a second roll to make a set of red and blue clowns.

MAKES 4 CLOWN PIECES

1¼ cups (250 g) prepared sushi rice, divided
Nori: ¼ x 4-in (6 mm x 10.5-cm) strip + ⅜ x 4-in (1 x 10.5-cm) strip + ½ half-sheet + ¼ half-sheet + two ⅓ half-sheets + 1½ half-sheets, "glued" together with a bit of rice to make an extended sheet
2 tablespoons pink *oboro* fish flakes
1 teaspoon *aonori* flakes
½ teaspoon toasted white sesame seeds
1 tablespoon minced *nozawana* pickled mustard greens
Mayonnaise to taste
Japanese Omelette (see page 10), cut into a ¾ x 1¼ x 4-in (2 x 3 x 10.5-cm) bar
4-in (10.5-cm) length pickled burdock root
4-in (10.5-cm) length fish sausage, cut in half lengthwise

TIPS *Squeeze out all liquid from minced pickled greens before mixing into sushi rice. • As in the Smiley Face Rolls, the eyes are created by slicing a thin roll in half. • Make the roll perfectly round, and be careful not to distort the shape when cutting. • Make sure to form the face into a balanced round shape before adding the hat.*

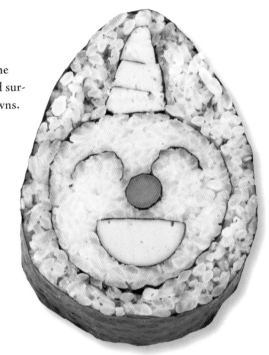

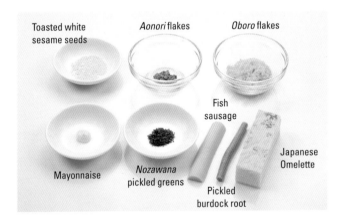

Toasted white sesame seeds — *Aonori* flakes — *Oboro* flakes

Fish sausage

Mayonnaise — *Nozawana* pickled greens — Pickled burdock root — Japanese Omelette

Nori Pieces

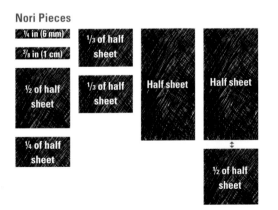

¼ in (6 mm)
⅜ in (1 cm)
⅓ of half sheet
½ of half sheet
⅓ of half sheet
Half sheet
Half sheet
¼ of half sheet
½ of half sheet

1 In a bowl, combine ⅔ cup (130 g) of the sushi rice with the *oboro* flakes. Gently mix to distribute the *oboro* evenly throughout to make pink rice. Separate into the following portions: 5 teaspoons; 3½ tablespoons; 2 teaspoons; 2⅔ tablespoons; 5 teaspoons; and 2 teaspoons x 2.

2 In a separate bowl, combine the remaining ¾ cup (150 g) of rice with mayonnaise and stir. Sprinkle in the pickled greens, sesame seeds, and *aonori*. Gently mix to blend all ingredients evenly, being careful not to break up the rice grains. Separate the green rice into portions of 7 tablespoons and 2⅔ tablespoons x 2.

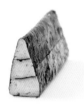
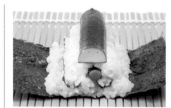
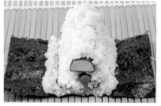

3 Make the hat. Set the Japanese Omelette bar on its short side and cut two lengthwise wedges from the top center to make a long isosceles triangle. Then lay the triangle on its side and make two lengthwise cuts to divide it into three parts. Sandwich the two strips of nori between these pieces, then wrap the entire hat in the ½ half-sheet of nori.

9 Place the "mouth" from step 4 on top, with the curved side facing up. Cover it with the 5 teaspoons of pink *oboro* rice.

4 Make the mouth and nose. Wrap the pickled burdock root in the ¼ half-sheet of nori to make the nose. Wrap the fish sausage in one of the ⅓ half-sheets of nori for the mouth.

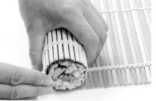

10 Form the two 2-teaspoon portions of *oboro* rice into rows the length of the roll. Lift up the sushi mat and use these to fill in the sections that will be the "cheeks." Wrap the elements, sealing the nori, and round out the shape. Place the sushi mat on a flat surface and continue to roll into a perfectly circular shape.

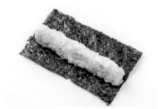
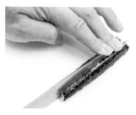

5 Make the eyes. Spread the 5 teaspoons of pink rice on the second ⅓ half-sheet of nori and form into a round roll. Cut in half lengthwise.

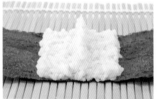

6 Assemble the face. Lay the half-sheet of nori on the sushi mat, with the short edge parallel to the slats. Spread the 3½ tablespoons of pink *oboro* rice across the center of the half-sheet, leaving 2⅜ inches (6 cm) of space on the left and right sides of the nori. Form 2 teaspoons of pink rice into a mountain shape and place it in the middle of the spread rice.

11 Assemble the entire roll. Lay the extended nori sheet on the sushi mat with the short edge parallel to the slats. Leaving 2 inches (5 cm) on either end of the nori sheet, spread the 7 tablespoons of green *aonori* rice across the nori.

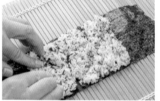

12 Place the round roll made in step 10 in the center of the rice so that the "face" is oriented upright. Place the nori-wrapped omelette "hat" from step 3 on top.

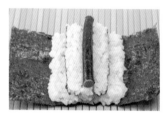
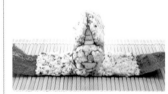

7 Place a half round roll from step 5 on either side of the rice "mountain," with cut side facing up, to form the eyes. Then place the "nose" of nori-wrapped pickled burdock from step 4 between the two half-rolls.

8 Form the 2⅔ tablespoons of pink rice into a rectangular strip. Place this on top of the eyes and nose.

13 Form the two 2⅔-tablespoon portions of green *aonori* rice into two rectangular strips. Place one on each side of the "hat" and press to mold the hat, rice, and face together.

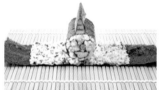
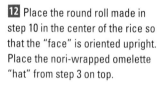

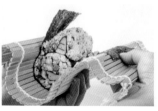
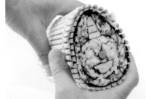

14 Lift the sushi mat and gradually roll and close up the nori, sealing the edges together. Use both hands to form the roll into a teardrop shape. Remove the sushi mat and use a very sharp knife dipped in vinegar water to cut the roll into 4 equal slices, wiping the knife clean after each cut.

Samurai Rolls

This gallant-looking warrior has eyebrows and a mouth made out of Kanpyo Simmered Gourd. The face is rolled into a circle first, then black sesame-seed rice frames his face as hair. The ensemble is completed with a helmet that is forged with a pressed sushi method using vinegar-marinated mackerel (*shimesaba*) and other ingredients.

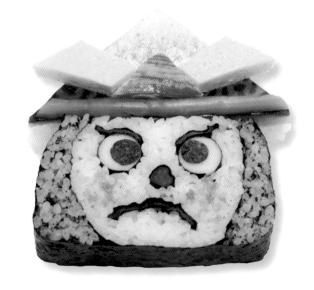

FOR 4 SAMURAI HEADS

2 cups (400 g) prepared sushi rice, divided
Nori: four ⅓ half-sheets + ½ half-sheet + ¼ half-sheet + 1⅓ half-sheets, "glued" together with a bit of rice to make an extended sheet + 1⅔ half-sheets, "glued" together with a bit of rice to make an extended sheet
1½ tablespoons finely minced pickled ginger, drained well
1½ tablespoons ground black sesame seeds
½ teaspoon *yukari* ground shiso powder
Two 1½ x 4-in (4 x 10.5-cm) strips Kanpyo Simmered Gourd (see page 10) (about 1 oz / 20 g)
Two 4-in (10.5-cm) cylinders cheese *kamaboko*
4-in (10.5-cm) stalk *nozawana* pickled mustard greens
1 teaspoon *tarako* pollock roe

Completed head

Completed helmet

TIPS *Line up the* kanpyo *pieces for the eyebrows and mouth before wrapping them in nori. • To give the eyebrows an arch, increase the height of the sushi rice toward the outer edge of the eye. • Create a slight depression at the top of face before adding the hair for the entire head. A mountain shape in the hair will be formed to fit into this space. • Cut a small section of the top of the head before placing the helmet on the head.*

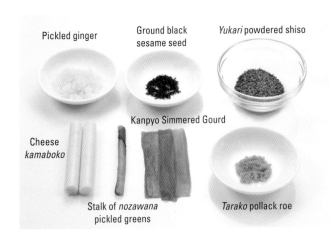

Pickled ginger

Ground black sesame seed

Yukari powdered shiso

Cheese *kamaboko*

Kanpyo Simmered Gourd

Stalk of *nozawana* pickled greens

Tarako pollack roe

Nori Pieces

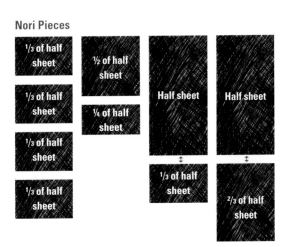

⅓ of half sheet

½ of half sheet

⅓ of half sheet

¼ of half sheet

⅓ of half sheet

Half sheet

Half sheet

⅓ of half sheet

⅓ of half sheet

⅔ of half sheet

1 Combine 1 heaping cup (220 g) of the sushi rice with the minced pickled ginger. Gently mix to incorporate the ginger throughout. Divide into portions of 3½ tablespoons; 2 tablespoons x 2; 5 teaspoons x 4; 1 tablespoon; and 3½ tablespoons.

2 Combine the remaining 1 scant cup (180 g) of the sushi rice with the black sesame seeds and ground shiso. Divide into portions of ½ cup (100 g) and 3½ tablespoons x 2.

3 Slice one of the *kanpyo* strips in half lengthwise for the eyebrows and wrap each one in a ⅓ half-sheet of nori. Wrap the remaining wide strip of *kanpyo* in the ½ half-sheet of nori to make the mouth.

4 Wrap each of the cheese *kamaboko* sticks in a ⅓ half-sheet of nori to make the eyes. Wrap the 4-inch stalk of *nozawana* pickled greens in the ¼ half-sheet of nori for the nose.

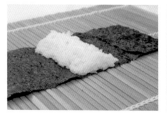 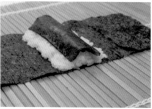

5 Lay the shorter extended nori sheet on the sushi mat with the short end parallel to the slats. In the center of this sheet, spread a 3½ table-spoon portion of ginger rice in a mound shape about 2 inches wide. Drape the *kanpyo* "mouth" on top of the mound.

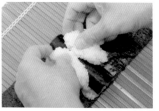 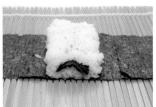
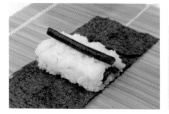 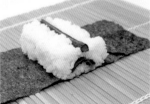

6 Place the two 2-tablespoon portions of ginger rice on either side of the "mouth" and smooth it out to make an even surface. Lay the "nose" in the center of this and add a 5-teaspoon portion of ginger rice on either side. Again, smooth and flatten out the rice to create a level surface.

38

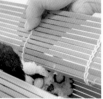 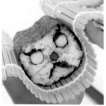

7 Make another mountain shape from the 1-tablespoon portion of gin-ger rice and place it on top of the nose. Set the nori-wrapped *kamaboko* "eyes" on either side and arrange a 5-teaspoon portion of rice on either side, shaping the rice so it is a little higher at the outer edges. Balance the nori-wrapped *kanpyo* "eyebrows" on top of the eyes at an angle.

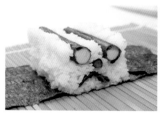 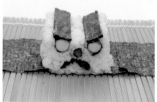

8 Add the second 3½-tablespoon portion of ginger rice on top of the eyebrows and level out the surface. Lift up the sushi mat and roll to seal the nori. As nori edges are sealed, press down and depress the top of the head a little. Round out the roll, but make sure the depressed area remains.

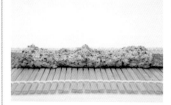

9 Lay the longer extended nori sheet on the sushi mat with the short end parallel to the slats. Spread ½ cup (100 g) of the black-sesame rice in the center of the nori, leaving about 2¾ inches (7 cm) on either side. Heap up the rice along the edges and down the center of the covered area.

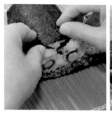

10 Invert the "face" roll from step 8 and lay it on the black sesame rice. The heaped rice down the center should match the depression at the top of the head, and should frame the face at the sides. Lift up the sushi mat and add 3½ tablespoons of sesame rice on each side of the face, pressing the rice in gently. Seal the nori.

11 Use a very sharp knife dipped in vinegar water to cut the roll into 4 equal slices, wiping the knife clean after each cut. Make small pieces of nori into circles for the center of the eyes, and sprinkle the *tarako* over the cheeks. Make a helmet for each head (see opposite). Cut the very top of the head off and set the helmet in place.

FOR 4 HELMETS

¾ cup (150 g) prepared sushi rice, divided
2 x 4-in (5 x 10.5-cm) fillet Marinated Mackerel (see sidebar)
Four 2-in (5-cm) stems *nozawana* pickled mustard greens
Japanese Omelette (see page 10), cut into four ³⁄₁₆ x 1¼ x 4-in (.5 x 3 x 10.5-cm) bars
2-in (5-cm) length *kanikama* artificial crab

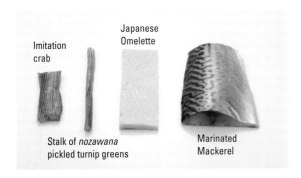

Imitation crab

Japanese Omelette

Stalk of *nozawana* pickled turnip greens

Marinated Mackerel

1 Slice the mackerel to a thickness of ³⁄₁₆ inch (5 mm). Cut in half to make two squares, then cut each square diagonally to make 4 triangles, each one 2 inches (5 cm) long at the base.

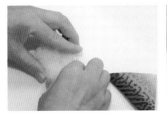
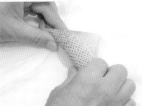

2 Shape 3 tablespoons of the rice into a triangle the same size as the mackerel triangle, then place the mackerel on the rice. Repeat with each piece of mackerel.

3 Decorate the helmet with the Japanese Omelette, imitation crab and pickled mustard green stem as shown in the photos on page 37.

Marinated Mackerel

Marinated mackerel (*shimesaba*) is fresh mackerel that has been cured in rice vinegar, rice wine and sugar overnight. It is a common ingredient for sushi in Japan and you can find it in large Asian markets, but you can make your own easily by following this recipe.

2 boned fillets fresh mackerel (approximately 8 oz / 225 g) at least 4 in (10.5 cm) long
Sea salt to coat
1¼ cups (300 ml) rice vinegar
½ cup (120 ml) mirin
5 teaspoons sugar

1 Generously salt the mackerel fillets and place in a single layer on a shallow pan or container. Refrigerate for 1 to 2 hours (any longer will make the flesh tough), with the pan tilted slightly toward one end so the fish is not sitting in any liquid that may be expressed.

2 Rinse the salt off and pat the fish dry thoroughly. Combine the vinegar, mirin, and sugar in a liquid measuring cup, stir until sugar is dissolved, and pour into a heavy-duty zip-top freezer bag. Add the mackerel filets and close the bag securely, eliminating as much air as possible. Refrigerate overnight, up to 15 hours. Before use, pull off the transparent outer skin of the fish by hand, being careful not to tear the flesh.

Forming sushi rice into a mountain shape helps stabilize and balance the various elements that comprise Kazari Sushi. These mounds of rice are frequently used to fill in spaces for complex and advanced designs. Shape the specified portion of sushi rice to match the nori size that will be used, then vary the height and contours of the mountain shape as you see fit. Morning Glory Rolls (page 42), Samurai Rolls (page 37), Panda Rolls (page 62) and many other decorative rolls utilize the mountain shape.

Tulip Rolls

The flower is made out of cheese *kamaboko* fish cake, the leaf out of cucumber, and the planter out of Japanese Omelette. Sushi rice segments will fill the space between the flower elements. Sushi rice blended with *ikura* salmon roe surrounds the planter, adding a splash of color and flavor.

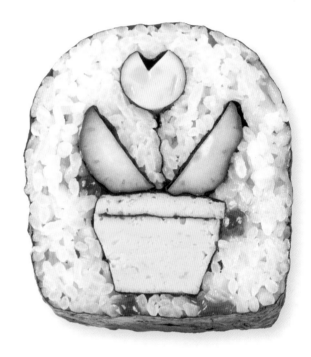

MAKES 4 TULIP PIECES

1 cup plus 3 tablespoons (240 g) prepared sushi rice, divided
Nori: 1¼ x 4-in (3 x 10.5-cm) strip + ⅔ half-sheet + three ½ half-sheets + 1½ half-sheets, "glued" together with a bit of rice to make an extended sheet
1 tablespoon salmon roe (*ikura*)
Japanese Omelette (see page 10), cut to a bar shape 1¼ x 1¼ x 4 in (3 x 3 x 10.5 cm)
4-in (10.5-cm) length Japanese or English cucumber
4-in (10.5-cm) cylinder cheese *kamaboko*

TIPS *Take extra care as you shape the "mountains" that fit between the flower and the leaves, and keep the nori between them, which forms the stem, as straight as possible. • Prepare all ingredients in advance, shaping the specified portions of sushi rice into the required shapes and sizes ahead of time. • Have the flower, leaf, and planter elements close at hand, since you will be holding the roll in one hand as you assemble them.*

Nori Pieces

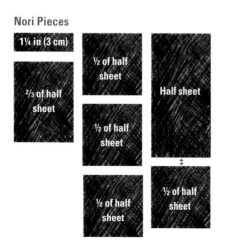

1¼ in (3 cm)

⅔ of half sheet

½ of half sheet

½ of half sheet

½ of half sheet

Half sheet

½ of half sheet

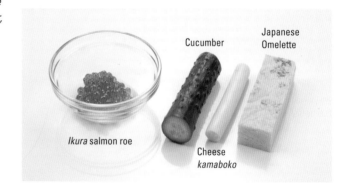

Ikura salmon roe

Cucumber

Japanese Omelette

Cheese *kamaboko*

1 Combine 7 tablespoons of the sushi rice with the salmon roe. Mix gently to distribute evenly. Divide into portions of 2 teaspoons x 2; 2 tablespoons x 2; and 5 teaspoons. Divide the remaining sushi rice into one ½-cup (100-g) portion and two 2-tablespoon portions.

2 Make the flower. Cut out a small V shape along the length of the cheese *kamaboko*, referencing a tulip shape as you do so.

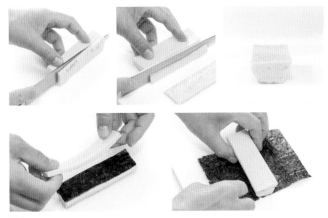

3 Make the flowerpot. Cut a ³⁄₁₆-inch (5-mm) slice from the edge of the omelette and set aside. Cut each side of the remaining larger omelette equally at a slight diagonal so that the base is smaller than the top. Then sandwich the 1¼-inch (3-cm) strip of nori between the two pieces. Wrap the whole flowerpot in the ⅔ half-sheet of nori.

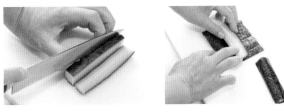

4 Make the leaves. Cut the cucumber lengthwise into three equal pieces. Wrap each of the side pieces in a ½ half-sheet of nori, setting the center piece of cucumber aside for another use.

5 Lay the extended nori sheet on the sushi mat with the short edge parallel to the slats. Spread ½ cup (100 g) of the sushi rice on the extended sheet, leaving a space of 1⅝ inches (4 cm) on either side. Shape the 2-tablespoon portions of sushi rice into 1¼-inch (3-cm) high "mountains" at the center of the nori, with ⅜ inch (1 cm) between them.

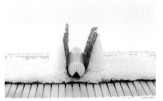
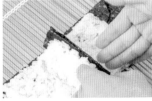

6 Have all ingredients close at hand as you assemble the roll. First, fold the remaining ½ half-sheet of nori in half and place between the "mountains" with the fold down. Place the *kamaboko* "flower" upside-down in the middle. Wrap the nori around the flower. Then, keeping the nori together and as straight up as possible, press in the sushi rice on either side to enclose the "stem" and make a slope.

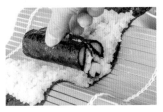
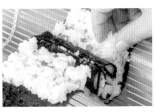

7 Holding the sushi mat in one hand, place a nori-wrapped cucumber "leaf" on either side of the "stem," with the flat side against the rice slope.

8 Tightening the sushi mat from both the left and right sides, add 2 teaspoons of the salmon-roe rice on either side of the leaves and level the surface.

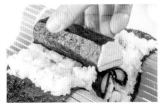
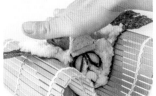

9 Place the nori-wrapped omelette "flowerpot" upside-down on top. Press down with your palm to secure it.

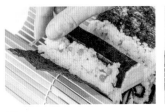
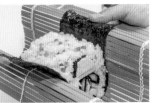

10 Fill each side of the planter with 2 tablespoons of salmon-roe rice. Tighten the sushi mat again and then add the remaining 5 teaspoons of salmon-roe rice on top, smoothing it to level the surface. Seal the nori and compress the sushi mat.

11 Remove the sushi mat and place the roll flat-side-down on a cutting board. Cover with the sushi mat and press from the top to adjust the shape. Remove the sushi mat and use a very sharp knife dipped in vinegar water to cut the roll into 4 equal slices, wiping the knife clean after each cut.

Morning Glory Rolls

This beauty is made from a combination of thin-roll flowers and cucumber leaves. And with this recipe you can make two differently-hued flowers at the same time. This recipe uses *oboro* and powdered shiso to tint the two kinds of rice, but feel free to use just one color. Experiment with a variety of hues for a brilliant garden of morning glories.

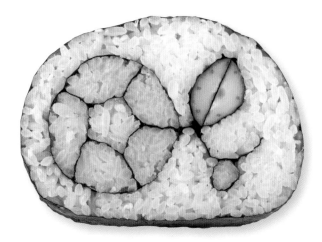

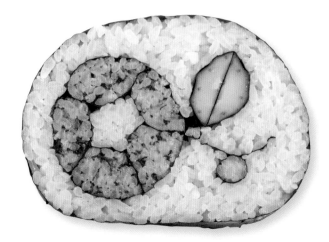

MAKES 4 MORNING GLORY PIECES

1¾ cups (350 g) prepared sushi rice, divided
Nori: ¾ x 4-in (2 x 10.5-cm) strip + 1½ x 4-in (4 x 10.5-cm) strip
 + three ½ half-sheets + ¾ half-sheet + 1½ half-sheets, "glued"
 together with a bit of rice to make an extended sheet
 + ¼ half-sheet + ⅓ half-sheet
4-in (10.5-cm) length Japanese or English cucumber
2 teaspoons pink *oboro* fish flakes
1 teaspoon *yukari* dried shiso powder
1 teaspoon white sesame seeds
2 teaspoons minced pickled ginger

TIPS The shape and position of the sushi-rice "mountain" and the layering of the nori can make or break the design. • Follow the photos and instructions carefully.

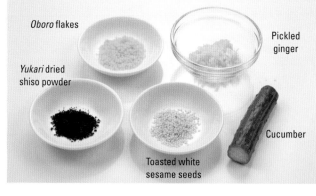

Nori Pieces

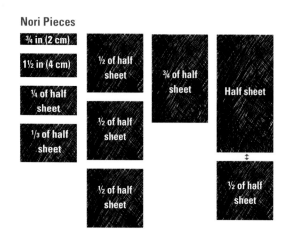

¾ in (2 cm)

1½ in (4 cm)

¼ of half sheet

⅓ of half sheet

½ of half sheet

½ of half sheet

½ of half sheet

¾ of half sheet

Half sheet

½ of half sheet

1 Combine 5 tablespoons of the sushi rice with the *oboro* flakes. Gently mix to distribute evenly, then divide into three portions of 5 teaspoons each.

2 Combine 5 tablespoons of the sushi rice with the *yukari* dried shiso powder. Gently mix to distribute coloring throughout, then divide into three portions of 5 teaspoons each.

3 Divide the remaining sushi rice into portions of 2 teaspoons; 1 tablespoon; ½ cup; 2 tablespoons x 2; 2 teaspoons x 2; and 3½ tablespoons. Arrange portions in order for easy sequential assembly.

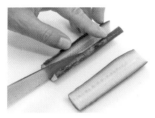
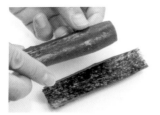

4 Make the leaf. Cut the cucumber lengthwise into 3 equal pieces. Set the middle piece aside for another use, and sandwich the ¾-inch (2-cm) strip of nori between the pieces.

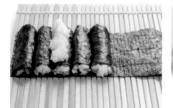

5 Make the vine. Spread the 2 teaspoons plain sushi rice evenly across the 1½ inches (4 cm) piece of nori and make a very thin round roll.

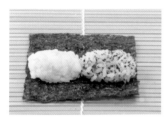

6 Make the flower. Lay a ½ half-sheet of nori on the sushi mat with the long edge parallel to the slats. Place a 5-teaspoon portion of *oboro* rice on the left half and a 5-teaspoon portion of shiso rice on the right half and spread out evenly, leaving a narrow space at the top and bottom edges. Make a thin round roll. Repeat with two more of the ½ half-sheets of nori to make 3 round rolls in all. Slice each roll lengthwise. (You will only use 5 of the resulting half-rolls.)

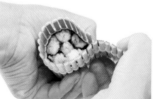

7 Lay the ¾ half-sheet of nori on the sushi mat with the short edge parallel to the slats. Making sure that the filling in each half-roll is facing the same way, place 5 of the half-rolls face-down on the nori, starting at the edge. Shape the 1-tablespoon portion of plain sushi rice into a cylinder and place it on top of the middle half-roll. Then hold the sushi mat in one hand and press into a rounded shape, sealing the nori shut.

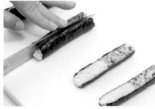

8 Lay the extended nori sheet on the sushi mat with the short end parallel to the slats. Leaving a space of 3⅛ inches (8 cm) on one side, spread the ½-cup (100-g) portion of plain sushi rice evenly across the nori. Scatter the pickled ginger and toasted white sesame seeds over the surface.

9 Form 2 sushi rice mountains from the 2-tablespoon portions of plain sushi rice and place them at the center of the rice from step 8. Fold the ⅓ half-sheet of nori in half and insert it between the two rice mountains with the crease facing down.

10 Fold the ¼ half-sheet of nori in half and place the very thin "vine" roll from step 5 in the middle. Spread 2 teaspoons of sushi rice on either side of the roll.

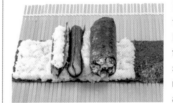

11 Insert the cucumber leaf from step 4 in the fold of the nori between the two sushi-rice mountains. Place the nori and vine from step 10 next to the left sushi-rice mountain, pressing the nori firmly against the side. On the outer side of the right sushi-rice mountain, place the flower roll from step 7.

12 Lift up the sushi mat and gradually close up the roll by pressing from both the left and right sides. Before closing completely, cover the top with the remaining 3½ tablespoons of sushi rice in an even layer, then seal the nori.

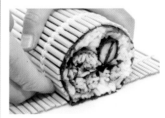

13 Remove the sushi mat and place the whole roll on a cutting board. Cover the roll with the mat and press from the top, adjusting it into a rounded shape. Remove the sushi mat and use a very sharp knife dipped in vinegar water to cut the roll into 4 equal slices, wiping the knife clean after each cut.

Ingredients like Japanese Omelette and *kamaboko* fish cake are often used in Kazari Rolls. Sometimes the natural shapes of the components flow into the design; at other times, their shapes are altered by cutting or slicing. The versatility of cheese *kamaboko*, fish sausage, cucumber and pickled burdock root make them ideal ingredients. Cutting and preparing the ingredients to ensure consistency in design no matter where the roll is sliced is a sign of a well-made Kazari Roll.

Bell Rolls

This roll incorporates a bell shape cut out of a Japanese Omelette piece, which is wrapped in *aonori*-blended sushi rice. Served alongside Santa Claus (page 52) and Reindeer (page 48) rolls, the combination is perfect for the Christmas holidays.

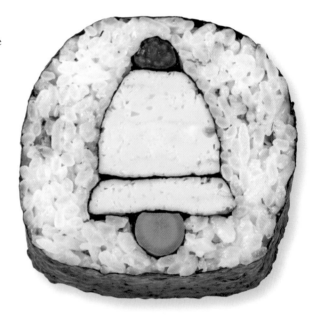

MAKES 4 BELL PIECES

1 scant cup (180 g) prepared sushi rice, divided
Nori: two ½ half-sheets + two ¼ half-sheets + 1⅓ half-sheets, "glued" together with a bit of rice to make an extended sheet
Japanese Omelette (see page 10), cut into 1¼ x 1¼ x 4-in (3 x 3 x 10.5-cm) and ¼ x 1⅜ x 4-in (.5 x 3.5 x 10.5-cm) bars
4-in (10.5-cm) length pickled burdock root
4-in (10.5-cm) stalk *nozawana* pickled mustard greens
½ teaspoon mayonnaise
½ teaspoon toasted white sesame seeds
1 teaspoon *aonori* dried laver flakes

TIPS *Stir the mayonnaise into the sushi rice before adding the* aonori *and toasted white sesame seeds.* • *Use a smooth motion to carve the omelette into a pretty curved line for the bell shape.* • *Tightly fill the space one either side of the bell with* aonori *rice before assembling the entire roll.* • *To center the bell in the roll, add equal amounts of rice on either side of the roll.*

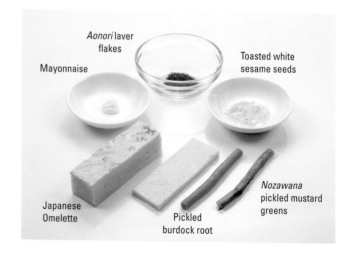

Nori Pieces

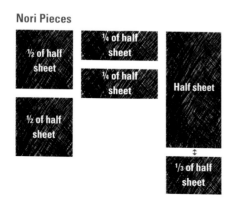

½ of half sheet

¼ of half sheet

¼ of half sheet

½ of half sheet

Half sheet

⅓ of half sheet

1 In a small bowl, combine the sushi rice and the mayonnaise. Stir gently to distribute, then add the sesame seeds and sprinkle the *aonori* over. Gently mix to combine. Divide into one ½-cup (100-g) portion, and four 5-teaspoon (20-g) portions.

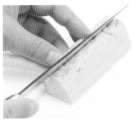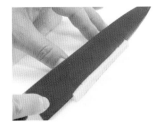

2 Make the bell. Cut the larger piece of Japanese Omelette into a rounded bell shape. Cut the smaller piece into a trapezoidal shape, shaving the left and right sides slightly at an angle. Wrap each omelette piece in a ½ half-sheet of nori. Stack the larger piece on top of the smaller piece to form the "bell."

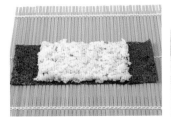

3 Slice off a rounded part of the pickled burdock root to make a flat surface and wrap in one of the ¼ half-sheets of nori. Wrap the *nozawana* stalk in the other ¼ half-sheet of nori.

4 Lay the extended nori sheet on the sushi mat with the short edge parallel to the slats. Spread the ½-cup (100-g) portion of rice across the sheet, leaving a space of 1½ inches (4 cm) on either side. Press down to make a ⅜-inch (1-cm) furrow in the middle of the rice.

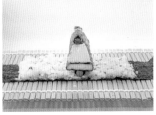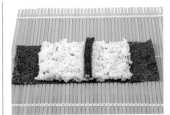

5 Place the nori-wrapped burdock root in the furrow, with the rounded side down. Place the omelette "bell" on top of the burdock, followed by the nori-wrapped stalk of pickled greens.

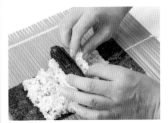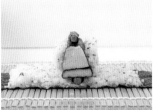

6 Shape two of the 5-teaspoon portions of rice into flattened rectangular strips and press one into each side of the bell.

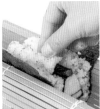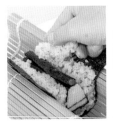

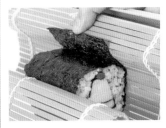

7 Lift up the sushi mat and compress. Add the remaining two 5-teaspoon portions of rice to either side of the wrapped stalk of pickled greens. Smooth the rice to create a level surface. Close the roll and seal the nori.

8 Remove the sushi mat and place the completed roll on a cutting board. Cover the roll with the sushi mat and adjust the shape into a square by pressing from above.

9 Remove the sushi mat and use a very sharp knife dipped in vinegar water to cut the roll into 4 equal slices, wiping the knife clean each time.

Penguin Rolls

The penguin's ample torso is made by sticking two pieces of *kamaboko* fish cake together. Because of this, this Kazari Roll contains less rice than others. The wings are constructed separately, then sliced and attached at the end. Try out different expressions by cutting various eye shapes out of nori.

MAKES 4 PENGUIN PIECES

1 cup (200 g) prepared sushi rice, divided
Nori: ¼ half-sheet + 2 half-sheets + four ⅓ half-sheets
 + 1⅔ half-sheets, "glued" together with a bit of rice to make
 an extended sheet + additional small pieces for the eyes
2 tablespoons ground black sesame seeds
1 teaspoon *yukari* dried shiso powder
1 teaspoon pink *oboro* fish flakes
⅜ x ⅜ x 4-in (1 x 1 x 10.5-cm) bar Japanese Omelette (see page 10)
2 half-moon bars *kamaboko* fish cake, ⅜ x 2 x 4 in (1 x 5 x
 10.5 cm) each

TIPS *Wrap the* kamaboko *pieces together tightly with nori. If the nori seems to be loosening, secure the ends with a few grains of rice.* • *It's easier to construct the penguin's head by forming the sushi rice into a rectangular strip first.*

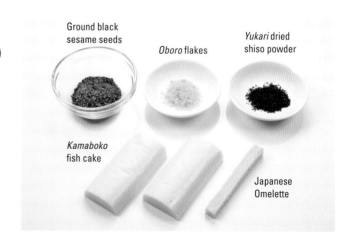

Ground black sesame seeds

Oboro flakes

Yukari dried shiso powder

Kamaboko fish cake

Japanese Omelette

Nori Pieces

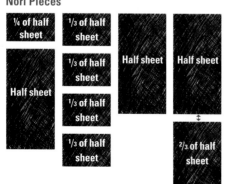

¼ of half sheet

⅓ of half sheet

Half sheet

⅓ of half sheet

⅓ of half sheet

Half sheet

Half sheet

⅓ of half sheet

⅔ of half sheet

1 Combine 2 tablespoons of the sushi rice with 1 teaspoon of *oboro*. Gently mix to blend, then divide into two equal portions.

2 Combine ¾ cup (150 g) of the sushi rice with the black sesame seeds and shiso powder. Gently mix to distribute evenly. Divide into portions of 5 teaspoons x 2, 4 tablespoons, and 5 tablespoons.

3 Make the beak. Cut the Japanese Omelette into a long triangle with ⅜-inch (1-cm) sides. Wrap in the ¼ half-sheet of nori.

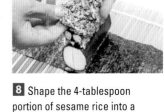

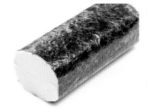

4 Make the torso. Put the two half-moon bars of *kamaboko* together and wrap tightly in a half-sheet of nori, securing the end with a few grains of rice if necessary.

8 Shape the 4-tablespoon portion of sesame rice into a rectangle about 2⅜ inches (6 cm) wide, making sure the thickness is uniform. Lay this on top of the eyes to complete the head.

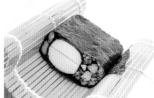

5 Make the eyes. Spread one tablespoon of the plain sushi rice on one of the ⅓ half-sheets of nori and make a round thin roll. Repeat.

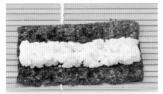

7 Form two 5-teaspoon portions of the sesame rice into 4-inch (10.5-cm) long cylinders; set these on top of the torso. Place the nori-wrapped "beak" in between them, and set the "eyes" from step 5 on top.

9 Lift up the sushi mat and tighten, sealing the nori edges at the end. Use a few rice grains to secure the roll.

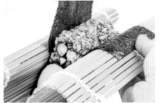

6 Make the feet. Form 1 tablespoon of the *oboro* rice into a flattened log. Place on a ⅓ half-sheet of nori and make an elliptical roll. Repeat. Place the extended nori sheet on the sushi mat with the short edges parallel to the slats. Set the two *oboro* rolls in the center and place the nori-wrapped "torso" on top.

10 Remove the sushi mat, turn the roll on its side and compress with the sushi mat. Adjust the shape to form a rounded head and balanced body. Use a very sharp knife dipped in vinegar water to slice the roll into 4 pieces, wiping the blade clean each time.

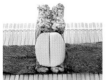

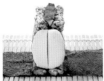

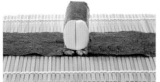

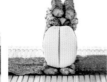

11 Make the wings. Form 5 tablespoons of the sesame rice into a 1½-inch (4-cm) high log the length of a half-sheet of nori. Place a half-sheet of nori on the sushi mat with the long edges parallel to the slats and make a long elliptical roll. Cut the long roll in half, then cut each half into quarters to make 8 pieces or 4 pairs of wings, wiping the blade clean each time. Attach 2 wings to each Penguin slice. Cut out nori eyes and decorate.

Reindeer Rolls

This roll takes a classic *date-maki* sweet rolled omelette and cleverly shapes it into reindeer antlers. The omelette is unrolled and filled with sushi rice. The face is constructed separately and combined with the antlers at the end, but keep in mind the overall balance as you create the multiple components.

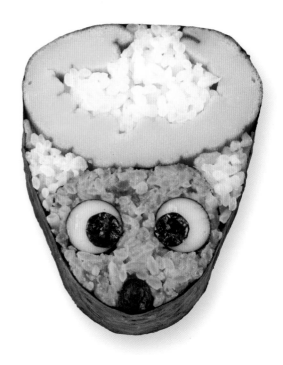

MAKES 4 REINDEER PIECES

1 cup plus 2 tablespoons (220 g) prepared sushi rice, divided
Nori: three ⅓ half-sheets + ½ sheet + 1⅔ half-sheets, "glued" together with a bit of rice to make an extended sheet + 8 small circles (for the eyes)
4-in (10.5-cm) length Kanpyo Simmered Gourd (page 10) (about ¼ oz / 10 g)
Two 4-in (10.5-cm) cylinders cheese *kamaboko*
2 tablespoons *tori soboro* Simmered Ground Chicken (see page 10)
4-in (10.5-cm) roll Sweet Baked Omelette (see sidebar)

TIPS *Adjust the amount of rice filling depending on the size of the omelette. • When the "antlers" are filled with rice, the opening between them should be about ⅜ inch (1 cm).*

Nori Pieces

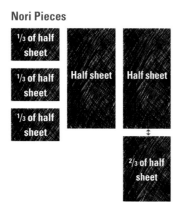

¹/₃ of half sheet

¹/₃ of half sheet

¹/₃ of half sheet

Half sheet

Half sheet

²/₃ of half sheet

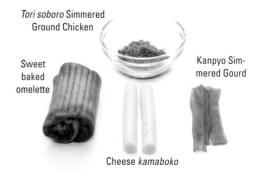

Tori soboro Simmered Ground Chicken

Sweet baked omelette

Kanpyo Simmered Gourd

Cheese *kamaboko*

Sweet Baked Omelette Date Maki

2 oz (50 g) *hanpen* fish cake (you can substitute shelled shrimp, scallops, or very well-drained tofu)
2 eggs
½ tablespoon sake
1 tablespoon mirin
½ tablespoon sugar
½ teaspoon honey
½ teaspoon soy sauce

1 Line a 4 x 8-inch (10.5 x 20-cm) loaf pan with parchment. Preheat oven to 390°F (200°C).

2 Cut the *hanpen* into small pieces. Whisk the eggs well. Combine all ingredients in a blender and purée until smooth. Strain twice through a fine sieve, then pour into parchment-lined loaf pan and bake for 20 minutes or until slightly brown on top. Broil for 2 minutes to brown if necessary.

3 Lift parchment out of pan and set omelette on a flat surface. Use a sharp knife to score the surface crosswise at 2-inch intervals. Place the sushi rolling mat on top of the omelette, with the slats parallel with the long edge. Invert the omelette and remove the parchment.

4 Use the sushi mat to roll the omelette into a cylinder, then roll the entire mat around (not into) the omelette. Secure with rubber bands and place upright. Put a plate underneath to catch moisture that seeps from the omelette as it cools.

5 When cool, cut a 4-inch (10.5-cm) length to use in the Reindeer Roll.

1 Make the nose. Place the Kanpyo Simmered Gourd on one of the ⅓ half-sheets of nori. Starting at the front edge, roll the nori tightly into a thin roll. Wrap a *kamaboko* cylinder in each of the other two ⅓ half-sheets to make the eyes.

2 Combine ½ cup (100 g) of the sushi rice with the ground chicken. Gently stir to distribute evenly. Divide into portions of ¼ cup (50 g); 5 teaspoons; and 3½ tablespoons. Divide the remaining sushi rice into portions of ½ cup (100 g) and 1 tablespoon x 2.

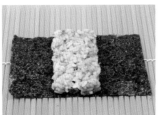

3 Make the face. Lay a half-sheet of nori on the sushi mat, aligning the short edges with the slats. Place the nori-wrapped *kanpyo* "nose" in the center. Place the ¼-cup (50-g) portion of ground-chicken rice on top of the nose and shape into a 2¾-inch (7-cm) wide rectangle.

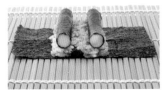
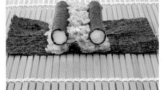

4 Place the two nori-wrapped *kamaboko* "eyes" on either edge of the rectangle. Fill the space between them with 5 teaspoons of ground-chicken rice.

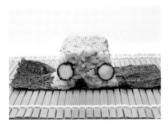
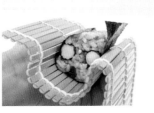

5 Shape the 3½-tablespoon portion of rice into a rectangle and place it on top of the eyes. Press down gently to unify all ingredients, then lift up the mat and wrap the nori around everything. Compress gently.

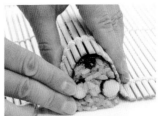

6 Remove the sushi mat and invert the roll so the nose is at the top. Place on a cutting board. Cover the roll with the sushi mat and shape into a triangle by pressing from the top as shown.

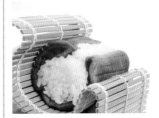

7 Make the "antlers." Spread the omelette and fill with about ½ cup (100 g) of plain sushi rice (adjust the amount of rice based on the size of the omelette). Lightly press with sushi mat.

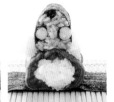

8 Lay the extended nori sheet on the sushi mat. Place the antlers from step 7 in the center with the open side down. Set the "face" roll from step 6 on the antlers, oriented with the nose at the top. Fill in the space on either side of the antlers with the two 1-tablespoon portions of sushi rice.

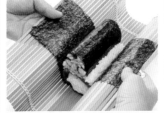
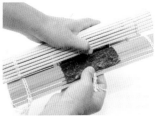

9 Lift up the sushi mat and press from each side, closing up the nori. Secure the ends of the nori with a few grains of rice.

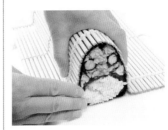

10 Remove the sushi mat and place the roll on a cutting board with the antler side down. Cover the roll with the sushi mat and adjust into a triangular shape by pressing from the top. Use a very sharp knife dipped in vinegar water to slice the roll into 4 pieces, wiping the blade after each cut. Add small nori circles to decorate the eyes.

Train Car Rolls

The train car is made from Japanese Omelette and *kamaboko* fish cake, while sushi rice blended with *tarako* pollock roe forms the outer layer of this inside-out roll. The "wheels" are constructed from cheese *kamaboko* wrapped in a single piece of nori. Several slices can be lined up to create a train effect.

MAKES 4 TRAIN CAR PIECES

¾ cup (150 g) prepared sushi rice
Nori: three ⅜-in (1-cm) strips + 2-in (5-cm) piece half-sheet
 + 6¾-in (17-cm) piece half-sheet + 1⅓ half-sheet, "glued"
 together with a bit of rice to make an extended sheet
Kamaboko fish cake, cut into a ⅜ x 2 x 4-in (1 x 5 x 10.5-cm)
 rectangle
Japanese Omelette (see page 10), cut into a ⅝ x 2 x 4-in (1.5 x 5
 x 10.5-cm) rectangle
2 tablespoons *tarako* pollock roe
Two 4-in (10.5-cm) cylinders cheese *kamaboko*

TIPS *Try to slice the Japanese Omelette and* kamaboko *as evenly as possible. A ruler or cutting board with marked measuring lines is helpful.* • *To keep the wheels from shifting or distorting, measure the distance between them and fill the space completely with sushi rice.* • *Complete the roll by shaping it into a rectangle. View the design from the side to adjust the shape.*

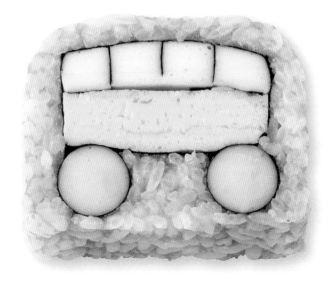

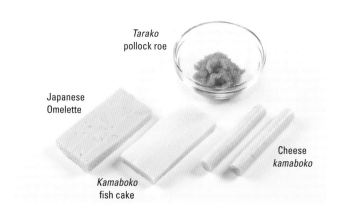

Lining up multiple slices looks so cheerful.

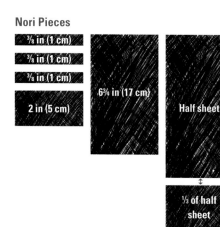

Nori Pieces

1 Make the train car. Cut the *kamaboko* rectangle lengthwise into 4 equal pieces. Sandwich a ⅜-inch (1-cm) strip of nori between each *kamaboko* slice and stack them together.

2 Place the 2-inch (5-cm) piece of nori on top of the Japanese Omelette. Put the *kamaboko* structure from step 1 on top. Wrap everything in the 6¾-inch (17-cm) piece of nori.

3 Combine the sushi rice and the *tarako* pollock roe. Mix gently to incorporate and divide into a ½-cup (100-g) portion and a ¼-cup (50 g) portion.

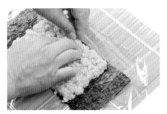
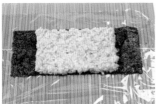

4 Assemble the entire roll. Cover the sushi mat with plastic wrap and lay the extended nori sheet on it with the short edges parallel to the slats. Spread the ½-cup (100-g) portion of rice evenly across the nori, leaving a 1½-inch (4-cm) space on either side.

5 Flip the nori over so that the *tarako* rice is now on the bottom.

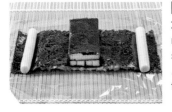

6 Place the "train car" from step 2 in the center of the extended nori sheet, with the *kamaboko* side facing down. Place a cheese *kamaboko* cylinder ¾ inch (2 cm) from either edge.

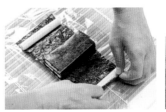
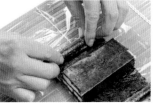

7 Wrap the underlying nori once around the cheese *kamaboko* to make the wheels. Each wrapped cheese *kamaboko* cylinder should be resting on the edge of the spread rice beneath.

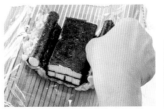
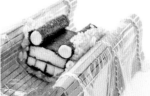

8 Lift the sushi mat and squeeze in both the left and right sides, lifting the cheese *kamaboko* "wheels" onto the train car.

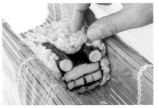
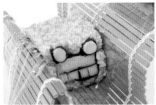

9 Spread the remaining ¼ cup (50 g) of rice on and between the wheels. Press to create a level surface.

10 Encase the roll in the sushi mat and tighten, compressing to form the entire roll into a rectangular shape.

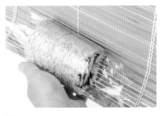
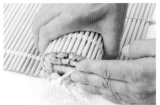

11 Remove the sushi mat and place the Train Car roll on a cutting board. Cover the roll with the sushi mat and adjust the shape further. Look at the design from the side as you adjust.

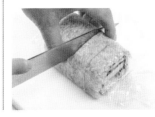

12 Remove the sushi mat, keeping the plastic around the roll. Use a very sharp knife dipped in vinegar water to slice the roll into 4 pieces, wiping the blade clean after each cut.

Santa Claus Rolls

Build the face and hat, then attach a beard made from an inside-out roll. The different additions to the rice offer a range of red hues for visual interest. The decorative eyebrows, eyes, mouth and pom-pom are added after the roll is sliced.

MAKES 4 SANTA CLAUS PIECES

1½ cups (300 g) prepared sushi rice, divided
Nori: ⅔ half-sheet + 1 half-sheet, cut crosswise into thirds
 + ¾ half-sheet + 1½ half-sheets, "glued" together with a bit
 of rice to make an extended sheet + small pieces for the eyes
 and mouth
1 teaspoon *tarako* pollock roe
2 teaspoons pink *oboro* fish flakes
2 teaspoons *tobiko* flying-fish roe
½ teaspoon toasted white sesame seeds
2 teaspoons finely minced pickled ginger
2 x ¼ x 4-in (5 x .5 x 10.5-cm) piece *kamaboko* fish cake
Two 4-in (10.5-cm) cylinders cheese *kamaboko*

TIPS *Make sure that the face, hat trim, and base of the hat are equal in width. • Use a cutting board with measurements to monitor the length of the hat as you shape the roll. • When forming the beard, shape the sushi rice with the fullest part in the center, then taper the edges into a gentle mountain shape.*

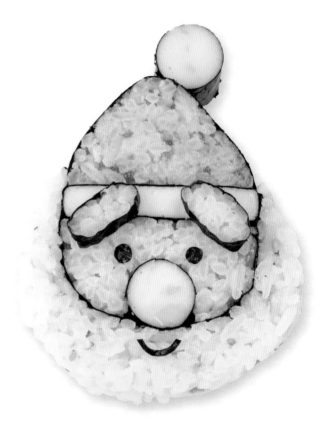

Nori Pieces

⅔ of half sheet	⅓ of half sheet	Half sheet
⅓ of half sheet	¾ of half sheet	
⅓ of half sheet		½ of half sheet

1 Set aside 2 tablespoons of plain sushi rice. Combine 8 tablespoons (100 g) of the remaining rice with the *tarako* and gently mix until evenly distributed. Divide into two equal portions. Combine 6 tablespoons (60 g) of the sushi rice with the *oboro* flakes and the *tobiko* flying-fish roe. Combine the remaining ½ cup (100 g) of sushi rice with the sesame seeds and pickled ginger.

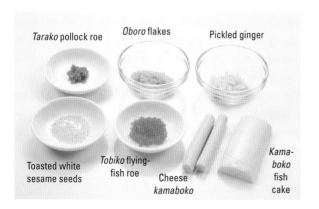

Tarako pollock roe | Oboro flakes | Pickled ginger

Toasted white sesame seeds | Tobiko flying-fish roe | Cheese kamaboko | Kamaboko fish cake

2 Wrap the *kamaboko* rectangle in the ⅔ half-sheet of nori to make the hat trim. Wrap each of the cheese *kamaboko* sticks in ⅓ half-sheet of nori for the nose and the hat pom-pom.

3 Spread the 2 tablespoons plain sushi rice on the remaining ⅓ half-sheet of nori and roll into a flattened oval for the eyebrows.

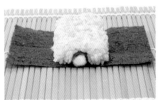

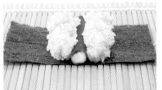

4 Assemble the face and hat. Place the nose from step 2 on the ¾ half-sheet of nori. Place the two portions of *tarako* rice on either side of the nose. Spread to cover the nose and form into a trapezoid shape.

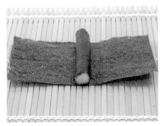

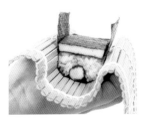

5 Lift up the sushi mat and adjust the shape of the roll into a half circle. Place the hat trim from step 2 on top of the *tarako* rice.

6 Make the beard. Cover the sushi mat with plastic wrap and place the extended nori sheet on top with the shiny side up. Place the white sesame seed rice in a mound in the middle of the nori. Keeping the center higher than the rest, spread the rice to a width of 4 inches (10.5 cm), forming a shallow arc when viewed from the side.

7 Flip the rice and nori combination upside down so that the rice side faces the plastic wrap.

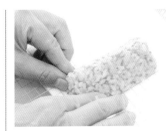

8 Form the hat from the *oboro-tobiko* rice by shaping it into a 4-inch (10.5-cm) long triangle with 2-inch (5-cm) sides.

9 Place the Santa face from step 5 on top of the nori from step 7. Place the hat from step 8 on top.

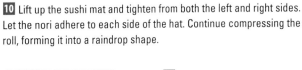

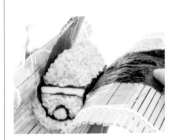 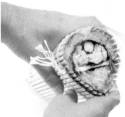

10 Lift up the sushi mat and tighten from both the left and right sides. Let the nori adhere to each side of the hat. Continue compressing the roll, forming it into a raindrop shape.

 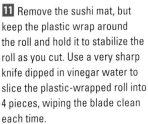

11 Remove the sushi mat, but keep the plastic wrap around the roll and hold it to stabilize the roll as you cut. Use a very sharp knife dipped in vinegar water to slice the plastic-wrapped roll into 4 pieces, wiping the blade clean each time.

12 Slice the pom-pom roll from step 2 into 4 equal pieces. Cut 8 thin slices from the eyebrow roll from step 3 (part of the roll will be left over). Cut eyes and a mouth from nori for each Santa slice. Decorate each Santa slice with a pom-pom, eyebrows, eyes and mouth.

Rolls Featuring a "Branch" Made out of Kanpyo Simmered Gourd

Flowers, trees and other nature motifs are commonly used in Kazari Sushi Rolls. Using simmered gourd wrapped in nori works well for this, as it's easy to adjust the thickness, and its malleability is great for branches and stems for flower and tree designs. This versatility is showcased in the Flowering Cherry Tree Rolls (page 56), the Persimmon Rolls (page 58) and the Pine Tree Rolls (page 60).

Sunflower Rolls

The stalk is formed by wrapping nori around a piece of Kanpyo Simmered Gourd. Multiple half-rolls of elliptical thin rolls are pressed together to make the flower petals. To achieve the yellow of the petals, Japanese Omelette is mixed into the rice. This Kazari Roll is a fantastic way to use up omelette scraps from other rolls.

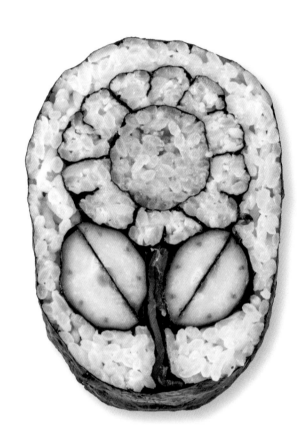

1 cup plus 6 tablespoons (280 g) prepared sushi rice, divided
Nori: three ½ half-sheets + six ⅓ half-sheets + two ¾ x 4-in (2 x 10.5-cm) strips + ⅔ half-sheet + 1½ half-sheets, "glued" together with a bit of rice to make an extended sheet
2 teaspoons *tori soboro* Simmered Ground Chicken (see page 10)
2 tablespoons minced Japanese Omelette (see page 10)
4-in (10.5-cm) length Japanese or English cucumber
1½ x 4-in (4 x 10.5-cm) strip Kanpyo Simmered Gourd (see page 10) (about ½ oz / 15 g)

TIPS *Be sure the thin rolls for the flower petals are uniform in thickness. • Use one smooth motion to cut them lengthwise, and wait until the nori feels slightly moist to the touch. • Add the petals one at a time as you assemble the flower, opening the sushi mat a little as you rotate the roll. • When it's all together, wrap the flower roll tightly so that it keeps its shape.*

Nori Pieces

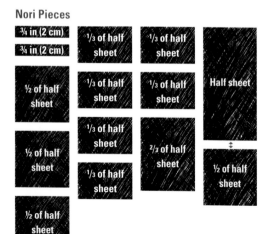

¾ in (2 cm)
¾ in (2 cm)
½ of half sheet
⅓ of half sheet
⅓ of half sheet
⅓ of half sheet
⅓ of half sheet
⅓ of half sheet
Half sheet
½ of half sheet
⅔ of half sheet
½ of half sheet
½ of half sheet

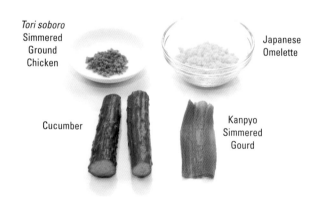

Tori soboro Simmered Ground Chicken

Japanese Omelette

Cucumber

Kanpyo Simmered Gourd

1 Combine 4 tablespoons of the sushi rice with the ground chicken and set aside.

2 Combine ⅓ cup (65 g) of the sushi rice with the minced omelette. Divide into six equal portions of 1 tablespoon each.

3 Divide the remaining sushi rice into a ½-cup (100-g) portion and two 2½-tablespoon portions.

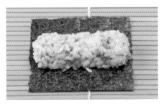

4 Spread the ground-chicken rice on a ½ half-sheet of nori and make a round roll.

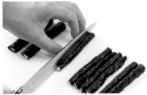

5 Make the petals. Spread a 1-tablespoon portion of the omelette rice lengthwise across a ⅓ half-sheet of nori and roll. Press the roll from the top to form an elliptical roll. Repeat with remaining omelette rice and ⅓ half-sheets to make 6 rolls. Cut each roll in half lengthwise to make 12 long, thin petals.

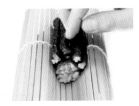
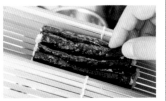

6 Place the chicken-rice roll from step 4 on the sushi mat; this will form the center of the flower. Adding one at a time, arrange the cut omelette roll "petals" from step 5 around the chicken-rice roll with their cut sides facing the center. Keep rotating the flower inside the sushi mat as you add the petals.

7 Once all 12 petals are in place, enclose the flower in the sushi mat and compress tightly into a round roll.

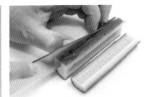
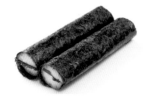

8 Make the leaves. Slice one of the cucumbers lengthwise into 3 equal parts. Setting aside the center for another use, sandwich a ¾-inch (2-cm) strip of nori between the two outside pieces. Wrap both pieces in ½ half-sheet of nori. Repeat with the second cucumber.

9 Make the flower stem. Spread the Kanpyo Simmered Gourd to a width of 1½ inches (4 cm). Place on the ⅔ half-sheet of nori and wrap.

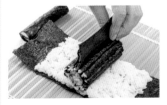
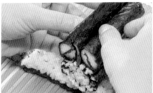

10 Assemble the entire roll. Lay the extended nori sheet on the sushi mat with the short edges parallel to the slats. Evenly spread ½ cup (100 g) of the sushi rice on the nori, leaving a space of 1½ inches (4 cm) at the edges. Place the flower from step 7 in the center of the rice.

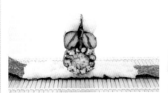

11 Place the flower stem from step 9 on top of the flower. Symmetrically place a cucumber "leaf" from step 8 on each side of the stalk.

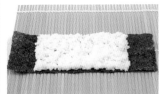
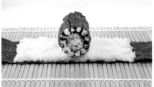

12 Fill the space above the leaves with 2½ tablespoons of sushi rice per side. Lift up the sushi mat and seal the nori, tightly wrapping the contents.

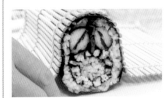

13 Remove the sushi mat and place the roll on a cutting board. Cover the roll with the sushi mat again and adjust the shape by pressing from above, then remove the mat. Use a very sharp knife dipped in vinegar water to slice the roll into 4 pieces, wiping the blade clean after each cut.

Flowering Cherry Tree Rolls

The charming Flowering Cherry Tree Rolls take advantage of the natural texture of Kanpyo Simmered Gourd. Unlike many other Kazari Rolls, the featured image is not wrapped in nori. Adding pink sushi rice gradually creates the effect of branches sprouting from the trunk, along with a profusion of blossoms. Vary the amount of sushi rice added for an asymmetrical, more natural-looking tree.

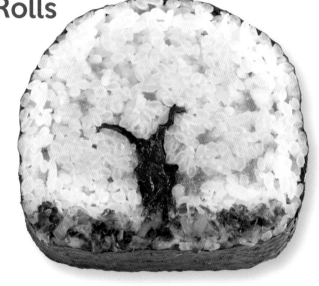

MAKES 4 FLOWERING CHERRY TREE PIECES

1¾ cups (350 g) prepared sushi rice, divided
Nori: three ⅙ half-sheets + 1⅔ half sheets, "glued" together
 with a bit of rice to create an extended sheet
¾ x 4-in (2 x 10.5-cm) strip Kanpyo Simmered Gourd (see page
 10) (about ¾ oz / 25 g)
5 teaspoons pink *oboro* fish flakes
2 teaspoons minced pickled ginger
½ teaspoon toasted white sesame seeds
1 teaspoon *mentaiko* spiced pollock roe
½ teaspoon *aonori* laver flakes
1 teaspoon finely minced *nozawana* pickled mustard greens

TIPS *Keep in mind that the tree trunk will need to be centered when placing the first mound of sushi rice. • The two sushi-rice mountains will rise higher at the left and right edges. When you add them, stabilize the trunk by firmly pressing the sushi rice on either side. • Shape the pink rice into a half-circle before placing it on the roll will produce better results.*

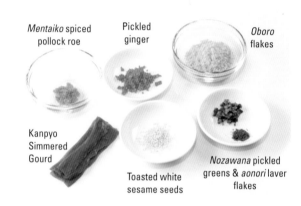

Mentaiko spiced pollock roe Pickled ginger *Oboro* flakes

Kanpyo Simmered Gourd

Toasted white sesame seeds

Nozawana pickled greens & *aonori* laver flakes

1 Combine ¾ cup (150 g) of the sushi rice with the *oboro* and minced pickled ginger. Gently mix to incorporate. Divide into the following portions: 3½ tablespoons; 5 teaspoons; 2½ tablespoons; 7 tablespoons. Divide the remaining plain sushi rice into portions of 7 tablespoons; 2⅔ tablespoons x 2; and 3½ tablespoons.

Nori Pieces

⅙ of half sheet

⅙ of half sheet

⅙ of half sheet

Half sheet

⅔ of half sheet

2 Sandwich the Kanpyo Simmered Gourd between two of the ⅙ half-sheets of nori. Lay the extended nori sheet on the sushi mat with the short edge parallel to the slats. Spread the 7 tablespoons of plain sushi rice on the nori, leaving a 2-inch (5-cm) space on either side. Sprinkle the sesame seeds evenly over the rice.

3 Identify the center of the rice foundation from step 2, then form the 2⅔-tablespoon portion of sushi rice into a mountain shape. Place the mountain so that the right edge is at the center of the spread rice. The left side of the mountain should be more sharply sloped.

4 Place the nori-wrapped *kanpyo* "trunk" on the right side of the mountain from step 3. Make sure the trunk is right on the center of the sushi-rice base.

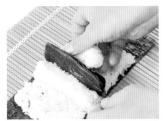

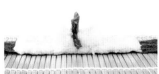

5 Form the second 2⅔-tablespoon portion of sushi rice into another mountain and place it on the right side of the tree trunk. The slope should be steeper on the right side, matching the height of the mountain on the left.

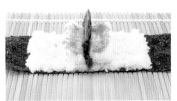

6 Sprinkle spiced pollock roe on the inner slopes of each mountain.

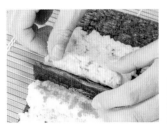

7 Shape the 3½-tablespoon portion of pink *oboro* rice into a cylinder and place on the right side of the trunk. Shape the 5-teaspoon portion of pink *oboro* rice into a cylinder and place on the left side of the trunk.

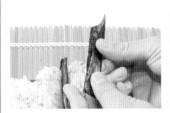

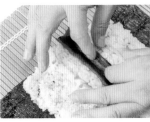

8 Fold the third ⅙ half-sheet of nori in half lengthwise. Split the top of the *kanpyo* trunk and insert the nori with the folded edge down. Press it onto the *kanpyo* and create a V shape.

9 Shape the 2½-tablespoon portion of pink *oboro* rice into a cylinder and place on the left side of the trunk.

10 Shape the 7-tablespoon portion of pink *oboro* rice into a 4-inch (10.5-cm) long half-circle and place on top of the structure from step 9.

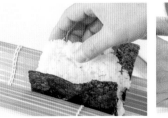

11 Lift up the sushi mat and tighten from both the left and right sides. Spread the remaining plain sushi rice to cover the top of the "tree" and seal the nori, pressing firmly. Remove the sushi mat and place the roll on a cutting board. Cover the roll with the sushi mat and adjust the shape by pressing from above.

12 Remove the sushi mat. Use a very sharp knife dipped in vinegar water to slice the roll into 4 pieces, wiping the blade clean each time. Mix the *aonori* laver flakes and the chopped pickled greens together and sprinkle a little at the base of each tree for the "grass."

Persimmon Rolls

The key point of this roll is to balance of all the elements. The design includes the persimmon fruit, the stem, two leaves and a simple sushi-rice background, which all makes for a pretty composition.

MAKES 4 PERSIMMON PIECES

1 cup plus 6 tablespoons (280 g) prepared sushi rice, divided
Nori: 1¼ x 4-in (3 x 10.5-cm) strip + ⅔ half-sheet + two ⅓ half-sheets + ¾ half-sheet + 1½ half-sheets, "glued" together with a bit of rice to make an extended sheet
1 tablespoon *tobiko* flying-fish roe
⅜ x 4-in (1 x 10.5-cm) strip Kanpyo Simmered Gourd (see page 10)
2⅜ x 4-in (6 x 10.5-cm) strip Kanpyo Simmered Gourd (see page 10)
4-in (10.5-cm) length Japanese or English cucumber
¼ oz (10 g) spinach, blanched and squeezed
1 teaspoon toasted white sesame seeds

TIPS *Because the stem (shorter branch) will be vertical, it will be inserted by making a narrow opening in the sushi rice with a kitchen knife. • Plan the position and direction of the branch and leaves prior to placing them. • Be sure to measure the sushi-rice portions accurately. The design is deliberately asymmetrical and using the exact portions will make the assembly easier. • Pack the rice firmly to prevent pockets of space from opening up and distorting the design.*

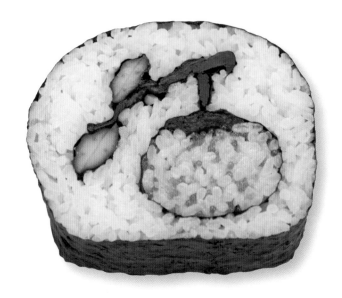

Nori Pieces

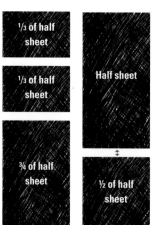

1¼ in (3 cm)

⅔ of half sheet

⅓ of half sheet

⅓ of half sheet

¾ of half sheet

Half sheet

½ of half sheet

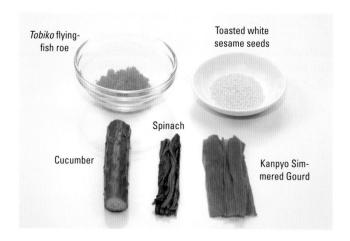

Tobiko flying-fish roe

Toasted white sesame seeds

Spinach

Cucumber

Kanpyo Simmered Gourd

1 Combine ⅓ cup (65 g) of the sushi rice with the *tobiko* flying-fish roe and set aside. Divide the plain sushi rice into the following portions: ½ cup (100 g); 2 teaspoons; 5 teaspoons x 2; 1 tablespoon x 2; and 3 tablespoons.

2 Make 2 branches. Arrange the ⅜-inch (1-cm) strip of *kanpyo* onto the 1¼-inch (3-cm) strip of nori and wrap. Arrange the 2⅜-inch (6-cm) strip of *kanpyo* onto the ⅔ half-sheet of nori and wrap.

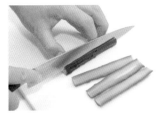 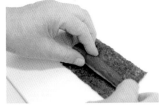

3 Make the leaves. Cut 4 sides of the cucumber away to make a square bar. Set aside the bar for another use. Sandwich 2 of the outer pieces together with the peel facing out. Wrap in ⅓ half-sheet of nori. Repeat with other 2 outer cucumber pieces.

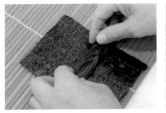 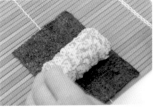

4 Make the persimmon. Cut the spinach to a length of 4 inches (10.5 cm). Place in the middle of the ¾ half-sheet of nori. Shape the *tobiko* rice into a cylinder and place on top of the spinach. Press gently to flatten slightly.

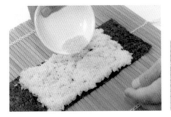 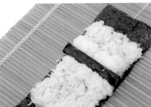

5 Lay the extended nori sheet on the sushi mat with the short edges parallel to the slats. Spread the ½ cup (100 g) of plain sushi rice across the nori, leaving a space of 1½ inches (4 cm) on either side. Sprinkle the sesame seeds evenly over the rice.

6 Form a mountain out of the 2-teaspoon portion of plain sushi rice and place in the center of the rice bed. Place one of the leaves from step 3 on the right side, positioning it to face diagonally downward. Arrange a 5-teaspoon portion of sushi rice along the right side of the leaf.

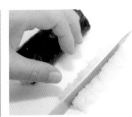 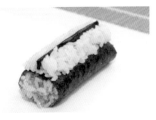

7 Shape 5 teaspoons of plain sushi rice into a ¾ x 4-inch (2 x 10.5-cm) rectangle. Using a kitchen knife, make a vertical incision in the center of the rice without cutting all the way through. Insert the shorter piece of nori-wrapped *kanpyo* from step 2 in the incision. Then place the rice on top of the persimmon roll to connect the "branch" to the spinach side of the persimmon.

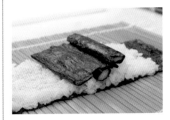 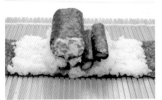

8 Take the longer branch from step 2 and place it diagonally on top of the leaf assembly from step 6. Place the other wrapped leaf on the right edge of the branch.

 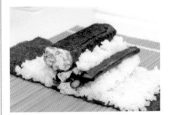

9 Fill the left side of the branch with a 1-tablespoon portion of sushi rice, then place the persimmon construction from step 7 on top with the shorter branch side facing down.

10 Fill the space between the leaves and persimmon with the second 1-tablespoon portion of sushi rice.

11 Lift the sushi mat and tighten from both the left and right sides. Cover the top with the remaining 3 tablespoons sushi rice, then seal the nori and wrap tightly. Remove the sushi mat and place the roll on a cutting board. Cover the roll with the sushi mat and adjust the shape by pressing from the top, then remove the sushi mat. Use a very sharp knife dipped in vinegar water to slice the roll into 4 pieces, wiping the blade clean each time.

Pine Tree Rolls

The pine tree is a very popular design and is a part of the pine-bamboo-plum trio that symbolizes good fortune in Japan. For this roll, layers of Kanpyo Simmered Gourd are wrapped in nori to make a sturdy tree trunk. Different amounts of sushi rice fill the space beside the tree trunk; the overall balance is dependent on the composition of the pine leaves and the S-shaped curve representing the trunk and branches. Although this is a serene and understated design, the flavor is lively because of the *bettarazuke* white pickled daikon and *tsukudani* (seafood, meat or seaweed simmered in mirin and soy sauce) that are added to the sushi rice.

MAKES 4 PINE TREE PIECES

1¾ cups (350 g) prepared sushi rice, divided
Nori: 1 half-sheet + 1½ half-sheets, "glued" together with a bit of rice to make an extended sheet
2 tablespoons finely minced *bettarazuke* white pickled daikon
1 tablespoon *aonori* laver flakes
2 teaspoons green *tobiko* flying-fish eggs
1 teaspoon *ami no tsukudani* soy-simmered shrimp (or other finely minced *tsukudani* ingredient (see page 10)
½ tablespoon ground black sesame seeds
Two 2 x 4-in (5 x 10.5-cm) strips Kanpyo Simmered Gourd (see page 10) (about 1 oz / 30 g)

TIPS *The strips of* kanpyo *are layered in a particular way to achieve a thicker trunk and thinner branch tips. • To showcase the bend of the trunk, create a smooth curve with the nori-wrapped* kanpyo. *• Lightly compress the sushi rice forming the branches and the space between branches into cylinders before adding, and press them firmly to stabilize the overall structure.*

Nori Pieces

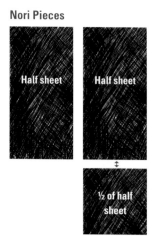

Half sheet

Half sheet

½ of half sheet

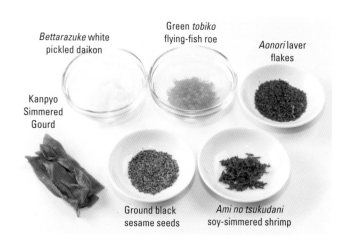

Bettarazuke white pickled daikon

Green *tobiko* flying-fish roe

Aonori laver flakes

Kanpyo Simmered Gourd

Ground black sesame seeds

Ami no tsukudani soy-simmered shrimp

1 Combine 1 cup (200 g) of the sushi rice with the minced *bettarazuke* and gently mix to incorporate. Divide into the following portions: ½ cup (100 g), 5 teaspoons x 2; 3½ tablespoons x 2.

2 Combine ½ cup (100 g) of the sushi rice with the *aonori* laver flakes and green *tobiko* flying-fish roe and gently mix to incorporate. Divide into portions of 3½ tablespoons, 2½ tablespoons, and 5 teaspoons.

3 Combine the remaining ¼ cup (50 g) sushi rice with the *tsukudani* and black sesame seeds and gently mix to incorporate. Divide into two equal portions.

4 Make the trunk. Lay one strip of Kanpyo Simmered Gourd across the center of the half-sheet of nori. Layer the second strip on top so the front part is thicker. Fold the nori in thirds around the *kanpyo* layers.

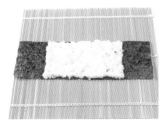

5 Lay the extended nori sheet on the sushi mat with the short edges parallel to the slats. Spread the ½-cup (100-g) portion of white *bettarazuke* rice evenly over the nori, leaving a 2-inch (5-cm) space on either side.

6 Shape the 3½-tablespoon portion of green rice into a flat cylinder about 1 inch (2.5 cm) wide and place it in the center of the white *bettarazuke* rice. Shape a 5-teaspoon portion of *bettarazuke* rice into a cylinder and lean it against the left side of the green rice.

7 Place the "trunk" from step 4 on top of the green rice with the thinner side facing down. Form 3½ tablespoons of the white *bettarazuke* rice into a cylinder and place it against the right side of the trunk. Curve the trunk toward the right.

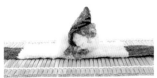
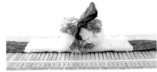

8 Shape 2½ tablespoons of the green rice into a cylinder and stack on top of the white *bettarazuke* rice on the right side of the trunk. Do the same with a 5-teaspoon portion of green rice and place it on the left side.

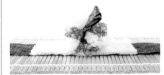
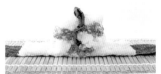

9 Shape 3½ tablespoons of the white *bettarazuke* rice into a cylinder and stack it on top of the green rice on the left side. Do the same with a 5-teaspoon portion of *bettarazuke* rice and place it on the right side. Curve the trunk to the left.

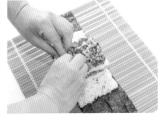

10 Place a portion of brown *tsukudani* rice on either side of the trunk. Gently press and shape to make the surface smooth and even.

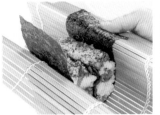
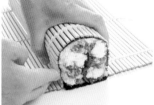

11 Lift the sushi mat and tighten from both the left and right sides. Seal the nori and wrap tightly. Remove the sushi mat and place on a cutting board. Cover with a sushi mat and adjust the shape by pressing from above, then remove the sushi mat. Use a very sharp knife dipped in vinegar water to slice the roll into 4 pieces, wiping the blade clean each time.

Adding "Ears" to Animal-Shaped Rolls

Animals and popular animal characters make great Kazari Sushi designs. These involve small details like eyes and ears, but construction is made easier by adding the ears after the roll has been assembled, as in the Panda Rolls on this page. The Bunny Rabbit Rolls on page 64 also incorporate this technique. But it's also possible to add the ears when assembling the design.

Panda Rolls

Due to the simplicity of the color scheme and their indisputably adorable appearance, pandas are an ideal subject for Kazari Sushi. As you will see, the steps for making the eyes and the ears have been streamlined and allow for uniformity. The roll for the eyes will be sliced in half crosswise; the roll for ears will be sliced crosswise into 8 pieces.

MAKES 4 PANDA PIECES

1½ cups (300 g) prepared sushi rice, divided
Nori: ½ half-sheet, cut lengthwise + ¾ half-sheet, cut lengthwise + two ⅓ half-sheets, cut crosswise + 1⅓ half-sheets, "glued" together with a bit of rice to make an extended sheet
2 tablespoons finely minced *bettarazuke* white pickled daikon
1 teaspoon toasted white sesame seeds
2 teaspoons ground black sesame seeds
Pinch *yukari* dried shiso powder
Two ¾ x 4-in (2 x 10.5-cm) strips Kanpyo Simmered Gourd (see page 10)
8 round slices pickled burdock root (for the eyes)

TIPS *Position the elliptical rolls for each eye at an angle so they look like two downward-facing wings. • When you cut the roll lengthwise to make the mouth, be sure not to cut all the way through the nori. • When shaping the final roll, make the top of the head rounded, but flatten the chin area.*

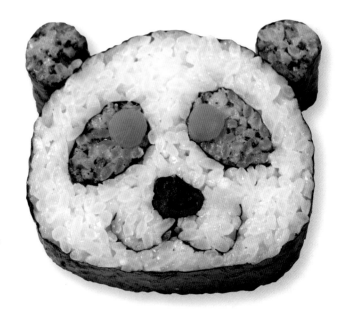

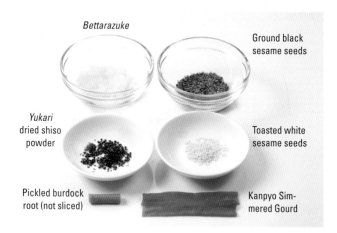

Bettarazuke

Ground black sesame seeds

Yukari dried shiso powder

Toasted white sesame seeds

Pickled burdock root (not sliced)

Kanpyo Simmered Gourd

Nori Pieces

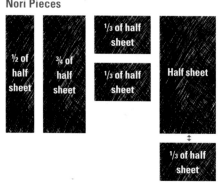

½ of half sheet

¾ of half sheet

⅓ of half sheet

⅓ of half sheet

Half sheet

⅓ of half sheet

1 Combine 1 cup (200 g) of the sushi rice with the minced *bettarazuke* and the white sesame seed. Gently mix to incorporate, then divide into the following portions: 5 teaspoons; ½ cup (100 g); 1 tablespoon x 4; and 3½ tablespoons.

2 Combine the remaining ½ cup (100 g) of sushi rice with the black sesame seed and shiso powder. Divide into a 3-tablespoon portion and a 5-tablespoon portion.

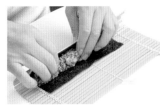

3 Make the ears. Place the long ½ half-sheet of nori on the sushi mat with the long edges parallel to the slat. Arrange the 3-tablespoon portion of black sesame-seed rice along the center of the nori and make a round thin roll. Slice into 8 pieces.

4 Make the eyes. Place the long ¾ half-sheet of nori on the sushi mat with the long edges parallel to the slat. Arrange the remaining 5 table-spoons of black sesame-seed rice along the center of the nori and form into an elliptical roll. Slice in half crosswise to make 2 shorter rolls.

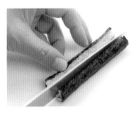

5 Make the mouth. Lay ⅓ half-sheet of nori on the sushi mat with the long edges parallel to the slats. Arrange a 5-teaspoon portion of white *bettarazuke* rice on the nori and make a round roll. Being care-ful not to cut all the way through the nori at the bottom, slice the roll in half lengthwise. Open up the roll.

6 Make the nose. Lay the remaining ⅓ half-sheet of nori on the sushi mat with the long edges parallel to the slats. Arrange the Kanpyo Simmered Gourd on the nori, close to the front of the long edge. Roll into a thin cylinder, starting at the front edge.

All the components of the Panda Rolls' features.

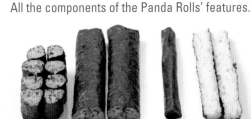

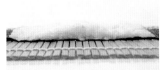

7 Assemble the face. Lay the extended nori sheet on the sushi mat with the short edges parallel to the slats. Spread the ½-cup (100-g) por-tion of white *bettarazuke* rice across the nori, leaving a 1½-inch (4-cm) space on either side. Form the rice so that it is slightly higher at the center, as shown in the photo.

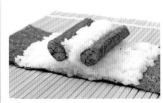

8 Shape a 1-tablespoon portion of the *bettarazuke* rice into a low mountain and set it on the center of the rice bed. Place one of the ellip-tical eye rolls from step 4 on either side of this mountain, angling each one outward and upward.

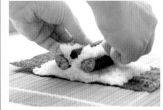

9 Fill the space between the eyes with another 1-tablespoon portion of the white rice. Place the nori-wrapped *kanpyo* "nose" in the center.

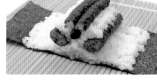

10 Fill in the space on either side of the nose with 1-tablespoon por-tions of *bettarazuke* rice. Gently smooth the surface so it is flat and even, then place the "mouth" from step 5 face-down on top.

11 Form the remaining 3½ table-spoons of *bettarazuke* rice into an even rounded mound over the mouth.

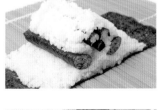

12 Lift the sushi mat and tighten from both the left and right sides. Seal the nori and wrap tightly. Looking at the roll so the design is visible from the side, adjust the overall shape into an oval. Remove the sushi mat and place the roll face-down on a cutting board. Cover with the mat again and shape so the top of the head is rounded and the chin area is flat. Remove the sushi mat.

13 Use a very sharp knife dipped in vinegar water to slice the roll into 4 pieces, wiping the blade clean each time. Decorate by adding two ears from step 3 to each slice and placing a slice of pickled burdock on each eye.

Bunny Rabbit Rolls

The face and ears of this adorable bunny are constructed separately; the long ears are filled with *mentaiko* spiced pollock roe, and the blushing cheeks are tinted with pink *oboro* rice.

MAKES 4 BUNNY RABBIT PIECES

1⅓ cups (275 g) prepared sushi rice, divided
Nori: two ⅔ half-sheets + three ⅓ half-sheets + ¼ half-sheet
 + 1¼ half-sheets, "glued" together with a bit of rice to make
 an extended sheet + 8 small circles (for the eyes)
1 tablespoon finely minced *bettarazuke* white pickled daikon
1 teaspoon pink *oboro* fish flakes
1 teaspoon *mentaiko* spiced pollock roe
Two 4-in (10.5-cm) cylinders cheese *kamaboko*
4-in (10.5-cm) length pickled burdock root

TIPS *Roll the ears into an elongated comma shape. Experiment with attaching them straight up or askew and curving them in different ways to add character. • When forming the face roll, spread the sushi rice on the elongated nori sheet so that it slopes upward to the center; this will shift the facial features toward the chin, which looks cuter. • Don't make the "cheeks" too large, and be sure to place them at the same level on either side of the nose.*

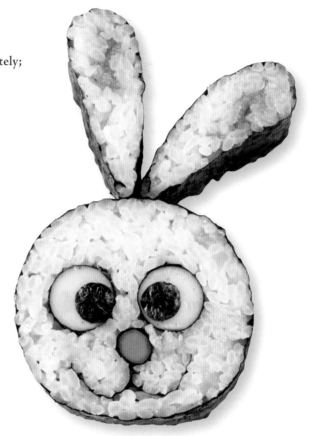

Nori Pieces

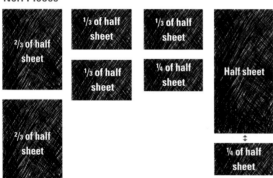

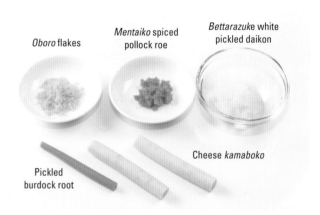

1 Set aside two ¼-cup (50-g) portions of plain sushi rice. In a separate bowl, combine ⅔ cup sushi rice with the *bettarazuke* and gently mix to incorporate. Divide into the following portions: 5 teaspoons; 4 tablespoons; 1 tablespoon; 2 teaspoons x 2; and 2⅔ tablespoons. In another bowl, combine the remaining 2 tablespoons of sushi rice with the *oboro* flakes and gently mix to incorporate. Divide into two equal portions.

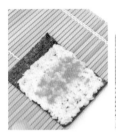

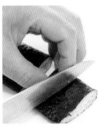

2 Make the ears. Lay one ⅔ half-sheet of nori on the sushi mat with the short edge parallel to the slats. Spread ¼ cup (50 g) of plain sushi rice over the nori, leaving ⅜ inch (1 cm) of space at the back. Spread half of the *mentaiko* spiced pollock roe across the middle in a band about 1¼ inches (3 cm) wide. Fold the sushi mat over as if to fold the nori in half, then bend the edge of the nori back. Press the front edge of the sushi mat to form the roll into a raindrop shape. Open the mat, turn the roll over, then re-wrap and adjust into an elongated comma shape. Repeat to make a second roll. Use a very sharp knife dipped in vinegar water to slice each roll into 4 pieces, wiping the blade clean each time.

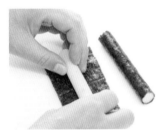
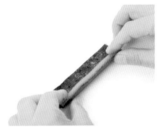

3 Make the eyes by wrapping each cylinder of cheese *kamaboko* in ⅓ half-sheet of nori. Make the nose by wrapping the pickled burdock root in ¼ half-sheet of nori.

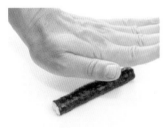
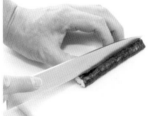

4 Make the mouth. Spread the 5-teaspoon portion of white *bettarazuke* rice across the center of the remaining ⅓ half-sheet of nori and form a round roll. Flatten the roll into an elliptical cylinder. Without cutting all the way through to the bottom, slice the roll in half lengthwise and open it up.

5 Assemble the face. Lay the extended nori sheet on the sushi mat with the short edges parallel to the slats. Spread the 4-tablespoon portion of *bettarazuke* white rice across the nori, leaving a 2¾-inch (7-cm) space on either side. Shape the rice so it slopes gently upward toward the center.

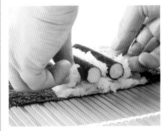

6 Form a mountain from the 1-tablespoon portion of *bettarazuke* rice and place it in the middle of the rice from step 5. Place the eyes from step 3 on either side of this mountain. Spread a 2-teaspoon portion of *bettarazuke* rice on the outer side of each eye.

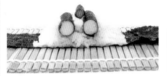
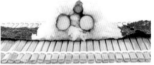

7 Place the nori-wrapped pickled burdock nose on the rice between the eyes. Fill the space on either side of the nose with the two portions of *oboro* rice, creating a smooth, level surface.

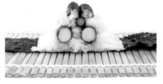
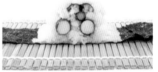

8 Place the mouth from step 4 on top, cut side down. Form the remaining 2⅔ tablespoons of *bettarazuke* rice into a rounded mound over the mouth.

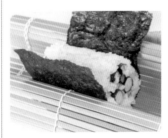
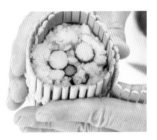

9 Lift the sushi mat and tighten from both the left and right sides. Seal the nori and wrap tightly. Unwrap the sushi mat and turn the roll right side up, then re-wrap and form into a perfect cylinder. Remove the sushi mat. Use a very sharp knife dipped in vinegar water to slice the roll into 4 pieces, wiping the blade clean each time. Attach two of the ears from step 2 to each slice and decorate the eyes with circular nori pieces.

Rolls with Japanese kanji characters are always a crowd pleaser, particularly when names and celebratory words are spelled out. We will use the characters 日 (*nichi* or *hi,* for "sun") and 本 (*hon,* for "origin") as examples of how to combine thin rolls into kanji characters. Together these two characters make the word 日本 (Nihon), which means "Japan." These rolls work better for simple characters. When multiple characters constructed separately are part of the presentation, try to keep the thickness of all the rolls uniform.

Rolls with 日, the Kanji Character for "Sun" Hi

Given that the kanji character 日 requires only a few straight lines, it is relatively easy to construct, making it a good starting point. Since there are so many celebratory occasions that involve the word *hi*, like Kodomo no Hi (Children's Day), 日 is a useful character to have in your sushi-making arsenal.

MAKES 4 "SUN" KANJI PIECES

1½ cups (300 g) prepared sushi rice, divided
Nori: two ⅔ half-sheets + three ½ half-sheets + 1½ half-sheets, "glued" together with a bit of rice to make an extended sheet
5 teaspoons pink *oboro* fish flakes
2 teaspoons *mentaiko* spiced pollock roe
5 teaspoons minced *bettarazuke* white pickled daikon
½ teaspoon toasted white sesame seeds

TIPS *For best results, spread the rice as evenly as possible and cut the pieces to the specified lengths as precisely as you can.* • *Keep the angles of the character lines in mind when assembling the pieces.* • *When completing the roll, wrap the sushi mat around it carefully to avoid distorting the kanji character.*

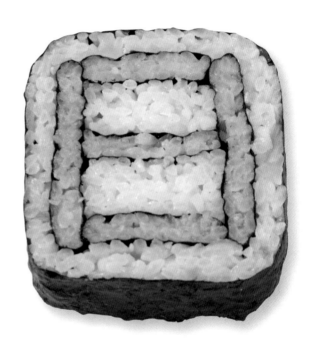

Nori Pieces

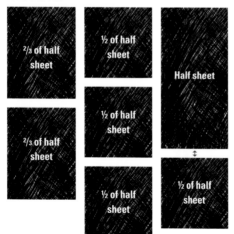

⅔ of half sheet

½ of half sheet

Half sheet

⅔ of half sheet

½ of half sheet

½ of half sheet

½ of half sheet

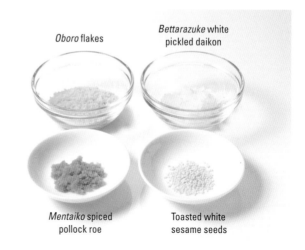

Oboro flakes

Bettarazuke white pickled daikon

Mentaiko spiced pollock roe

Toasted white sesame seeds

1 Combine ½ cup (100 g) of the sushi rice with the *oboro* flakes and *mentaiko* spiced pollock roe. Gently mix to incorporate evenly. In a separate bowl, combine ⅔ cup (130 g) of the sushi rice with the *bettarazuke* pickled daikon and the sesame seeds, and gently mix to incorporate. Divide into a ½-cup (100-g) portion and a 3½-tablespoon portion. Divide the remaining sushi rice into two equal 3½-tablespoon portions.

2 Using a cutting board with measurements or a ruler, shape the pink *oboro* rice into a 9½ x 4-inch (24 x 10.5-cm) rectangle. Cover the rice with plastic wrap. Cut crosswise to make two pieces that are 2⅜ inches (6 cm) wide and three pieces that are 1½ inches (4 cm) wide. Each piece should be 4 inches (10.5 cm) long.

 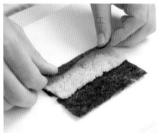

3 Handling the pieces very carefully so that their size and shape does not change, wrap each pink *oboro* rectangle in nori. Use the two ⅔ half-sheets for the 2⅜-inch (6-cm) pieces, and the three ½ half-sheets for the 1½-inch (4-cm) pieces. Place the rice in the center of the nori, oriented so that both rice and nori are 4 inches (10.5 cm) across. Fold one side of the nori over the rice, then overlap with the other side.

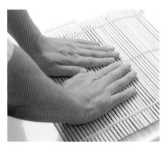

4 Once all pieces have been wrapped, line them up in a single layer on the cutting board and place the sushi mat on top. Press down gently with both hands to make sure all pieces are the same thickness. Let the nori settle before proceeding to the next step (the nori will shrink a bit and feel slightly damp).

All the components of the kanji character.

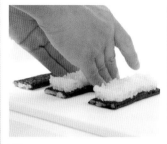

5 Spread 3½ tablespoons of the sushi rice in an even layer over two of the 1½-inch (4-cm) wide nori-wrapped pieces. Place one on top of the other, then place the remaining 1½-inch (4-cm) wide nori-wrapped piece on top.

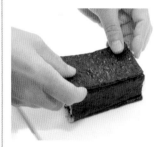

6 Align the stack of rice and nori pieces. Place one 2⅜-inch (6-cm) piece on either side of the stack.

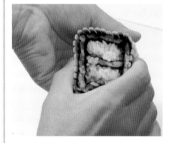

7 Place the entire construction on the sushi mat with the long edge parallel to the slats. Press firmly to align the sides into a perfect rectangle.

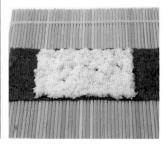

8 Assemble the entire roll. Lay the extended nori sheet on the sushi mat with the short edges parallel to the slats. Spread the ½-cup (100-g) portion of *bettarazuke* rice across the nori, leaving a 1½-inch (4-cm) space on either side.

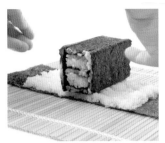

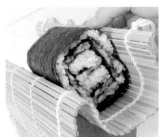

9 Place the assembled character in the center of the rice, handling carefully to prevent the shape from becoming distorted. Lift the sushi mat and press from both sides.

11 Unwrap the sushi mat and turn the roll over. Re-wrap in the mat and adjust the shape into a square, viewing the roll from the side as you work, then remove the mat. Use a very sharp knife dipped in vinegar water to slice the roll into 4 pieces, wiping the blade clean each time.

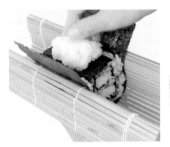
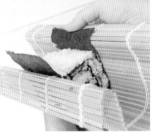

10 Spread the remaining 3½ tablespoons of *bettarazuke* rice on top of the character in an even layer. Seal the nori and wrap the mat tightly around the construction.

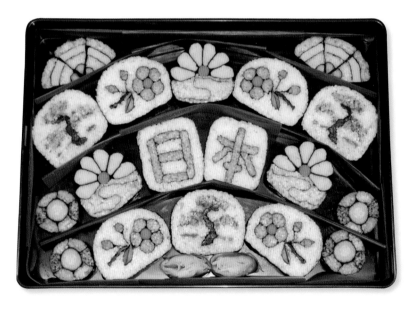

Example of a sushi arrangement featuring different Kazari Sushi rolls

This sushi display features rolls with auspicious symbols like chrysanthemum flowers and pine trees, as well as the characters that form 日本 (Nihon, or Japan). Depending on the rolls selected, this array would be appropriate for a variety of celebratory occasions. Pieces of nigiri sushi or other kinds of rolls could also be included.

Rolls with 本, the Kanji Character for "Origin" Hon

This roll involves a little more than stacking and sticking, and you will practice inserting elements into incisions during the construction process. The kanji character "本" is made up of straight lines, but the distinctive and subtle variations in line lengths require extremely precise measuring and cutting.

MAKES 4 "ORIGIN" KANJI PIECES

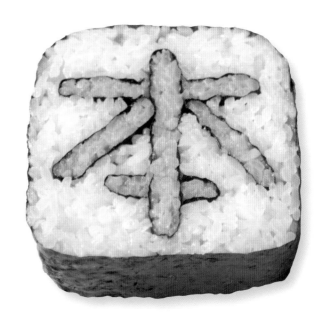

1²⁄₃ cups (325 g) prepared sushi rice, divided
Nori: two ²⁄₃ half-sheets + two ¹⁄₂ half-sheets + ¹⁄₃ half-sheet + 1¹⁄₂ half-sheets, "glued" together with a bit of rice to make an extended sheet
2 teaspoons pink *oboro* fish flakes
1 teaspoon *mentaiko* spiced pollock roe
1 tablespoon minced *bettarazuke* white pickled daikon
¹⁄₂ teaspoon roasted white sesame seeds

TIPS: *Be sure to stabilize all the parts as you stand them up. • As you wrap the sushi mat around the roll, be sure it is symmetrical, and use equal pressure on all sides. • Keep an eye on the design, adjusting as necessary to keep the kanji undistorted in the center.*

Nori Pieces

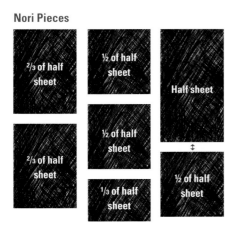

²⁄₃ of half sheet

¹⁄₂ of half sheet

Half sheet

²⁄₃ of half sheet

¹⁄₂ of half sheet

¹⁄₃ of half sheet

¹⁄₂ of half sheet

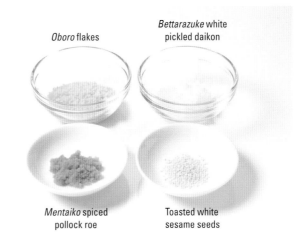

Oboro flakes

Bettarazuke white pickled daikon

Mentaiko spiced pollock roe

Toasted white sesame seeds

1 Combine 7 tablespoons of the sushi rice with the *oboro* flakes and the *mentaiko* spiced pollock roe. Gently mix to distribute evenly. In a separate bowl, combine ½ cup plus 2 tablespoons (125 g) of the sushi rice with the minced *bettarazuke* and toasted white sesame seeds and gently mix to distribute evenly. Divide into a ½-cup (100-g) portion and a 2⅔-tablespoon portion. Divide the remaining plain sushi rice into the following portions: 2 ⅔ tablespoons; 1 tablespoon x 2; 2 teaspoons x 2; and 5 teaspoons x 2.

 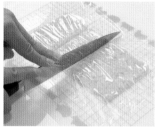

2 Using a cutting board with measurements, or measuring carefully with a ruler, shape the *oboro* pink rice into an 8 x 4-inch (20 x 10.5-cm) rectangle. Cover rice with plastic with plastic wrap and slice crosswise into pieces of the following widths (each piece should be 4 inches / 10.5 cm long): 2⅜ inches (6 cm), 2 inches (5 cm), 1⅜ inches (3.5 cm), 1⅜ inches (3.5 cm), ¾ inch (2 cm).

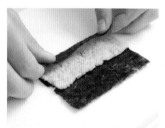 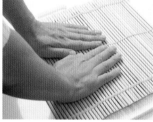

3 Being careful not to alter the shape, remove the 2⅜-inch (6-cm) piece from the board and wrap in a ⅔ half-sheet of nori. Wrap the 2-inch (5-cm) piece in the other ⅔ half-sheet of nori. Wrap the two 1⅜-inch (3.5-cm) pieces in the ½ half-sheets of nori. Finally, wrap the ¾-inch (2-cm) piece in the ⅓ half-sheet of nori.

4 Once all pieces are wrapped, arrange them in a single layer on the cutting board and place the sushi mat on top. Press gently with both hands to ensure that all pieces are the same thickness. Let the nori settle before proceeding to the next step—it will shrink slightly and feel slightly damp).

All the components of the kanji character.

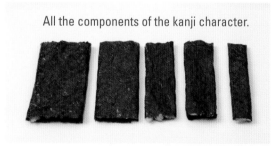

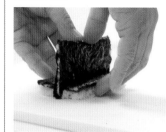 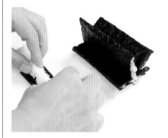

5 Spread 2⅔ tablespoons of plain sushi rice in an even layer on top of the wrapped 2-inch (5-cm) piece. Flip it over and cut it down the center lengthwise. Pull the pieces apart slightly and insert the 2⅜-inch (6-cm) piece in the opening.

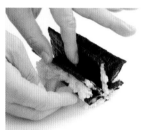 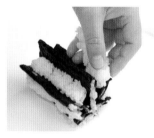

6 On top of each nori-wrapped 1⅜-inch (3.5-cm) piece, form a 1-tablespoon portion of plain sushi rice into a long triangular mountain shape. Turn the rice side down and prop the assembly at an angle next to the vertical 2⅜-inch (6-cm) piece. Press the rice down to stabilize. Repeat on the other side of the vertical piece.

 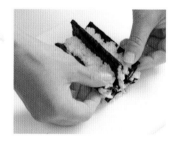

7 Fill the space above each of the angled 1⅜-inch (3.5-cm) pieces with 2 teaspoons of plain sushi rice. Even out the sides so the rice is level with the topmost part of the angled pieces.

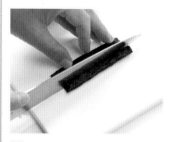 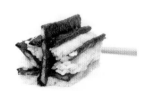

8 Cut the wrapped ¾-inch (2-cm) piece in half lengthwise. Place each half on the rice from step 7, adjoining the vertical piece.

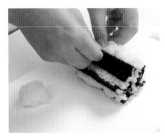 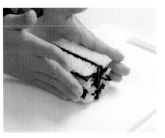 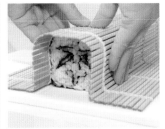 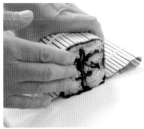

9 Add a 5-teaspoon portion of sushi rice on each side of the space above the pieces from step 8. Make the surface smooth and even. Use your hands to shape the assembled pieces into a square.

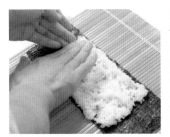

10 Assemble the entire roll. Lay the extended nori sheet on the sushi mat with the short ends parallel to the slats. Spread the ½-cup (100-g) portion of *bettarazuke* white rice in an even layer over the nori, leaving a 1½-inch (4-cm) space on either side.

13 Unwrap the sushi mat and turn the roll over. Look at the kanji character from the side as you continue to adjust the shape with the mat, forming the roll into a perfect square. You may also want to place it on a cutting board and shape it by placing the sushi mat on top and pressing from above. Remove the sushi mat. Use a very sharp knife dipped in vinegar water to slice the roll into 4 pieces, wiping the blade clean each time.

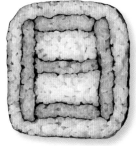 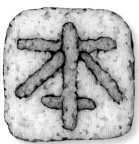

Pair with the 日 Kanji Roll from page 66 to form the word 日本 (Nihon), meaning "Japan."

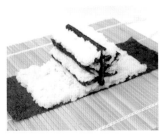 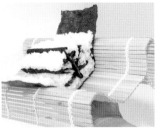

11 Carefully place the kanji character from step 9 in the middle of the rice. Lift up the sushi mat and tighten from both the left and right sides.

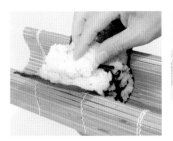 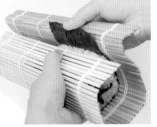

12 Spread the remaining *bettarazuke* rice in an even layer on top of the kanji character, seal the nori and wrap tightly.

For kanji characters with more complicated script structures, *kanpyo* is a versatile ingredient to accommodate curves and multiple intersections. For each segment of the kanji character, you will cut the simmered *kanpyo* to the specified width and wrap it in nori. The wrapped *kanpyo* pieces will then be combined to form the kanji character. In cases where the kanji character is asymmetrical, make sure that you are slicing from the correct side of the roll. Cut a sliver off the end of the roll at first to double-check that you're slicing from the right direction.

Rolls with 祝, the Kanji Character for "Celebration" Iwai

This classic representation of festivities and congratulations is a Kazari Sushi staple. First create the 礻 segment, then add 兄. Because the character will be assembled upside down, pay attention to the placement of the elements as you build the roll.

MAKES 4 "CELEBRATION" KANJI PIECES

1²/₅ cups (280 g) prepared sushi rice, divided
Nori: 1¼ x 4-in (3 x 10.5-cm) strip + three ⅓ half-sheets + ¼ half-sheet + three ½ half-sheets + 1½ half-sheets, "glued" together with a bit of rice to make an extended sheet
1 tablespoon pink *oboro* fish flakes
½ teaspoon toasted white sesame seeds
Japanese Omelette (see page 10), cut into a ¾ x 1 x 4-in (2 x 2.5 x 10.5-cm) bar
Eight 4-in (10.5-cm) long strips Kanpyo Simmered Gourd (see page 10), cut to the widths indicated in the table (opposite)

TIPS *Make sure the heights of the two elements in the character (礻 and 兄) are equal. • Pack the rice firmly in the spaces between the wrapped nori pieces to avoid loose rice that will turn into holes when sliced, and use firm pressure to stick the pieces together as you assemble the roll. • When completing the roll, go slowly and be careful to avoid distorting the shape of the elements inside.*

Nori Pieces

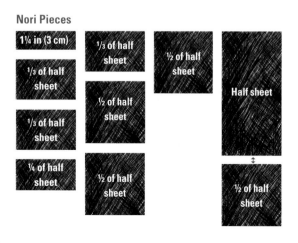

1¼ in (3 cm)
⅓ of half sheet
⅓ of half sheet
⅓ of half sheet
¼ of half sheet
½ of half sheet
½ of half sheet
½ of half sheet
½ of half sheet
Half sheet
½ of half sheet

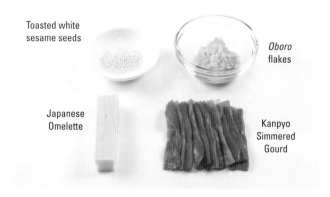

Toasted white sesame seeds
Oboro flakes
Japanese Omelette
Kanpyo Simmered Gourd

1 Combine ⅔ cup (130 g) of the sushi rice with the *oboro* flakes and white sesame seeds and gently stir to integrate. Divide into portions of ½ cup (100 g) and 3½ tablespoons. Divide the remaining sushi rice into the following portions: 2⅔ tablespoons; 5 teaspoons x 2; 2 teaspoons; 3½ tablespoons; and 1 tablespoon x 2.

2 Cut the Kanpyo Simmered Gourd into the widths specified below, then wrap in the nori sheet indicated.

	Width of *kanpyo* strip	Size of nori sheet
❶	⅜ inch (1 cm)	1¼ inches (3 cm)
❷	¾ inch (2 cm)	⅓ half-sheet
❸	1 inch (2.5 cm)	⅓ half-sheet
❹	⅝ inch (1.5 cm)	¼ half-sheet
❺	¾ inch (2 cm)	⅓ half-sheet
❻	1¼ inches (3 cm)	½ half-sheet
❼	2 inches (5 cm)	½ half-sheet

❶ ❷ ❸ ❹ ❺ ❻ ❼ ❽

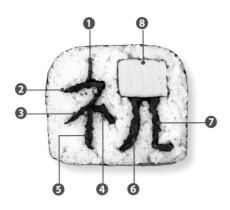

❶ ❽
❷
❸
❼
❺ ❹ ❻

3 Wrap the cut Japanese Omelette in the remaining ½ half-sheet of nori (this will be ❽ in the instructions).

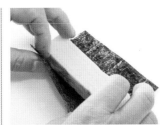

 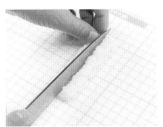

4 Begin making the left part of the character (ネ). Shape 2⅔ table-spoons of the plain sushi rice into a ⅜ x 4-inch (1 x 10.5-cm) rectangle. Without cutting all the way through the rice, make a lengthwise incision down the middle. Insert ❶ into the incision. Place ❷ on top.

5 Make a mountain shape out of 5 teaspoons of sushi rice. Lay ❸ at an angle on the side of the rice mountain.

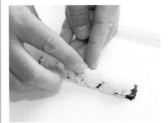 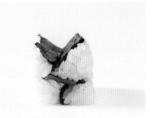

6 Form 2 teaspoons of sushi rice into a triangular mountain on top of ❹. With the rice side facing down, press it down firmly on the left side of the construction from step 5 so that it adheres.

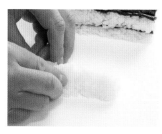

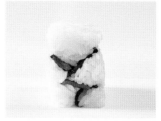

7 Form a 3½-tablespoon portion of sushi rice into a long triangle and place it upside-down on top of the structure from step 6.

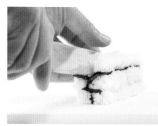
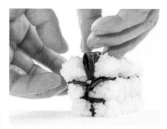

8 Use a kitchen knife to make an incision in the triangle of rice from step 7. Insert **5** vertically into the opening.

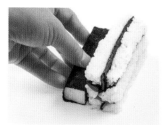

9 Now begin making the left-hand component of the character. (兄). Line up **8**, the Japanese Omelette piece, on the left side of the upside-down ネ.

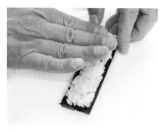

10 Spread a 1-tablespoon portion of sushi rice on **6**, making one side thicker than the opposite side to create an incline. With the thicker side facing down and to the right, place the piece vertically on the upper right section of the wrapped omelette.

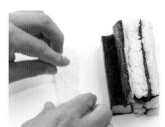
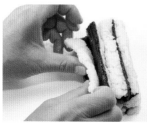

11 Form the other 1-tablespoon portion of sushi rice into a 1¼ x 4-inch (3 x 10.5-cm) rectangle, and "paste" on the upper left side of **6** (placed in step 10).

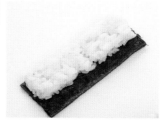
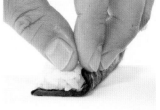

12 Leaving a little space along one edge, spread 5 teaspoons of sushi rice on **7**. Bend the edge upward into a curve and press into the rice.

13 Attach the piece from step 12 to the structure from step 11 to complete the kanji character.

14 Assemble the entire roll. Lay the extended nori sheet on the sushi mat with the short edges parallel to the slats. Spread the ½-cup (100-g) portion of pink *oboro* rice on the nori, leaving about 2 inches (5 cm) of space on either side. Place the completed kanji in the middle.

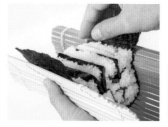
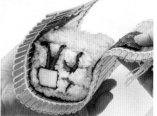

15 Lift the sushi mat, tightening from both the left and right sides while being sure not to distort the kanji. Add the remaining *oboro* rice on top and smooth to make the surface level, then seal the nori.

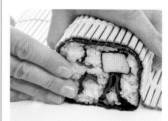

16 Remove the sushi mat and place the finished roll on a cutting board. Cover the roll with the mat and shape it by pressing from above. Remove the sushi mat. Use a very sharp knife dipped in vinegar water to cut off a thin slice in order to make sure you are cutting from the correct side of the roll to display the kanji correctly. If correct, slice the rest of the roll into 4 pieces, wiping the knife clean after each cut.

Rolls with 寿, the Kanji Character for "Long Life"

Kotobuki

As a very auspicious kanji character that represents long life, 寿 (*kotobuki*) is ideal for anniversaries, birthdays, and New Year's celebrations. Due to the stacked and sinuous lines, this involved character requires quite a few steps to craft. You'll start by matching up the widths of the *kanpyo* pieces. Then you'll stack and balance them to form the kanji.

MAKES 4 "LONG LIFE" KANJI PIECES

1½ cups (300 g) prepared sushi rice, divided

Nori: four ½ half-sheets + ¾ half-sheet + ⅔ half-sheet + ¼ half-sheet + 1½ half-sheets, "glued" together with a bit of rice to make an extended sheet

1 tablespoon pink *oboro* fish flakes

4-in (10.5-cm) length pickled burdock root

1 teaspoon toasted white sesame seeds

Six 4-in (10.5-cm) long strips Kanpyo Simmered Gourd (see page 10), cut to the widths indicated in the table on page 76

TIPS *The nori will shrink as it absorbs moisture, so try not to wrap the* kanpyo *too tightly. • Keep all pieces aligned and balanced as you stack them, and take care not to distort the shape when you make cuts and incisions. • Firmly pack the sushi rice between the* kanpyo *pieces so there are no gaps when the finished roll is cut. • Both the kanji character and the completed roll will have an overall square shape.*

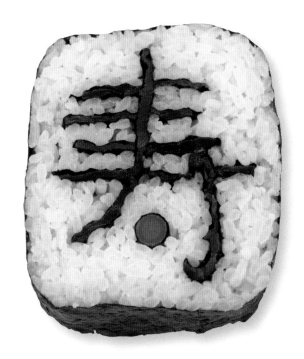

Nori Pieces

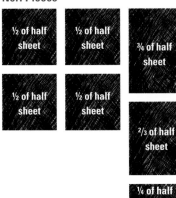

½ of half sheet | ½ of half sheet | ¾ of half sheet | Half sheet
½ of half sheet | ½ of half sheet | ⅔ of half sheet | ½ of half sheet
¼ of half sheet

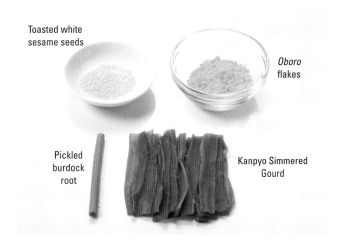

Toasted white sesame seeds

Oboro flakes

Pickled burdock root

Kanpyo Simmered Gourd

1 Combine ⅔ cup (130 g) of the sushi rice with the *oboro* flakes and gently mix to incorporate. Divide into a ½-cup (100-g) portion and a 3½-tablespoon portion. Divide the plain sushi rice into the following portions: a scant ½ cup (90 g); 5 teaspoons; 1 tablespoon x 2; 2 teaspoons; and 2⅔ tablespoons.

	Width of *kanpyo* strip	Size of nori sheet
❶	1¼ inches (3 cm)	½ half-sheet
❷	1¾ inches (4.5 cm)	½ half-sheet
❸	2⅜ inches (6 cm)	¾ half-sheet
❹	2 inches (5 cm)	⅔ half-sheet

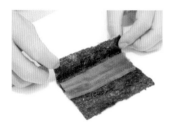

2 Create the components of the kanji character. Cut the *kanpyo* strips to the widths indicated below and wrap in the specified size of nori sheet.

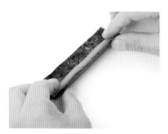

3 Wrap the pickled burdock root in the ¼ half-sheet of nori (this will be ❺ in the following instructions).

❺ [❶] ❶ ❷ ❸ ❹

❶
❷
❸
❹
❺

4 Begin assembling the kanji character. Spread the scant ½ cup (90 g) of sushi rice into an 8 x 4-inch (20 x 10.5-cm) rectangle on a cutting board. Cover with plastic wrap and cut crosswise into 5 pieces of equal width (each one should be ¾ inches / 2 cm wide).

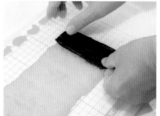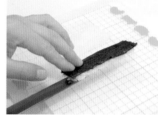

5 Remove the plastic wrap, and place the three 1¼-inch (3-cm) pieces of nori-wrapped *kanpyo* (❶) and the 1¾-inch (4.5-cm) piece (❷) on four of the sliced rice sections. Press the nori-wrapped pieces firmly onto the rice so that they adhere. With the nori side on the bottom, stack the 4 pieces on top of each other, starting with ❷.

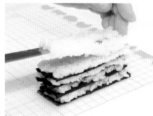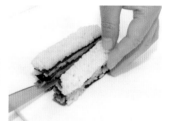

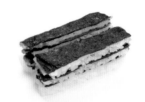

6 Place the remaining rectangle of rice on top of the stacked layers from step 5. Press down, and let the shape settle. Dip a very sharp knife in vinegar water and slice the stack in half lengthwise. Turn the stacks over so the nori is on the top.

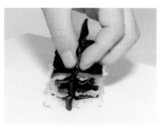

7 Sandwich ❸ between the stacks. Fill the space on the right side of ❸ with 5 teaspoons of sushi rice. Lean the nori-wrapped *kanpyo* at an angle to the right.

8 Evenly spread 1 tablespoon of the plain sushi rice on **4**, leaving ¼ inch (6 mm) of space at the top and bottom edges. Curl up the front edge of the nori and flip the entire piece over. Then spread another tablespoon of sushi rice on the other side in the same way.

9 Make a lengthwise cut up to the second layer of nori on the left side of the construction from step 7. Insert the piece from step 8 in the incision. The top edge of the nori should curl to the right.

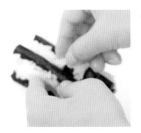

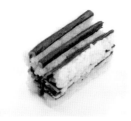

10 Firmly pack 2 teaspoons of sushi rice in the gap between **3** and **4**. Place the nori-wrapped pickled burdock root (**5**) on top of this rice.

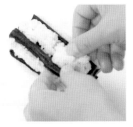

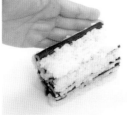

11 Cover the top with the final 2⅔ tablespoons of sushi rice. Mold the assembled pieces into a square shape.

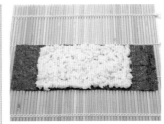

12 Assemble the entire roll. Lay the extended nori sheet on the sushi mat with the short edges parallel to the slats. Spread the ½-cup (100-g) portion of pink *oboro* rice over the nori, leaving a 1½-inch (4-cm) space on either side. Sprinkle the toasted white sesame seeds over the rice and place the kanji character in the middle.

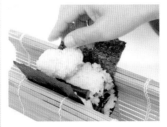

13 Lift the sushi mat and tighten from both the left and right sides. Spread the remaining 3½ tablespoons of *oboro* rice on top, creating a level surface. Seal the nori.

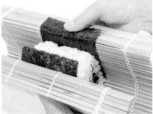

14 Remove the sushi mat and place the roll on a cutting board. Cover the roll with the sushi mat and shape into a square by pressing from above. Remove the sushi mat. Use a very sharp knife dipped in vinegar water to cut off a thin slice in order to make sure you are cutting from the correct side of the roll to display the kanji correctly. If correct, slice the rest of the roll into 4 pieces, wiping the knife clean after each cut.

Rolls with 福, the Kanji Character for "Good Fortune" Fuku

As when making the rolls featuring 祝 (page 72), you will first create the left-hand element 礻 on the left side, then add the remainder of the design on the right side. This recipe uses Japanese Omelette and pink *oboro* rice in the right-hand side of the kanji character, but you should feel free to use *kamaboko* fish cake or other ingredients instead.

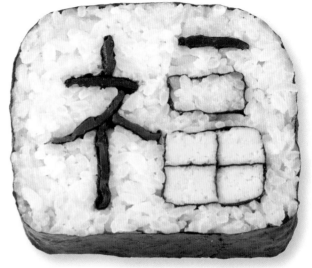

MAKES 4 "GOOD FORTUNE" KANJI PIECES

Scant 1½ cups (290 g) prepared sushi rice, divided
Nori: 1 x 4-in (2.5 x 10.5-cm) strip + 1¼ x 4-in (3 x 10.5-cm) strip + ¾ x-4-in (2 x 10.5-cm) strip + five ⅓ half-sheets + ¼ half-sheet + 1½ half-sheets, "glued" together with a bit of rice to form an extended sheet
1 tablespoon pink *oboro* fish flakes
½ teaspoon toasted sesame seeds
¾ x 1 x 4-in (2 x 2.5 x 10.5 cm) bar Japanese Omelette (see page 10)
Six 4-in (10.5-cm) long strips of Kanpyo Simmered Gourd (see page 10), cut to the widths indicated in the table (opposite)

TIPS *Be sure the two components of the kanji character are equal in height, and don't leave too much space between them • The components on the right-hand side of the character should line up on top of each other. • As in all kanji rolls, wrap the final layer of nori carefully to avoid distorting the shape of the character inside.*

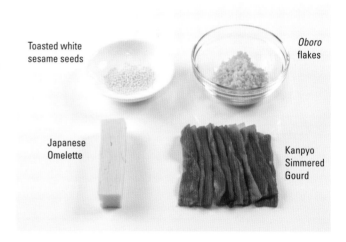

Toasted white sesame seeds

Oboro flakes

Japanese Omelette

Kanpyo Simmered Gourd

Nori Pieces

1 in (2.5 cm)	⅓ of half sheet	⅓ of half sheet
¾ in (2 cm)		
1¼ in (3 cm)	⅓ of half sheet	⅓ of half sheet
⅓ of half sheet	¼ of half sheet	

Half sheet

‡

½ of half sheet

1 Combine ⅘ cup (160 g) of the sushi rice with the *oboro* flakes and white sesame seeds and gently mix to incorporate. Divide into the following portions: 5 teaspoons; ½ cup (100 g); and 3½ tablespoons. Divide the remaining ⅔ cup (130 g) of sushi rice into the following portions: 2⅔ tablespoons; 5 teaspoons; 2 teaspoons; 3½ tablespoons; 1 tablespoon; and 2 teaspoons.

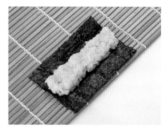

2 Spread the 5-teaspoon portion of pink *oboro* rice into a 1-inch (2.5-cm) wide rectangle on a ⅓ half-sheet of nori. Roll into a rectangular shape (this will be **7** in the instructions on page 79).

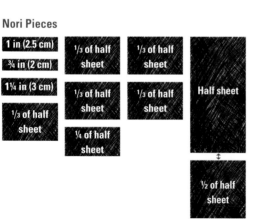

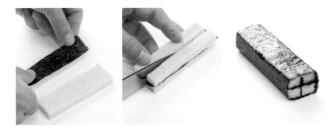

3 Slice the omelette in half lengthwise along the wider side. Sandwich the 1-inch (2.5-cm) strip of nori between the two halves. Then cut the omelette in half lengthwise along the other side, and sandwich the ¾-inch (2-cm) piece of nori between those halves to make a cross shape inside the omelette. Wrap the assembled omelette in a ⅓ half-sheet of nori.

4 Cut the *kanpyo* strips to the widths specified in the table below, and wrap in nori sheets as indicated.

	Width of *kanpyo* strip	Size of nori sheet
❶	⅜ inch (1 cm)	1¼ inches (3 cm)
❷	¾ inch (2 cm)	⅓ half-sheet
❸	1 inch (2.5 cm)	⅓ half-sheet
❹	⅝ inch (1.5 cm)	¼ half-sheet
❺	¾ inch (2 cm)	⅓ half-sheet
❻	¾ inch (2 cm)	⅓ half-sheet

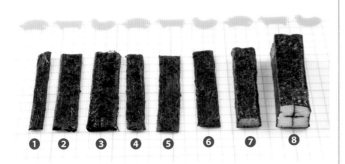

5 Follow steps 4–8 on pages 73–74 for creating the left-hand element (ネ) for 祝.

6 Spread 1 tablespoon of sushi rice on ❻. Place this, with the nori side facing down, on the left side of the assembled pieces from step 5. Place the wrapped rectangle of *oboro* rice (❼) on top of it.

7 Spread 2 teaspoons of sushi rice on top of the wrapped *oboro* rectangle (❼), and add the Japanese Omelette (❽) on the very top. Be sure that ❻, ❼ and ❽ are aligned vertically.

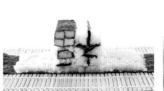 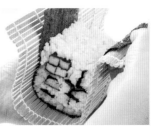

8 Assemble the entire roll. Lay the extended nori sheet on the sushi mat with the short edges parallel to the slats. Spread the ½-cup (100-g) portion of pink *oboro* over the nori, leaving a 1½-inch (4-cm) space on either side. Place the kanji character in the middle.

9 Lift the sushi mat and tighten from both the left and right sides. Spread the remaining 3½ table-spoons of *oboro* rice on top, creating a level surface. Seal the nori.

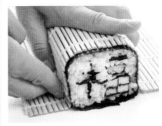

10 Remove the sushi mat and place the roll on a cutting board. Cover the roll with the sushi mat and shape into a square by pressing from above. Remove the sushi mat. Use a very sharp knife dipped in vinegar water to cut off a thin slice in order to make sure you are cutting from the correct side of the roll to display the kanji correctly. If correct, slice the rest of the roll into 4 pieces, wiping the knife clean after each cut.

Novelty Rolls

The silhouettes of these creative Kazari Rolls are inspired by the objects they represent. For example, the Sparrow Rolls are shaped like a bird. Adjust the pressure as you assemble the entire roll in the sushi mat, and view the shape from the side to ensure uniformity across the roll. Be extra careful when slicing the roll to avoid distorting the meticulously crafted shapes. There's a multitude of ideas to experiment with, and once you've mastered the basics you can try coming up with your own original designs.

Sparrow Rolls

This charming roll looks like the side view of a perched bird. The colors may be subdued, but the overall effect is cheerful. Using *kamaboko* fish cake in the belly curve makes the colors pop; furthermore, its sturdiness provides stability when assembling the entire roll.

MAKES 4 SPARROW PIECES

½ cup (100 g) prepared sushi rice

Nori: ⅓ half-sheet + ½ half-sheet + ¼ half-sheet + 1⅓ half-sheets, "glued" together with a bit of rice to create an extended sheet + 4 small circles for eyes

2 teaspoons *ami no tsukudani* soy-simmered shrimp (or other *tsukudani*; see page 10)

4-in (10.5-cm) length Japanese or English cucumber, cut in half lengthwise

4-in (10.5-cm) length *takuan* pickled daikon, shaped into a triangular rod about ⅜ in (1 cm) on each side

4 pinches ground black sesame seeds

TIPS *Use a smooth slicing motion to cut the* kamaboko *for the curved lower part of the torso. • The outer nori will have a tendency to peel away from the beak and tail, so firmly press or fold it against the surface underneath. • When cutting the completed roll, rotate it to find the most stable position.*

Nori Pieces

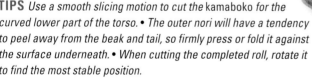

⅓ of half sheet

½ of half sheet

¼ of half sheet

Half sheet

⅓ of half sheet

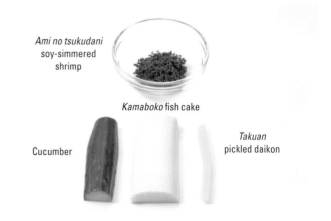

Ami no tsukudani soy-simmered shrimp

Kamaboko fish cake

Cucumber

Takuan pickled daikon

1 Combine the *tsukudani* with the sushi rice and gently mix to incorporate.

2 Trim ⅝ inch (1.5 cm) from the bottom of the *kamaboko*. Place the *kamaboko* with the rounded side down and set a very sharp knife about two-thirds of the way from the left edge. Carve out a curved piece toward the edge. Set the knife in the same spot and cut another curve in the opposite direction, making a peak in the center of the *kamaboko*.

3 Cover the carved section with the ⅓ half-sheet of nori. Press the nori onto the surface, then flip over and trim the excess from the side.

 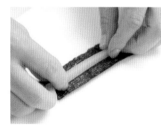

4 Make the tail and beak. Lay the cucumber face-down and insert the knife as if to slice it in half lengthwise across the flat side, but angle the knife downward toward the far edge to create a long wedge. Wrap in the ½ half-sheet of nori to make the tail. Wrap the *takuan* pickled daikon in the ¼ half-sheet of nori to make the beak.

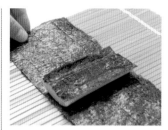 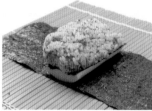

5 Assemble the roll. Lay the extended sheet of nori on the sushi mat with the short edges parallel to the slats. Place the *kamaboko* in the center with the convex side down. Shape the *tsukudani* rice into a pear-shaped length and set it on the *kamaboko* so that the left side is higher than the right. Press and shape the rice to conform to the *kamaboko*.

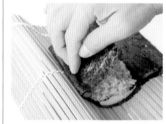 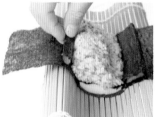

6 Lift the sushi mat and place the tail on the right side and the beak on the left.

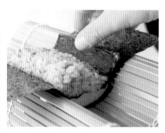 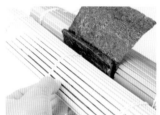

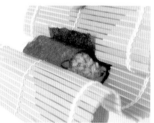 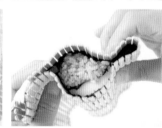

7 Fold over the nori on the left side, securely enclosing the beak. Continue pressing the nori onto the *tsukudani* rice. Fold over the right side of the nori and seal closed. While viewing from the side of the sushi mat, shape the roll into a bird silhouette. Take extra care to press the nori on the beak and tail firmly.

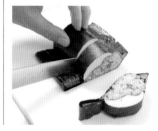

8 Remove the sushi mat and use a very sharp knife dipped in vinegar water to slice evenly into 4 pieces, wiping the blade clean after each cut. Decorate with eyes cut out from nori and sprinkle ground sesame seeds under the eyes to complete.

Guitar Rolls

Since the guitar is made up of two symmetrical halves, only half the guitar will be created in the roll. Once it is sliced, a complete guitar will be made from two slices. This means that this roll creates only two completed pieces instead of the usual four. The neck, strings and the tuning pegs are added as decoration at the end.

MAKES 2 GUITAR PIECES

½ cup (100 g) prepared sushi rice
Nori: ¼ half-sheet + 1 half-sheet + 6 very thin strips for strings + 2 short, thin strips for the base of the headstock
1 tablespoon *tori soboro* Simmered Ground Chicken (see page 10)
Two 1¼ x 1 x 2½-in (3 x 2.5 x 6.5-cm) pieces Japanese Omelette (see page 10)
4-in (10.5-cm) cylinder cheese *kamaboko*
2 small rectangular slivers Japanese or English cucumber peel for the bridge
8 tiny slices pickled burdock root for tuning pegs

TIPS *When using the sushi mat to adjust the half-guitar shape, make sure that the left and right edges (the top and bottom of the guitar body) are perpendicular to the surface. This will make it easier to match the two halves when putting them together. • Try not to move the blade back and forth too much as you slice the roll; use a smooth pushing movement instead. • If you try to withdraw the knife the slice will stick to the blade, so keep the sliced piece on the blade as you open up the roll and attach the left and right sides of the guitar to each other.*

Nori Pieces

¼ of half sheet

Half sheet

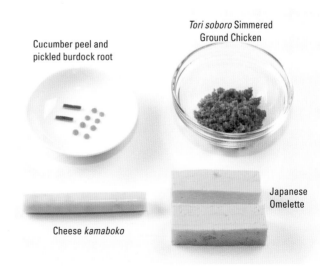

Cucumber peel and pickled burdock root

Tori soboro Simmered Ground Chicken

Cheese *kamaboko*

Japanese Omelette

1 Combine the sushi rice and the *tori soboro* Simmered Ground Chicken and gently mix to incorporate. Divide into portions of ⅓ cup (65 g), 3½ tablespoons, and 2 teaspoons.

2 Make the guitar "headstock" and neck from the Japanese Omelette. Cut a ⅛-inch (3-mm) slice three-quarters of the way up each side of the omelette, leaving about ⅝ inch (1.5 cm) from the top to form the head-stock. Trim each side of the headstock at a slight angle. Repeat with the second piece of omelette.

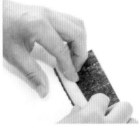

3 Cut the cheese *kamaboko* in half lengthwise. Wrap one half in the ¼ half-sheet of nori, setting the other half aside for another use.

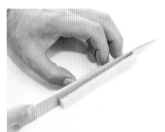

4 Assemble the body. Lay the half-sheet of nori on the sushi mat with the short edges parallel to the slats. Place the nori-wrapped cheese *kamaboko* half in the center.

 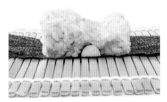

5 Shape the ⅓-cup (60-g) portion of *soboro* rice into a half-cylinder and place it on the left side of the cheese *kamaboko*. Shape the 3½-tablespoon portion and place it on the right side. Arrange the 2 teaspoons of *soboro* rice between the two piles of rice and gently press the rice into the shape of a half guitar.

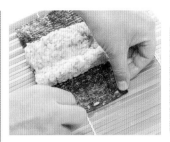 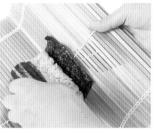

6 Mash a few grains of rice across the right edge of the nori to serve as glue when the roll is wrapped. Lift up the left edge of the sushi mat and wrap it around the sushi rice, enclosing it in nori. Repeat with the right edge of the mat. Press from above to seal the overlapping nori edges.

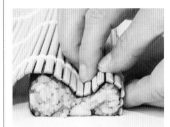

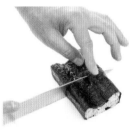

7 Remove the sushi mat and place the roll on a cutting board. Cover the top of the roll with the sushi mat and adjust the shape by pressing from above. Try to make the sides straight and perpendicular to the surface of the board.

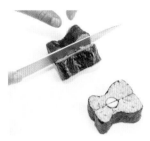

8 Remove the sushi mat and use a very sharp knife dipped in vinegar water to slice the roll in half with a single smooth motion. Wipe the blade clean and slice the halves in half again, but be careful not to slice through the bottom layer of nori this time. Tilt the blade sideways to gently open up the roll to form a complete guitar body, then carefully remove the blade. Wipe the knife clean and repeat with the second half-roll.

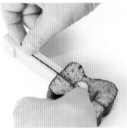 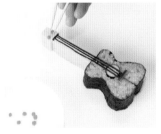

9 Attach the neck and headstock from step 2 to each guitar body, then decorate with the thin strips of nori for strings, cucumber peel for a bridge, and pickled burdock for the tuning pegs.

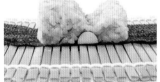

These Kazari Rolls are composed of sushi rice in various hues, just like a painting. It's important to be as precise as possible with the measurements and portions specified due to the number of elements in these rolls. Take extra care to spread the rice evenly and eliminate space between the elements. Prepare all the components, including the designated portions of sushi rice, before assembling. For possible ingredient substitutions, see page 11.

Mount Fuji Rolls

The majestic landscape of snow-capped Mount Fuji imparts an air of celebration. To create the gradations of the sky and mountain base, get creative with the sushi rice colors. The snow cap on the peak is a piece of *kamaboko* fish cake.

MAKES 4 MOUNT FUJI PIECES

1¼ cups (250 g) prepared sushi rice, divided

Nori: ¼ half-sheet + ½ half-sheet + ¾ half-sheet + 1½ half-sheets, "glued" together with a bit of rice to create an extended half-sheet

2 teaspoons *mentaiko* spiced pollock roe, plus a small amount for sprinkling

1 tablespoon green *tobiko* flying-fish roe

1 teaspoon *aonori* laver flakes

2 teaspoons minced *nozawana* pickled mustard greens, squeezed dry

1 teaspoon pink *oboro* fish flakes

2 teaspoons orange *tobiko* flying-fish roe

4-in (10.5-cm) length pink fish sausage

4-in (10.5-cm) length *kamaboko* fish cake

TIPS *Spread the two green-tinted portions of sushi rice outward from the* kamaboko *peak to create the appearance of a gentle slope.* • *Keep the mountain in the center as you add the sushi rice to each side and shape the roll.* • *When wrapping the final roll, squeeze the mat tightly to ensure seamless blending of all the elements.* • *The overall shape of the completed roll will be a half-cylinder.*

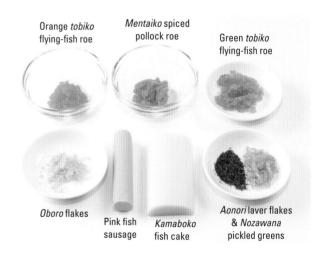

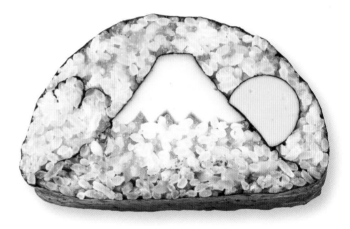

Orange *tobiko* flying-fish roe

Mentaiko spiced pollock roe

Green *tobiko* flying-fish roe

Oboro flakes

Pink fish sausage

Kamaboko fish cake

Aonori laver flakes & *Nozawana* pickled greens

Nori Pieces

½ of half sheet

¾ of half sheet

¼ of half sheet

Half sheet

½ of half sheet

1 Combine ⅓ cup (65 g) of the sushi rice with the *mentaiko* spiced pollock roe. Gently mix to incorporate, then divide into the following portions: 2 teaspoons; 5 teaspoons ; 3½ tablespoons. In a separate bowl, combine 3½ tablespoons of the sushi rice with the *oboro* flakes. Gently mix to incorporate, and divide into two 5-teaspoon portions.

2 Combine ¼ cup (50 g) of the sushi rice with the green *tobiko* flying-fish roe and mix gently to incorporate. In a separate bowl, combine ¼ cup (50 g) of the sushi rice with the *aonori* laver flakes and the minced pickled greens, and mix gently to incorporate. In yet another bowl, combine 3½ tablespoons of the sushi rice with the orange *tobiko* flying-fish roe and gently mix to incorporate.

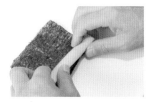

3 Make the sun. Cut about a third from the side of the fish sausage, then wrap in the ½ half-sheet of nori.

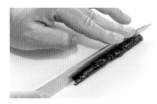

4 Make the flying bird. Spread 2 teaspoons of the *mentaiko* rice lengthwise on the ¼ half-sheet of nori and make a very thin round roll. Without cutting through the bottom nori layer, make a lengthwise incision down the center of the roll and open it up.

5 Make the mountain peak. Cut off each side of the *kamaboko* fish cake at an angle to form a mountain-shaped bar that is ⅝ inch (1.5 cm) wide at the top and 1½ inches (4 cm) wide at the base. Tilt the *kamaboko* to one side and cut 3 or 4 grooves into the base to form a jagged edge.

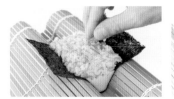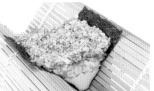

6 Place the ¾ half-sheet of nori on the sushi mat with the short edges parallel to the slats. Place the mountain peak from step 5 in the center, then lift the sushi mat and press the nori against either side of the peak. Cover the jagged edge of the *kamaboko* with green *tobiko* rice. Add the *aonori* rice on top of the *tobiko* rice. Slope the rice outward to form an upside-down mountain shape.

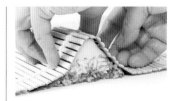

7 Set the mountain rice-side-down on a cutting board, being sure not to let the nori fold underneath. Cover the mountain with the sushi mat and adjust the shape by pressing from above. Trim off excess nori from the sides.

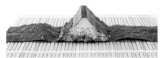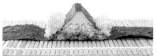

8 Assemble the entire roll. Lay the extended nori sheet on the sushi mat with the short edges parallel to the slats. Place the mountain in the center.

9 Form the 5-teaspoon portion of *mentaiko* rice into a cylinder and place it on the right side of the mountain. Shape the 3½-tablespoon portion of *mentaiko* rice into a long triangle and place it against the right side of the mountain at the bottom.

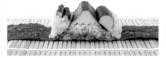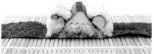

10 Place the fish-sausage "sun" from step 3 on the sushi rice on the right side of the mountain. Place the "bird" from step 4 rice-side-down on the rice on the left side.

11 Fill the space above the sun with 5 teaspoons of pink *oboro* rice. Do the same in the space above the bird.

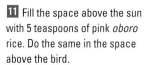

12 Cover the top of the mountain with orange *tobiko* rice and form the roll into a half-cylinder.

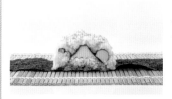

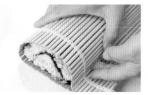

13 Lift up the sushi mat and tighten from both the left and right sides, sealing the nori. Remove the sushi mat and place the completed roll on a cutting board. Re-cover the roll with the sushi mat and adjust the shape by pressing from above. Remove the sushi mat, then use a very sharp knife dipped into vinegar water to slice the roll into 4 equal pieces, wiping the blade clean after each cut.

Seashore Rolls

The lighthouse by the shore, the setting sun, the flying seagulls—all enveloped in a brilliant sunset—make these landscape Kazari Rolls spectacular. The sunset hues are derived from various ingredients that are blended into sushi rice and layered to achieve a gradient effect.

MAKES 4 SEASHORE PIECES

1½ cups (300 g) prepared sushi rice, divided
Nori: two ⅝ x 4-in (1.5 x 10.5-cm) strips + three ½ half-sheets + four
 ⅓ half-sheets + 1⅔ half-sheets, "glued" together with a bit of
 rice to create an extended sheet + 1¼ x 4-in (3 x 10.5-cm) strip
1 tablespoon pink *oboro* fish flakes
1 teaspoon *aonori laver* flakes
¼ teaspoon mayonnaise
1 teaspoon *tobiko* flying-fish roe
3 teaspoons *tarako* pollock roe, divided
Two 4-in (10.5-cm) pieces *kamaboko* fish cake
4-in (10.5-cm) cylinder pink fish sausage
1½ teaspoons chopped Japanese Omelette (see page 10)

TIPS *Blend the coloring ingredients into the sushi rice a little at a time until it has the desired tint. • Cut the kamaboko and fish sausage cleanly, avoiding jagged edges. • Pack the rice between the pieces firmly, filling in the left and right sides evenly. • As a final step, wrap the sushi mat tightly to secure the contents. The final overall shape will be square.*

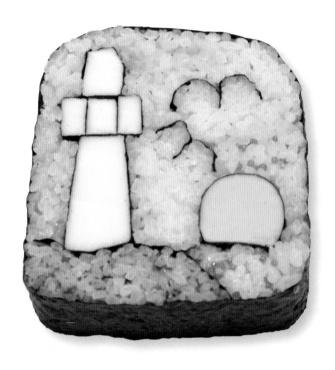

Nori Pieces

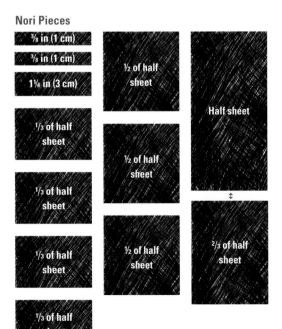

⅜ in (1 cm)

⅜ in (1 cm)

1¼ in (3 cm)

⅓ of half sheet

⅓ of half sheet

⅓ of half sheet

⅓ of half sheet

½ of half sheet

½ of half sheet

½ of half sheet

Half sheet

⅔ of half sheet

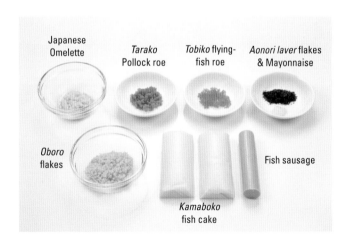

Japanese Omelette

Tarako Pollock roe

Tobiko flying-fish roe

Aonori laver flakes & Mayonnaise

Oboro flakes

Kamaboko fish cake

Fish sausage

1 Stir the mayonnaise into ⅓ cup (65 g) of the sushi rice. Sprinkle the *aonori* laver flakes over and gently stir to incorporate. In a separate bowl, combine the *oboro* flakes and 7 tablespoons of the sushi rice, mix to incorporate and divide into the following portions: 1 tablespoon x 2; 2⅔ tablespoons; 5 teaspoons x 2.

2 Combine the *tobiko* flying-fish roe with 4 tablespoons of the sushi rice, mix to incorporate, and divide into one 2⅔-tablespoon portion and one 5-teaspoon portion. In a separate bowl, combine 2 teaspoons of the *tarako* pollock roe with ⅔ cup (130 g) of the sushi rice. Gently mix to incorporate, then divide into the following portions: 2 teaspoons x 4; 5 teaspoons x 2; and 4⅓ tablespoons.

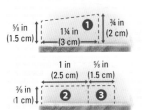 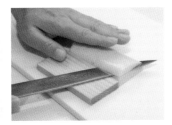

3 Make the lighthouse (refer to illustration for details). Cut one piece of *kamaboko* to a height of ¾ inch (2 cm) and a width of 1¼ inches (3 cm). Then cut diagonally from right to left so that the height of the left side is ⅝ inch (1.5 cm). Wrap in ½ half-sheet of nori. This is piece ❶.

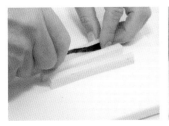 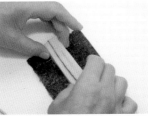

4 Cut the second piece of *kamaboko* to a height of ⅜ inch (1 cm), then cut lengthwise to make one bar 1 inch (2.5 cm) wide (this is piece ❷), and another bar ⅝ inch (1.5 cm) wide (this is piece ❸). Cut the 1-inch (2.5-cm) bar into thirds lengthwise, and sandwich the two ⅜-inch (1-cm) strips of nori between the pieces. Wrap in ½ half-sheet of nori.

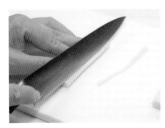

5 Round out the upper left and right corners of piece ❸, shaping it into a half-circle. Wrap in ⅓ half-sheet of nori.

All components of the Seashore Rolls.

 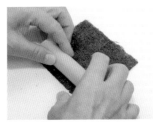

6 Make the sun. Cut off about ¼ of the fish sausage lengthwise. Wrap the larger piece in ½ half-sheet of nori.

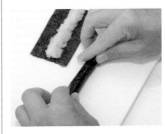

7 Make the seagulls. Spread 1 tablespoon of the *oboro* rice on ⅓ half-sheet of nori and make a round roll. Without cutting all the way through to the bottom nori layer, cut in half lengthwise and open up. Repeat with another tablespoon of *oboro* rice and another ⅓ half-sheet of nori.

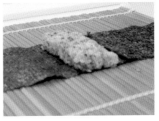 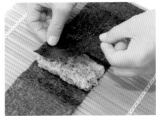

8 Begin assembling the entire roll. Lay the extended nori sheet on the sushi mat with the short edges parallel to the slats. Spread the green *aonori* rice in a 2-inch (5-cm) wide rectangle roughly in the center of the sheet. Make the right-hand side of the rice lower, creating a gentle slope. Cover the slope with ⅓ half-sheet of nori.

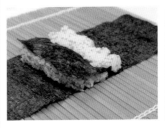 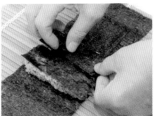

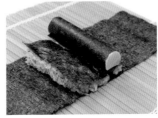

9 Arrange 2⅔ tablespoons of the *tobiko* rice along the right side of the slope. Cover with the 1¼-inch (3-cm) strip of nori. Place the nori-wrapped fish-sausage "sun" on top.

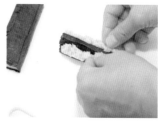
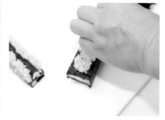

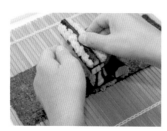

10 Construct the lighthouse. Place the rounded lighthouse piece (**❸**) on top of piece **❷**, in the center. Fill in each side of piece **❸** with 2 teaspoons of *tarako* rice. Spread 2 teaspoons of *tarako* rice along either side of piece **❶**.

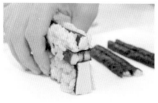

11 Place the lighthouse on the left side of the nori-covered green *aonori* slope from step 8.

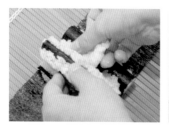 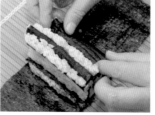

12 Fill the space between the lighthouse and the sun with 2⅔ tablespoons of *oboro* rice. Add one of the seagulls from step 5.

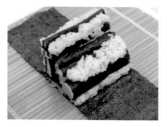 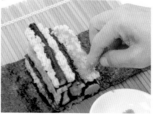

13 Place 5 teaspoons of *tobiko* rice on top of the sun. Sprinkle ½ teaspoon of *tarako* pollock roe on the rice.

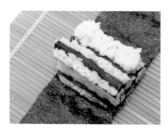 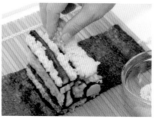

14 Layer 5 teaspoons of *oboro* rice on the sprinkled *tarako*, then add ½ teaspoon of the chopped Japanese Omelette.

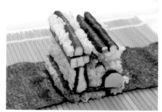 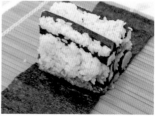
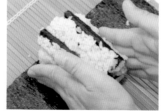 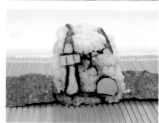

15 Place the other seagull on top, then cover with another 5 teaspoons of *oboro* rice. Add 5 teaspoons of *tarako* rice on each side, then press the left and right sides to secure.

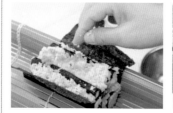 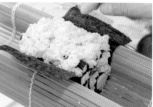

16 Lift the sushi mat and tighten from both the left and right sides. Add ½ teaspoon of chopped Japanese Omelette on each side and sprinkle the remaining ½ teaspoon of *tarako* pollock roe in the middle. Spread the remaining 4⅓ tablespoons of *tarako* rice evenly on top and flatten the surface.

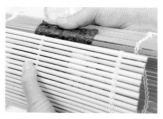 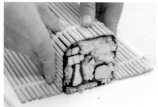

17 Seal the nori, form the roll into a square shape and wrap tightly. Remove the sushi mat and place the completed roll on a cutting board. Cover the roll with the sushi mat and adjust the shape by pressing from above. Remove the sushi mat, then use a very sharp knife dipped into vinegar water to slice the roll into 4 equal pieces, wiping the blade clean after each cut.

Creative Sashimi, Battleship Rolls and More

Layered sushi rolls have been around for a long time, but in recent years more modern and innovative presentations are gaining popularity, like the quintessential California Rolls. This section will introduce this new approach to sushi with a fresh twist which can be easily incorporated into restaurant menus as well.

Cutting Basics

Each sushi ingredient has a cutting technique best suited for its particular shape and texture. However, no matter the ingredient, each slice or cut must balance out the sushi rice in size and thickness. Uniformity of size is important as well; you also want to minimize waste. The following section provides practice steps for mastering fundamental and effective cutting techniques.

Tuna

Tuna blocks available in grocery stores tend to be slightly smaller than professional-grade sushi fish. Slice the tuna blocks at an angle to keep the sizes uniform. Alternatively, cut as though creating an intersecting crease with the grain of the fish.

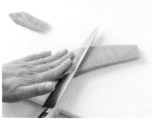

Place the tuna block at an angle. Holding the front of the tuna down with one hand, diagonally slice with the kitchen knife.

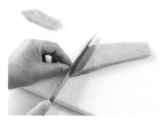

Pull the blade at an angle as you slice; as you near the end of the cut, straighten the knife and cut through.

White-Fleshed Fish

Many white-fleshed fish—flounder, for example—are very thin and are also quite tough to chew, so they are best served in thin slices.

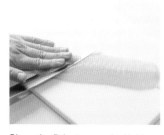

Place the fish at an angle. Hold down with one hand and set the knife at the starting point. Slice very thinly.

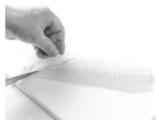

At the end of each cut, straighten the knife and slice through. Don't saw with the knife; rather, pull the blade in one smooth motion.

Squid

Because squid can be tough to chew, cut thin slices at an angle and score or crosshatch the flesh to make it easier to eat. As fresh squid is usually even tougher to chew, try cutting into matchstick slices.

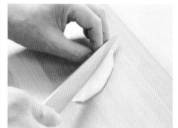

Place the skin side down and slice at an angle. Make extra cuts on the sides and / or top.

Gizzard Shad

The cutting method for gizzard shad will depend upon its size. The thickness and consistency of a single piece of this type of fish will vary greatly. Decorative cuts (see page 93) make it easier to eat.

Make deep cuts where the fish is thicker and shallow cuts where it is thinner.

A properly made piece of nigiri sushi will keep its shape securely when held with chopsticks, but will practically melt in the mouth. Practice forming nuggets of rice that are equal in size, shape and firmness. The specifics of the pressing techniques may differ among restaurants and sushi chefs, but following are some universal methods and key points.

Horizontal Flip Yokogaeshi

1 Before you make the rice ball, dampen your hands with a mixture of water and rice vinegar (20–30 percent vinegar). Place the vinegar water in a small bowl nearby.

2 Scoop out enough rice for one nigiri nugget (if you are right-handed, use your right hand; left for lefties) and lightly form into a ball.

6 Flip over the sushi horizontally so the topping is right side up.

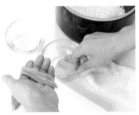

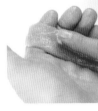

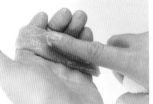

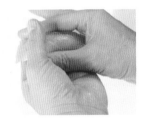

3 With your other hand, pick up the topping (usually fish). Add a smear of wasabi on the topping with the index finger of the hand holding the rice ball.

7 Use the thumb and index finger of the hand not holding the sushi to press the left and right sides. Then hold the top of the sushi with the index and middle finger pads and press with the bottom hand.

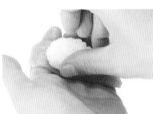

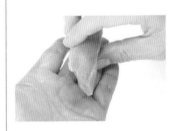

4 Place the rice ball on the topping, sandwiching the wasabi.

8 Rotate the sushi 180°.

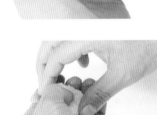

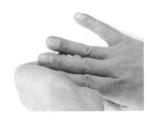

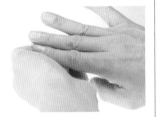

5 With the thumb of the hand on the bottom, press the center of the rice ball to form a small depression. With the opposite hand, press the top and bottom edges of the sushi ball and shape it into a nice oval. Wrap the bottom hand around the sushi while pressing the rice ball with the index and right finger pads of the opposite hand.

9 Repeat step 7.

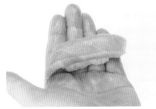

10 Complete.

Original Hand Flip Hontegaeshi

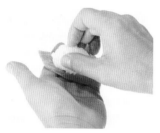 **1** Follow steps 1–4 of the Horizontal Flip (see page 91).

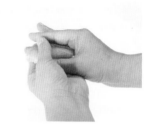

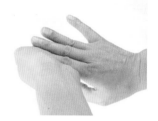

2 With the thumb of the hand on the bottom, press the center of the rice ball, forming a small depression. With the opposite hand, press the top and bottom edges of the sushi ball and shape it into a nice oval. Wrap the bottom hand around the sushi while pressing the rice ball with the index and right finger pads of the opposite hand.

6 With the thumb of the hand holding the sushi, press down on the topping, then use the thumb and index finger of the other hand to squeeze the left and right sides of the sushi to adjust the shape.

7 Rotate the sushi 180°.

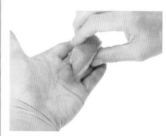

3 Use the hand holding the sushi to roll the sushi so the topping is right side up. Place the sushi on the index and middle fingers of the opposite hand.

8 Repeat step 6.

9 Complete.

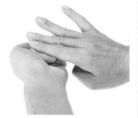

4 Transfer the sushi back to the original hand that held the sushi by first covering the sushi with the hand and then flipping it with the rice side facing up.

5 Press the index finger and middle finger of the other hand onto the sushi and gently roll it so the topping is facing up.

Key Points for Forming Nigiri Sushi

- Prepare the topping ingredients, sushi rice, wasabi, etc., in advance.
- Always keep the water and vinegar mixture, cloth and kitchen knives in the same place within easy reach.
- Maintain good posture and form the sushi rapidly with flowing movements.
- Lift up the toppings carefully and lightly and avoid prolonged contact.

Because nirigi sushi may come across as too visually simple, adding a little bit of sculpting and a few decorative elements enhances the overall aesthetic appeal. The following section presents some quick and easy techniques that don't require any special supplies. You will be able to practice various knife-work and distinctive combinations of ingredients, as well as techniques for shaping the rice nugget into different shapes, such as triangles, which expands the range of creative expression.

Decorative Knifework with Gizzard Shad Yokogaeshi

A traditional sushi variety that predates the Edo period, *kohada* gizzard shad is considered a test of a sushi chef's skill and mettle. Every sushi restaurant tends to have their own method of preparing and slicing it, and the mere angle in which the knife is inserted can make a difference in the enjoyment of the sushi. Here we will show you several classic styles of the *futatsukiri* knifework used to cut the filleted half of the fish when it is small enough to place on a single nugget of rice.

Cut the tail in two and remove the dorsal fin to prepare. Make a rather deep horizontal cut in the middle of the thickest part of the fillet. Finish by widening the cut.

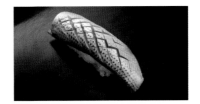

Create a crosshatch pattern on the entire piece. The distance between the lines should be equal, but keep in mind that the design will not be as attractive if the lines are too close together.

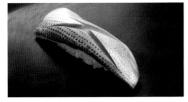

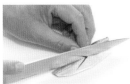

Insert the knife diagonally and make a fairly deep cut. Make another diagonal cut in the opposite direction to inter-sect the first one. Keep the lengths of the two cuts equal.

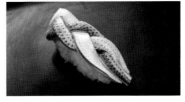

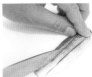 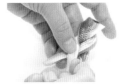

Leaving ³⁄₁₆ inch (5 mm) on the head side, slice the fillet into 3 equal sections and braid.

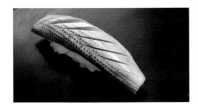

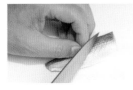

Make several diagonal parallel lines that are ⅛ inch or less (2–3 mm) apart. Make the cuts deeper in the thicker parts of the fillet, and shallower in the thinner parts.

Sculpting Squid

With its white simplicity, squid is a breeze to work with. This section covers a range of methods from quick and easy to elaborately crafted. Squid is one of the more popular types of nigiri sushi already; up the wow factor by adding some decorative knifework.

Sleeping Crane

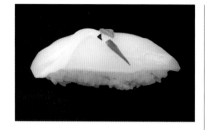

Swimming Squid

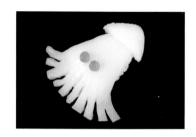

1 Cut the squid into a 1½ x 3⅛-inch (4 x 8-cm) rectangle. Trim the four corners.

2 Slice the longer side into a gentle arc.

3 On the opposite side of the arc, make a cut about ³⁄₁₆ inch (5 mm) from the edge; this will be the neck. Where the edge is wider, make several narrow cuts to represent the tail. These will make the nigiri easier to eat.

4 Form 1 tablespoon of sushi rice into a bullet or nugget shape and place the squid from step 3 on top. Cover with a clean lint-free cloth and press down from above so the squid conforms to the shape of the rice.

5 Curve the inner part of the neck across the body.

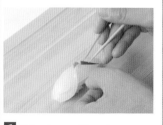

6 Cut out a crest from tuna, a beak from a piece of cucumber peel, and eyes from nori. Place them on the squid with tweezers or bamboo skewers.

1 Cut the squid into a 2 x 3⅛-inch (5 x 8-cm) rectangle and place horizontally. Slice off the left and right sides diagonally to form a triangle, reserving the slices.

2 Make the "legs" by cutting ¹⁄₁₆-inch (2-mm) long slits along the bottom edge.

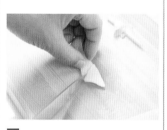

3 Cut out a small triangle for the fins on the top of the head. Cut a crosshatched design into the surface of the "fins."

4 Form 1 tablespoon of sushi rice into a long triangle.

5 Place the triangle of rice on top of the squid. Cover with a clean lint-free cloth and press from above so the squid conforms to the shape of the rice.

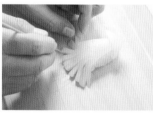

6 Place the fins on top of the head and separate the legs with a toothpick or bamboo skewer. Use two globes of *ikura* salmon roe for the eyes.

Cherry Blossom

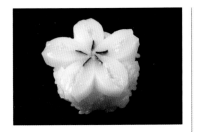

1 Cut the squid into a 2⅜ x 3⅛-inch (6 x 8-cm) rectangle. Make a shallow lengthwise incision down the middle (do not cut in half).

2 Flip the squid rectangle over and slice off about ³⁄₁₆ inch (5 mm) diagonally from the long sides so that the edges are angled.

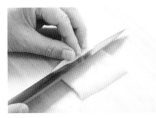

3 Spread 1 teaspoon of *oboro* flakes in the center of the squid. Flatten the flakes against the squid with the back of a spoon.

4 Cut thin strip of nori (about ³⁄₁₆ x 3⅛ inches / 5 mm x 8 cm) and place it along one edge of the squid.

5 Fold the squid rectangle in half lengthwise.

6 Form 1 tablespoon of sushi rice into a ball.

7 Slice the folded squid rectangle crosswise into 5 equal pieces to make the flower petals.

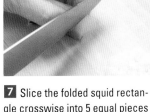

8 Arrange the petals on top of the ball of rice with the nori end in and the notched edge out.

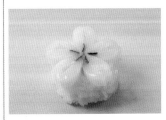

Rabbit

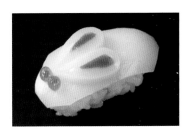

1 Cut a piece of squid into a 1¼ x 3⅛-inch (3 x 8-cm) rectangle. Slice the short sides at an angle so that they slant outward.

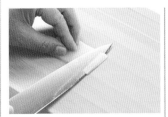

2 Carve a shallow trough about ¾ inch (2 cm) wide in the center of the rectangle.

3 Cut tuna into a thin wedge about ½ x 1¼ inches (1 x 3 cm). Place the tuna on the edge of the squid with the thicker end in the trough. Fold the squid over the tuna.

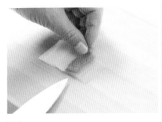

4 Slice into long raindrop-shaped slices for the rabbit ears.

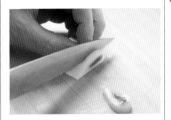

5 Cut another piece of squid into a 1½ x 3⅛-inch (4 x 8-cm) rectangle. Trim the corners to form an elliptical shape.

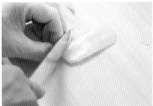

6 Make shallow crosshatched cuts across the whole top surface of the squid. Score the underside with a series of closely spaced horizontal cuts.

7 Form 1 tablespoon of sushi rice into a bullet or nugget shape and place the ellipse of squid on top.

Proud Peacock

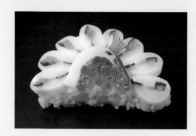

8 Cover with a clean lint-free cloth and press from above so the squid conforms to the shape of the rice.

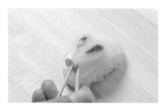

9 Decorate with two of the ear slices (step 4) and 2 globes of *ikura* cod roe for eyes.

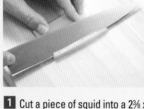

1 Cut a piece of squid into a 2⅜ x 3⅛-inch (6 x 8-cm) rectangle. Slice off the long edges at an angle.

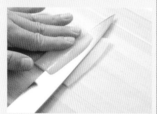

2 Make a narrow groove in the center of the squid.

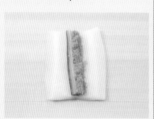

3 Break up a little *tarako* salted pollack roe and place it in the groove. Cut a 3⅛-inch (8-cm) piece of cucumber into a thin wedge and place it next to the *tarako*.

4 Cut a thin (³⁄₁₆ x 3⅛-inch / 5 mm x 8-cm) strip of nori and lay it along one edge of the squid rectangle.

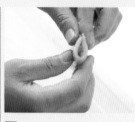

5 Fold the squid in half and slice evenly into 8 raindrop-shaped pieces to make the tail feathers.

6 Shape 3½ tablespoons of sushi rice into a semicircle.

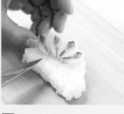

7 Arrange the tail feathers on top of the bed of rice.

8 Cover with a clean lint-free cloth and press from above so the squid conforms to the shape of the rice.

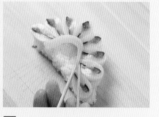

9 Cut another piece of squid into a 3⅛-inch (8-cm) long tapered strip. Arrange at the base of the tail feathers. Curve the pointed end to form the neck and head.

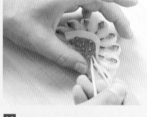

10 Fill the space in the front with a teaspoon of *ikura* salmon roe.

11 Cut a thick strip of cucumber peel into a small square. Make a series of fine cuts almost to its edge.

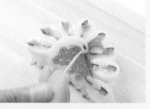

12 Spread the cuts from step 11 apart to form a crest. Cut a thin piece of cucumber peel for the beak. Cut small pieces of nori for the eye. Use tweezers or a skewer to place the items on the head.

Topping Variations

Get creative with your Kazari Sushi toppings by incorporating condiments and using small decorative rolls for embellishment. Experiment with the way colors and flavors work together, and you may come up with a new signature offering.

Scallops with Lemon

Wrap a nori sash around a scallop nigiri, then make a lengthwise incision in the scallop and insert a thin slice of lemon. The citrus tang of the lemon will enhance the scallop's flavor. The lemon slice may be removed before eating.

Tuna with Green Onion Shoots

Place green onion shoots and *benitade* red water-pepper sprouts on top of a tuna nigiri. The fragrant and peppery condiments lighten the rich taste of tuna. This is also delicious with marinated tuna.

Omelette with Ikura Salmon Roe

Prepare a thick slice of Japanese Omelette (see page 10) and make a lengthwise incision in the center. Stuff the opening with sushi rice and top with *oboro* and *ikura*. The simple addition of *ikura* adds abundant flavor and eye-catching appeal.

White-Fleshed Fish and Myoga Ginger Bud

This nigiri made with white-fleshed fish (flounder is shown here; sole or halibut is also suitable) is topped with a slivered *myoga* ginger bud and wrapped with a slim band of green shiso. The flavors complement each other and the condiments punch up the presentation. A splash of ponzu citrus sauce brightens the taste, making it perfect as a summer dish. A dab of grated fresh ginger root may be used in place of the *myoga*.

Sweet Shrimp and Uni Sea Urchin Roe

The combination of *amaebi* sweet shrimp with *uni* strengthens both flavors in this luxurious nigiri. Instead of letting the shrimp's tail hang down, curve it into a decorative shape.

Squid and Salmon

A thin slice of salmon is transformed into a miniature rose—complete with *kinome* prickly ash leaves (substitute a small fresh basil leaf if necessary)—that rests atop a squid nigiri. This delicate sculpture is sure to please everyone. Since you need only a small amount of salmon, it is also a very cost-effective design.

Using Nori and Green Shiso

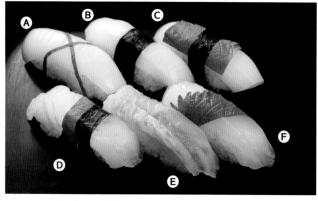

White-fleshed fish and squid provide an ideal blank canvas for Kazari Sushi. Merely wrapping or sandwiching pieces of nori or green shiso in the nigiri turns them into striking showpieces.

A	Cross two thin strips of green shiso to form an "x" on a squid nigiri
B	Wrap a ⅜-inch (1-cm) wide strip of nori around a squid nigiri.
C	Cut a piece of green shiso to match the width of a squid nigiri and place on top. Wrap a "sash" of nori around the whole thing.
D	Wrap ⅜-inch (1-cm) wide pieces of green shiso and nori around a nigiri made with white-fleshed fish.
E	Sandwich a piece of green shiso between the white-fleshed fish and the sushi rice beneath it.
F	Wrap a ¾-inch (2-cm) wide piece of green shiso diagonally on top of a nigiri made with white-fleshed fish.

B Wrap a ⅜-inch (1-cm) wide nori strip around a piece of squid nigiri. Press afterwards to adjust the shape.

E Place a strip of green shiso cut to matching size on top of a slice of white-fleshed fish. Then add the sushi rice and form into a nigiri.

Roses

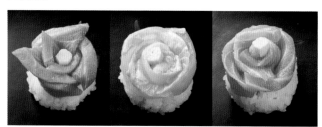

Form the sushi into a ball. Top with a rose made from tuna, salmon or white-fleshed fish. Slice each portion of fish into four thin pieces and line them all up into one long strip. Roll up the strip to create the flower shape. Lay a piece of green shiso on the rice, then add the rose. Finish with a ⅜-inch (1-cm) square of Japanese Omelette for the flower center.

Shape the sushi rice into a ball, then press down from the top and bottom to flatten it. Make a slightly deeper indentation in the center of the rice ball; this will help stabilize the flower.

Slightly overlap the sliced pieces into a long strip and start rolling from the edge. Keep one edge loose and the other edge tight as you roll to create an open blossom. It's easier to roll if you keep the tightly wound edge on the bottom.

Carnations

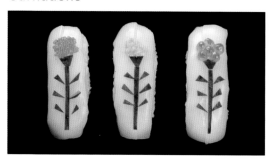

The bits of cucumber peel that form the stems and leaves are produced using a technique called *katsuramuki*, in which a paper-thin layer is cut from a cylindrical vegetable such as daikon or cucumber. If you are unfamiliar with this technique, use a peeler. *Tobiko* flying-fish roe, *oboro* flakes and *ikura* salmon roe become cheery carnations, each one topping a squid nigiri. This would be a delightful Mother's Day presentation.

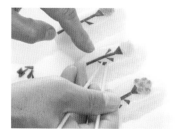

Bamboo skewers are helpful when decorating with small pieces.

Battleship rolls typically contain *ikura* salmon roe, *uni* sea urchin roe, or *kobashira* surf clam. However, you can expand your options by switching out the filling, using alternate wrappings in place of nori or by forming the sushi rice into a different shape. Regardless of shape or ingredient, use a firm touch when shaping the sushi rice base, since a stable foundation is essential.

Battleship Roll Basics

It's important to form the sushi rice into a smooth shape because the nori wrapping will show any protrusions or uneven sections. The sushi rice also needs to provide a sturdy foundation for the topping ingredients. The nori wrap will rise about 3/16 inch (5 mm) above the top of the sushi rice to contain the topping.

Ikura Salmon Roe Battleship Roll

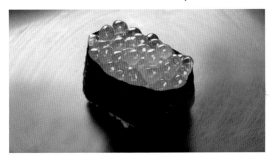

1 Form about a tablespoon of sushi rice into a bullet or nugget shape.

3 Use a few grains of rice to secure the end of the nori.

2 Wrap a strip of nori about 1¼ inches (3 cm) wide around the outside of the rice like a wall.

4 Spoon in the salmon roe.

Battleship Roll Variations

Create fresh looks by changing the shape of the sushi-rice base. It's not hard to form even complicated numbers and letters out of sushi rice. For different wrapping options, try Japanese Crêpe (page 33) or thin strips of cucumber or other vegetables (a peeler or mandoline will be very helpful for this)—great options for folks who may not enjoy nori.

Round Battleship Roll

1 Form a tablespoon of sushi rice into a flattened circle about 1½ inches (4 cm) in diameter.

2 Wrap a 1¼-inch (3-cm) wide strip of nori around the outside of the rice like a wall. Secure the ends of the nori with a few grains of rice. Fill with *ikura* salmon roe.

Battleship Roll Wrapped in Japanese Crêpe

1 Form 1 tablespoon sushi rice into a standard nigiri bullet. Wrap a 1¼-inch (3-cm) wide piece of Japanese Crêpe (page 33) around the rice.

2 Tie a stem of blanched *mitsuba* trefoil or parsley around the crêpe and fill the cavity with *tobiko* flying-fish roe.

Battleship Numbers

 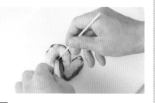

1 Combine about ⅓ cup (65 g) prepared sushi rice with 2 tablespoons of *oboro* flakes. Form the rice into numbers about ⅝ inch (1.5 cm) high.

3 Wrap the nori strips around the sushi rice numbers. Use a bamboo skewer or similar tool for detail work and to press the nori in tight corners. Secure nori ends with a few rice grains.

 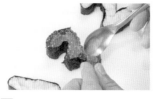

2 Cut several ¾-inch (2-cm) wide strips of nori (if you will not add fillings, cut the nori to ⅝ inch / 1.5 cm width). Use a few grains of rice to "glue" the nori pieces together to extend them as needed.

4 Depending on your color preference, fill with *ikura* salmon roe, *tobiko* flying-fish roe or other ingredients.

Daikon Battleship Roll

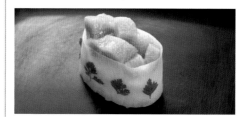

 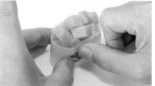

1 Cut a daikon radish lengthwise and peel or thinly slice a strip from the flat inner surface. Soak in salted water for about 20 minutes, then marinate in seasoned vinegar (see page 9). Meanwhile, form 1 tablespoon of sushi rice into a bullet or nugget shape for nigiri. Pat the daikon dry and wrap it around the outside of the rice.

2 Fill with chopped tuna. Apply chervil leaves onto the daikon wrap for decoration.

Cucumber Battleship Roll

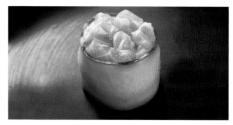

 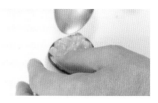

1 Cut a Japanese or English cucumber in half lengthwise and peel or thinly slice a strip from the inner surface. Soak the strip in salted water for about 10 minutes. Meanwhile, form 1 tablespoon of sushi rice into a flattened circle. Pat the cucumber dry and wrap it around the outside of the rice.

2 Fill the space with chopped salmon.

Spherical Sushi (Temari-zushi)

The distinctive feature of these delightful rolls is their ball-like shape. Wrap the thinly sliced ingredients uniformly around the sushi rice. In cases where the ingredient is naturally bumpy or uneven, shave or cut off the bumpy parts on the underside to even out the thickness. It will be easier to blend the elements if you trim the four corners of each layering piece.

Spherical Sushi Basics

Spherical sushi is a staple of the Kazari Sushi repertoire. It's a relatively easy style of sushi to make, because the sushi is formed by wrapping plastic wrap around it or covering it with a cloth and pressing it into a ball. Meld the sushi rice with the topping when shaping the assembled ingredients. If multiple spheres will be presented at the same time, try to make them equal in size.

Shrimp Spherical Sushi

1 Slice open the belly of a cooked shrimp and spread it out to butterfly. Cut in half crosswise and slice into a 1½-inch (4-cm) square. Shave the underside of the thicker parts to make the piece uniform in thickness. Trim off the corners.

3 Place the shrimp with the red side facing down on a square of plastic wrap. Place the rice ball on top.

2 Form a generous tablespoon of sushi rice into a ball.

4 Wrap the plastic around the assembled pieces and press tightly to form into a sphere.

Spherical Sushi Variations

Try combining unexpected ingredients, adding color with *oboro* flakes and / or other materials. The variations are limited only by your imagination. Making a flower from multiple spheres is another option for a simple yet vibrant and fun arrangement.

Gizzard Shad and Mentaiko Spiced Pollock Roe Spherical Sushi

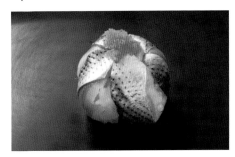

Slice a fillet of gizzard shad diagonally into thin strips and arrange in a radial pattern on the plastic wrap with skin side down. Form a generous tablespoon of sushi rice into a ball and place it on top of the fish. Wrap the plastic around the sushi and press to form into a sphere, then unwrap. Break up a small amount of *mentaiko* and arrange it in a mound on top.

Shrimp and Eel Spherical Sushi

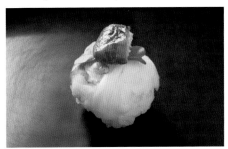

Make the basic shrimp sphere as described at left. Add a few *kaiware* daikon sprouts and place a small square piece of eel on top. Drizzle a little of any complementary condiment, such as eel sauce or plum sauce, to pump up the flavor and enhance the color.

Squid and Sea Urchin Spherical Sushi

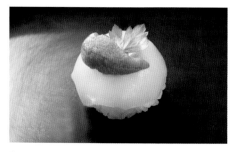

Cut a piece of squid into a thin 1½-inch (4-cm) square and trim the corners. Lay face-down on a piece of plastic. Form a generous tablespoon of sushi rice into a ball and place it on top of the shrimp. Wrap with the plastic and press to make a sphere, then unwrap. Place a small piece of sea urchin on top and tuck a leaf of Italian parsley into the side.

White Fish and Tobiko Spherical Sushi

Cut a piece of white-fleshed fish such as flounder or halibut into a very thin 1½-inch (4-cm) square and trim the corners. Slice the fish as thinly as possible to achieve the translucent effect for the colored rice to show through. Lay face-down on a piece of plastic. Form a generous tablespoon of sushi rice blended with red *tobiko* into a ball and place it on top of the fish. Wrap in plastic and press to make a sphere, then unwrap. Decorate with a mound of green *tobiko*.

Egg Flower Spherical Sushi

Cut a piece of Japanese Crêpe (page 33) into a 1½-inch (4-cm) square and trim the corners. Lay face-down on a piece of plastic. Form a generous tablespoon of *oboro* rice into a ball and place it on top of the omelette. Wrap in the plastic and press to make a sphere, then unwrap. Position the closed end of the crêpe on the bottom and wrap a ⅜-inch (1-cm) wide strip of nori around the bottom of the sphere. Make a cross-shaped cut in the top. Gently open up the cut section and fill with *ikura* salmon roe.

Tuna and Scallop Spherical Sushi

Cut a piece of tuna into a 1½-inch (4-cm) square of even thickness and trim the corners. Lay face-down on a piece of plastic. Form a generous table-spoon of green *tobiko*-blended sushi rice into a ball and place it on top of the tuna. Wrap in the plastic and press to make a sphere, then unwrap. Top with a piece of scallop cut into a small square and a few leaves of *benitade* or radish sprouts. The colorful sushi rice is delightfully festive.

Red and White Plum Blossoms

Cut 5 pieces of tuna into 1¼-inch (3-cm) squares of even thickness and trim the corners. Do the same with 5 pieces of squid. Make 10 small sushi-rice balls (1 scant tablespoon). Wrap in plastic to form 5 tuna spheres and 5 squid spheres. Arrange the 5 pieces into a flower shape and add chopped Japanese Omelette or pickled burdock root in the centers. Cover the entire flower with plastic wrap and press the pieces together, adjusting the shape to make a plum blossom.

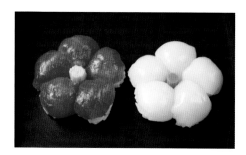

Trim the corners of the tuna and squid squares at an angle.

Wrap the assembled pieces tightly to secure them together.

Deep-Fried Tofu Pockets (Inari-zushi)

Being considered a humble dish, *inari-zushi* tends to fall into the realm of home cooking, but a few decorative elements or innovative shapes make it a worthy addition to any restaurant menu. Blend colorful ingredients into the sushi rice or wrap it differently to give it a little makeover. Beyond the examples shown here, experiment with other ideas such as cutting open the *abura-age* tofu pocket and folding it like a cloth around ingredients, or covering it with rice like an inside-out roll. Note that the deep-fried tofu pouches should be simmered in seasoning liquid (or bought pre-seasoned) before filling.

Inari Boats

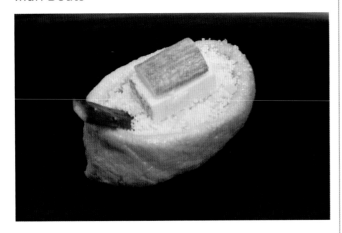

Fried Tofu-Skin Rolls

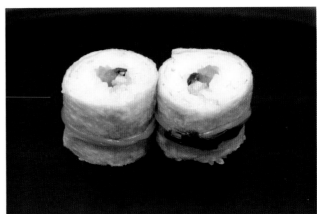

1 Gently open a simmered tofu pouch and fold the top edges inward.

3 Spread *oboro* flakes over the top of the rice.

1 Trim the sides away from a 2⅜ x 3⅛-inch (6 x 8-cm) simmered deep-fried tofu pouch, reserving them for filling. Open up the tofu to make a rectangular sheet.

3 Place the edges from the tofu pouch and a small amount of *noza-wana* pickled greens and pickled ginger in the center of the roll. Roll up from the front and form into a slightly flattened circle.

2 Lightly form 2 tablespoons sushi rice into a ball and pack firmly into the pouch. Flatten the bottom.

4 Cut a rectangle of Japanese Omelette (see page 10), top with a smaller piece of imitation crab, and add a wedge of cucumber for the "tiller."

2 Spread 3½ tablespoons of sushi rice across the tofu sheet, leaving 1½ inches (4 cm) of space at the top edge and a narrow space at the bottom edge.

4 Tie two stems of blanched *mitsuba* trefoil (or parsley) around the roll. Cut in half crosswise.

Reverse Rolls (Tezuna-zushi)

Reverse rolls are typically made by initially forming sushi rice into a cylinder and layering ingredients on top, then rolling with a sushi mat. It is easy to monitor the balance of the overall color and structure of the roll, making the outcome of a well-executed Reverse Roll nearly guaranteed. The toppings should be sliced even more thinly than for nigiri sushi. When placing the pieces diagonally, layer them all at the same angle. This produces a beautiful effect.

Sayori Halfbeak and Shrimp Reverse Rolls

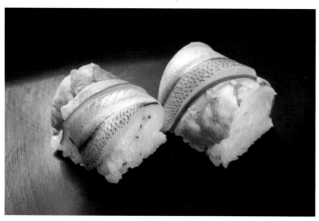

MAKES 6 REVERSE-ROLL PIECES

¾ cup (150 g) prepared sushi rice
4-in (10.5-cm) length Japanese or English cucumber peel
¼ cup prepared seasoned vinegar (see page 9)
2 cooked shrimp
1 *sayori* halfbeak or other small firm-fleshed white fish, boned, salted, and lightly marinated in vinegar
1 teaspoon toasted sesame seeds
1 teaspoon pickled ginger
1 green shiso leaf, finely slivered

1 Marinate the cucumber peel in the seasoned vinegar for at least 30 minutes.

2 Remove the tails from the shrimp. Butterfly them by opening up the stomach, then slice each one in half lengthwise. Cut into each piece widthwise to make each one half as thick, but do not slice all the way through. Spread the 4 resulting pieces flat.

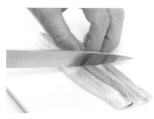

3 Cut the halfbeak in half lengthwise, then slice diagonally.

4 Combine the sushi rice with the toasted sesame seeds, the minced pickled ginger and the green shiso leaf. Form the rice into a log shape.

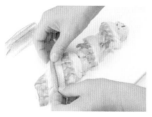

5 Arrange the shrimp and halfbeak pieces in alternating order diagonally on the rice log.

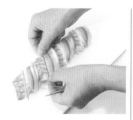

6 Thinly slice the cucumber peel and place 7 to 8 strips on the roll diagonally.

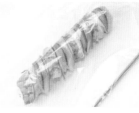

7 Drape the roll with plastic wrap.

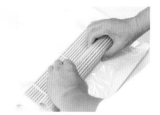

8 Cover with a sushi mat, and press the roll from above to squeeze the contents together. Flatten the bottom of the roll to shape it into a half-moon.

9 Remove the sushi mat and carefully remove the plastic wrap without distorting the roll. Slice.

Autumn Maple Leaf Reverse Rolls

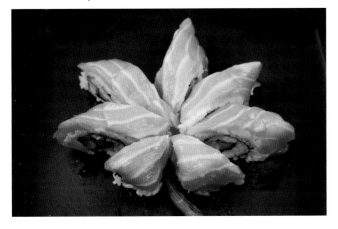

MAKES 7 REVERSE-ROLL PIECES

½ cup (100 g) prepared sushi rice
Half-sheet nori
4 oz (100 g) sushi-grade salmon fillet
½ teaspoon wasabi paste
2 teaspoons mayonnaise
⅛ avocado, thinly sliced into crescent-shaped pieces
2 lengthwise quarters cut from a 4-in (10.5-cm) Japanese or
 English cucumber
3⅛ in (8 cm) *nozawana* greens, rolled tight

1 Slice the salmon fillet into 7 extra-thin slices.

2 Spread the sushi rice on a half-sheet of nori.

3 Flip over the rice and nori and spread the wasabi and mayonnaise in the front section. Line the area with the avocado and the cucumber wedges.

4 Start rolling from the edge and cover with plastic wrap. Place the sushi mat on top and press from above, forming the roll into a half–moon shape.

5 Remove the sushi mat and plastic wrap. Lay the salmon slices diagonally across the roll.

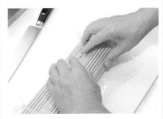

6 Cover with the plastic wrap and sushi mat again and press from above to squeeze the salmon and rice together and adjust the shape.

7 Remove the sushi mat and slice the roll into 7 diagonal pieces with the plastic wrap still on. Remove the plastic and arrange the cut pieces into a maple-leaf shape. Create a stem from *nozawana* pickled greens.

As sushi gains worldwide popularity, new types of sushi are cropping up that incorporate local flavors, ingredients and preferences. At the forefront of this development are creative variations on inside-out rolls. Even within Japan, these rolls are increasingly in demand. This section highlights some inside-out rolls that can very well be considered classics by now.

Inside-Out Roll Basics

The first roll to take the Western world by storm was the California Roll. People who found nori seaweed unpalatable had no problems when the rice was on the outside, covering the nori. Take care not to get the plastic wrap stuck in the roll when assembling it. For extra flourish in the presentation, the fillings are deliberately extended so they stick out of the endmost slices.

California Rolls

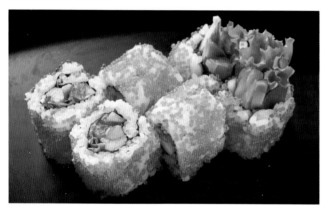

MAKES 6 INSIDE-OUT PIECES

½ cup plus 2 tablespoons (120 g) prepared sushi rice
Half-sheet nori
4-in (10.5-cm) length imitation crab
⅛ avocado
1 leaf lettuce (green-leaf variety)
½ teaspoon *tobiko* flying-fish roe
½ teaspoon wasabi paste
1 teaspoon mayonnaise
4-in (10.5-cm) Japanese or English cucumber, quartered lengthwise
Two ⅜ x ⅜ x 4-in (1 x 1 x 10.5-cm) pieces raw sushi-grade salmon

1 Cut the imitation crab in half crosswise with a diagonal cut. Slice the avocado into three thin wedges. Cut the leaf lettuce in half lengthwise, then diagonally into thin slices.

3 Leaving about ¾ inch (2 cm) of space at the front, spread the *tobiko* evenly across the rice, then flip the nori over.

5 Arrange the sliced lettuce across the nori. Add the imitation crab pieces, extending the slanted cut ends off the edges of the nori.

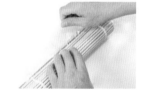

7 Carefully lift the front of the mat. Without shifting the contents or rolling the plastic wrap into the rice, start rotating the mat, pulling from the back and pressing from above.

2 Wrap the sushi mat with plastic wrap. Place the nori on the mat horizontally and spread the sushi rice over it in an even layer, covering the entire sheet and extending a little beyond the back edge so it will hide the nori when rolled.

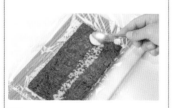

4 Spread wasabi and mayonnaise across the nori just in front of the center.

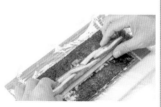

6 Lay the cucumber, salmon and avocado across the nori. Position the ingredients so they extend beyond the nori.

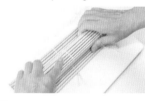

8 Open the mat to check the shape, then cover again to adjust into a round roll. Remove the mat and plastic wrap and use a very sharp knife dipped in vinegar water to cut the roll into 6 slices, wiping off the blade after each cut. Include the end slices with the ingredients poking out upwards as part of the presentation.

Inside-Out Roll Variations

Since inside-out rolls often include unconventional items, it's an excellent way to put your imagination to work. Incorporate different ingredients into your sushi rolls—the more colorful, the better. And depending on the materials used, the rolls can be modified to accommodate vegetarians or others with specific dietary needs and preferences.

Rainbow Rolls

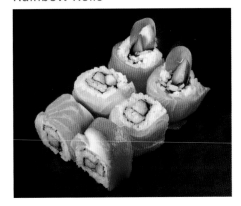

Shrimp Tempura Rolls

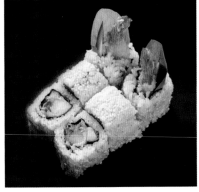

Dragon Rolls

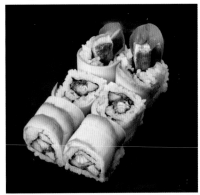

MAKES 6 INSIDE-OUT PIECES

½ cup plus 2 tablespoons (120 g) prepared sushi rice
Half-sheet nori
1 teaspoon mayonnaise
⅛ avocado, cut into thin wedges
1 Japanese or English cucumber, quartered lengthwise
1 tablespoon chopped baby leaf lettuce
Two 2 x 3⅛-in (5 x 8-cm) slices white-fleshed fish such as flounder
Two 2 x 3⅛-in (5 x 8-cm) slices salmon
Two 2 x 3⅛-in (5 x 8-cm) slices tuna

1 Wrap the sushi mat in plastic wrap. Place the nori on it horizontally and spread the sushi rice evenly across it.
2 Flip over the nori and rice. Spread the mayonnaise across the center of the nori. Arrange the avocado slices, cucumber pieces, and lettuce across the center of the nori, extending the ingredients just beyond the edges of the nori. Make a round roll.
3 Remove the sushi mat and plastic wrap and place the roll on a cutting board. Lay the fish pieces diagonally across the roll next to each other in alternating series (white-fleshed fish, then salmon, then tuna) one piece at a time. Cover with plastic wrap, then wrap tightly with the sushi mat and shape into a round roll.
4 Remove both the mat and plastic wrap and use a very sharp knife dipped in vinegar water to cut the roll into 6 slices, wiping off the blade after each cut.

MAKES 6 INSIDE-OUT PIECES

½ cup plus 2 tablespoons (120 g) prepared sushi rice
Half-sheet nori
1 teaspoon mayonnaise
2 teaspoons eel sauce or other sweet sauce
Two whole shrimp tempura
1 Japanese or English cucumber, quartered lengthwise
1 tablespoon chopped baby leaf lettuce
½ teaspoon toasted white sesame seeds

1 Wrap the sushi mat with plastic wrap. Lay the nori on the mat horizontally and spread the sushi rice evenly across it.
2 Flip the nori over. Spread the mayonnaise and sauce across the center. Arrange the shrimp tempura, cucumber pieces and lettuce in a row across the nori, extending the ingredients just beyond.
3 Remove the sushi mat and plastic wrap and sprinkle toasted white sesame seeds evenly over the roll.
4 Use a very sharp knife dipped in vinegar water to slice the roll into 6 pieces, wiping the blade clean after each cut.

MAKES 6 INSIDE-OUT PIECES

½ cup plus 2 tablespoons (120 g) prepared sushi rice
Half-sheet nori
1 teaspoon mayonnaise
½ teaspoon wasabi paste
Three ⅜ x 3⅛-in (1 x 8-cm) strips broiled eel
1 Japanese or English cucumber, quartered lengthwise
1 tablespoon chopped baby leaf lettuce
½ avocado, cut into thin wedges

1 Wrap the sushi mat with plastic wrap. Lay the nori on the mat horizontally and spread the sushi rice evenly across it.
2 Flip the nori over. Spread the mayonnaise and wasabi across the center. Arrange the eel, cucumber pieces and lettuce in a row across the nori, extending the ingredients just beyond the edges. Make a round roll.
3 Remove the sushi mat and plastic wrap and drape the avocado slices over the roll in an overlapping row. Cover the roll with plastic, wrap the sushi mat around it, and shape into a round roll without pressing too hard.
4 Remove both the mat and plastic wrap and use a very sharp knife dipped in vinegar water to cut the roll into 6 slices, wiping off the blade after each cut.

Pressed Sushi (Oshi-zushi)

Especially common in the Kansai region in the western part of Japan, pressed sushi is also called hako-zushi or box sushi due to the container used for the pressing process. Typical seafood ingredients include mackerel, trout, saltwater eel, and small sea bream; these are not used raw but are frequently marinated or boiled. Try to keep the thickness of the fish slices uniform. When pressing to form the sushi shape, adjust the pressure to avoid crushing the rice grains.

If you don't have the proper box setup for making pressed sushi, you can improvise with two flared loaf pans. Line one loaf pan with plastic wrap, arrange the toppings and sushi rice inside it and cover the ingredients with plastic wrap. Insert the second loaf pan into the first and exert even pressure across the bottom to press the sushi into shape, as described in the recipe below. Invert both pans and remove the first pan and plastic to reveal the pressed sushi. Carefully transfer to a serving platter.

Pressed Sushi Basics

The standard way of creating pressed sushi is by arranging the ingredients upside-down and fitting them into a box. As you arrange the ingredients, envision the right-side-up design. Layer bamboo leaves in the box before pressing; this will keep the surfaces clean and infuse the sushi with lovely fragrance. Create a level surface by pressing uniformly but not too firmly on the box lid for best results.

Shrimp and Salt-Water Eel Pressed Sushi

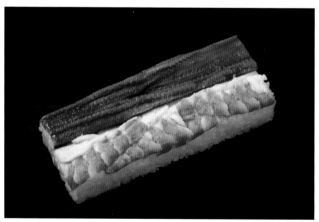

MAKES ONE 6 × 2 × 1-INCH (15 × 5 × 2.5-CM) SUSHI CAKE

1 cup (200 g) prepared sushi rice
Two 6-in (15-cm) bamboo leaves
2 large cooked shrimp, shells and tails removed, butterflied
6-in (15-cm) broiled saltwater eel fillet
2 teaspoons shredded Japanese Crêpe (see page 33)
3 or 4 sprigs of *mitsuba* trefoil or Italian parsley, briefly blanched

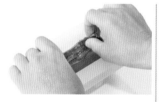

1 Line the bottom of the box with a bamboo leaf.

2 Arrange the shrimp along one side with the red side facing down. Lay the saltwater eel alongside the shrimp with skin side up.

3 Form ½ cup (100 g) of the sushi rice into a ball and pack it into the box.

4 Sprinkle the shredded egg omelette over the rice and add the *mitsuba*.

5 Spread the remaining ½ cup (100 g) rice evenly, exerting even pressure to fill the mold. Cover with the second bamboo leaf.

6 Place the box lid on top, and with light but even pressure, push down on the lid from the front toward the center and back.

7 Press from back to front, then from the front again. Repeat several times, increasing pressure.

8 Remove the lid and bamboo leaves. Slice crosswise and serve.

Pressed Sushi Variations

Another approach to pressed sushi is to compose it as though you are creating a painting with the ingredients. To do this, instead of forming the design upside down, it's easier to start by laying down the sushi rice and then placing the ingredients on top.

Mount Fuji Pressed Sushi

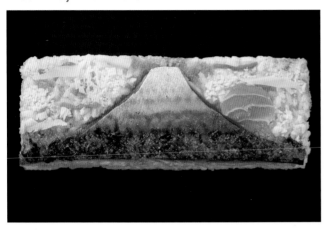

MAKES ONE 6 × 2 × 1-INCH (15 × 5 × 2.5-CM) SUSHI CAKE

1 cup (200 g) prepared sushi rice, divided
2 teaspoons *tarako* salted pollock roe
½ fillet *shimesaba* Marinated Mackerel (see page 39)
2 x 2-in (5 x 5-cm) square sushi-grade salmon
Two 6-in (15-cm) bamboo leaves
1 teaspoon toasted white sesame seeds
1 teaspoon minced pickled white ginger
½ teaspoon *mentaiko* spiced pollock roe
½ teaspoon pink *oboro* fish flakes
½ teaspoon minced *takuan* pickled daikon
½ teaspoon *aonori* laver flakes
½ teaspoon green *tobiko* flying-fish roe

1 Break up the *tarako* pollock roe and combine with ½ cup (100 g) of the sushi rice, gently mixing to incorporate. Cut the mackerel fillet widthwise to reduce the thickness by half. Make sure the thickness of the fillet is uniform.

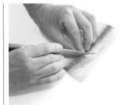

3 The fillet will have lighter skin on the belly side and patterned marks on the dorsal side. Use a paring knife to cut the piece into a mountain shape, making the lighter skin into the peak of the mountain.

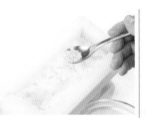

5 Line the bottom of the box with a bamboo leaf and pack in the ½ cup (100 g) of plain sushi rice. Sprinkle toasted white sesame seeds and minced pickled ginger on the rice.

7 Place the box lid on top of the rice and press gently once. Remove the lid.

2 Cut sides of the mackerel fillet to fit the sushi box (tip: place the box lid on top and trace around the sides with the knife).

4 Use the paring knife to cut the salmon into a circle. Cut a small section from the bottom with a straight cut.

6 Spread the *tarako* rice evenly over the surface and press into place.

8 Sprinkle the *mentaiko* here and there across the rice and lay the mackerel mountain on top.

9 Place the salmon circle against one side of the mountain. Scatter the *oboro* and *takuan* across the "sky."

11 Cover the box insert with plastic wrap.

13 Unwrap the plastic from the box insert. Remove the box and insert, leaving the plastic wrap on top of the sushi.

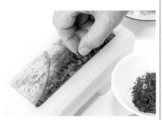

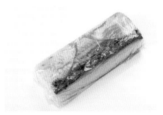

10 Arrange the *aonori* and green *tobiko* across the bottom of the mountain.

12 Place the plastic-wrapped insert on top of the rice and press as described in the recipe on page 108.

14 Completely encase the pressed sushi cake with the plastic wrap and let it rest and settle for at least 15 minutes.

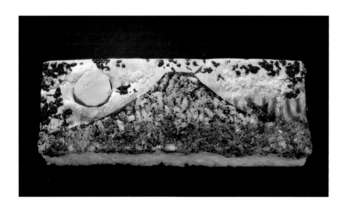

Nighttime Mount Fuji

For this variation, you'll use the Marinated Mackerel as the sky. Mix black sesame seeds into the sushi rice instead of *tarako*, and use a piece of Japanese Omelette (see page 10) cut into a circle for the moon. Sprinkle a little *yukari* dried shiso powder and minced pickled white ginger here and there across the "sky."

Vegetable Sushi Variations

The flavorings of a vegetable-focused sushi are very distinct from the seafood variety, and have their own appeal. Vegetable sushi is a go-to option for health-conscious people and is a standard offering in sushi restaurants outside Japan. It makes a great palate cleanser, and incorporating seasonal ingredients gives it a freshness that can't be beat. Try including pickles, vinegar-marinated foods and simmered sea vegetables for added variety.

Pickled Eggplant Nigiri
Thinly slice a small pickled eggplant lengthwise and place a slice on a bullet of sushi rice. Decorate with thin slivers of yuzu citrus peel. The purple of the eggplant and the yellow of the yuzu are complementary, as are their flavors.

Mushroom Nigiri
Saute the cap of a large shiitake mushroom in vegetable oil and add a little soy sauce. Place on top of the nugget of sushi rice and secure with a few strands of blanched *mitsuba* trefoil. Oyster mushrooms are a wonderful option as well.

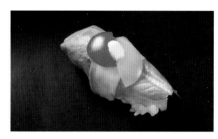

Cherry Tomato Nigiri
Quarter a cherry tomato and cut a thin slice of avocado. Layer a piece of baby leaf lettuce on top of a sushi rice ball, followed by an avocado slice and two tomato pieces. Top with a dab of mayonnaise.

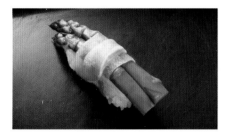

Asparagus Nigiri
Blanch asparagus tips, slice them in half lengthwise and place on top of the bullet of sushi rice. Wrap in a strip of prosciutto. The saltiness of the ham works well with the mild bitterness of asparagus.

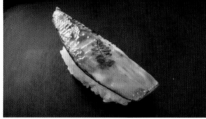

Bamboo-Shoot Nigiri
Cut the tip of a simmered bamboo shoot into a thin slab. Broil or saute in soy sauce, then briefly grill on high heat. Place on a bullet of sushi rice and decorate with a leaf of *kinome* Japanese prickly ash. Enjoy the rich textures and flavors.

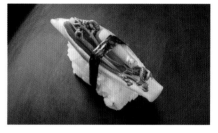

Myoga Ginger Bud Nigiri
Remove a few leaves from a *myoga* ginger bud. Place 2 to 3 *myoga* leaves curved-side-down on a bullet of sushi rice. Fill the leaves with simmered pieces of *warabi* bracken and *fuki* butterbur. Wrap with a narrow strip of nori.

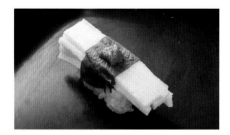

Yamaimo Mountain Yam Nigiri
Thin strips of mountain yam top the bullet of sushi rice, which is then wrapped with a thin strip of green shiso. Top with a bit of *umeboshi* pickled plum. The unique crunchiness of the raw mountain yam is what makes this nigiri special. Try using jicama as a substitute.

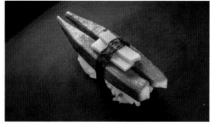

Okra Nigiri
Remove the stem end from an okra pod and massage with salt. Blanch and slice in half lengthwise. Blanch a few matchstick slices of carrot as well. Arrange the vegetables on a bullet of sushi rice and secure with a strip of nori.

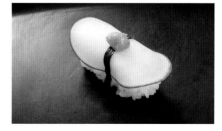

Red Radish Nigiri
Drape a very thin slice of red radish over a nugget of sushi rice. Wrap with a strip of nori and top with a dollop of miso. The bright, slightly spicy taste of the radish is a great foil for the rice. A slice of pink watermelon radish or colorful turnip would work as well.

Scattered Sushi Chirashi-zushi

Scattered sushi takes many forms. Sometimes ingredients are arranged on top of sushi rice, at other times they are mixed into the rice. Even *tekka-don*, a popular rice bowl topped with raw tuna, is a version of scattered sushi. Have fun by adding decorative ingredients on top of rice or arranging pieces into a clever design. The Hydrangea Chirashi outlined here is a good introduction to scattered sushi.

Hydrangea *Chirashi*

MAKES 1 SCATTERED SUSHI ARRANGEMENT

½ cup (100 g) prepared sushi rice
4-in (10.5-cm) length *bettarazuke* white pickled daikon
¼ teaspoon *yukari* dried shiso powder
¼ cup (65 ml) water
3 leaves green shiso
¼ teaspoon minced pickled ginger
¼ teaspoon toasted white sesame seeds
2 or 3 thin needles of yuzu citrus peel

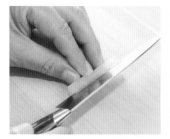

1 Cut the sides of the *bettarazuke* white pickled daikon to make a ⅝-inch (1.5-cm) square bar. Cut out a lengthwise triangular wedge from the center of each side.

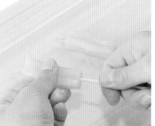

3 Insert a bamboo skewer in the center of the dyed *bettarazuke* to make a hole down the length of the bar. Insert the yuzu needles into the hole. Slice thinly crosswise to make small flowers.

4 Form the rice into a flattened ball. Place the shiso leaf tips on the rice and top with the "flowers," arranging them to look like a hydrangea.

2 Mix the *yukari* with the water. Marinate the cut *bettarazuke* bar for about 15 minutes, or until it has turned a pale pink color. Meanwhile, cut the shiso leaves in half crosswise so that you have 3 leaf tips. Set aside the bottom halves for another use. Combine the pickled ginger and white sesame seeds with the sushi rice and gently mix to incorporate.

Sushi Arrangements

Festive Kazari Sushi is always a crowd-pleaser. Still, developing basic techniques is essential in order to present sushi at its best. As you proceed in your sushi-making career, you will most likely formulate your own style, but you have to keep your skills honed as you progress. This section delves into the basics and the art of *morikomi* presentation and arrangement.

Morikomi refers to the arrangement of sushi pieces on a platter made specifically for serving sushi. It is the finishing touch for sushi making; a beautiful presentation increases the enjoyment and flavor of the sushi. There are many ways of presenting sushi, depending on several factors such as the number of people to be fed and the serving location. Let's review the basics first. The arrangements shown here incorporate Kazari Sushi in a presentation designed for three diners.

Flowing Arrangement Nagashi Mori

This arrangement features diagonally placed pieces of sushi lined up in rows. It is best to start at the back of the serving platter and work your way up, aligning the diagonal and horizontal pieces. Most designs avoid placing same-colored sushi side-by-side, but for certain occasions this rule is broken—one arrangement, for example, groups white sushi on the left side and red sushi on the right.

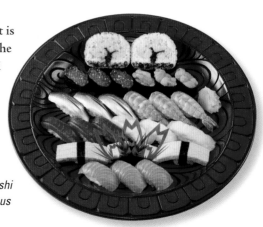

TIPS *Match the sushi angles and align the horizontal rows. • Avoid placing different sushi with the same toppings next to each other. • Position taller, more complicated sushi pieces toward the back and simpler ones toward the front. • Place toppings with obvious directional qualities so that the bottom points to the lower right (shrimp, for example, should be positioned with the tail downward). • Add the decorative cut bamboo leaves at the end, taking care that they don't obscure the sushi.*

1 First, place nori rolls and Kazari Sushi at the very back of the plate. Elaborate Kazari pieces tend to overshadow the other sushi, so place them near the back or on the side unless you want them to be the main focus.

3 Arrange gizzard shad and shrimp nigiri sushi in the next row forward. Point the tail end toward the lower right, and match the diagonal angle to that of the battleship rolls in the row above.

5 The Japanese Omelette nigiri should make up the next row. For variety, line them up horizontally.

2 Place two types of battleship rolls in the second row from the back. Because these rolls tend to be taller, it's best to keep them toward the back. Place them at a uniform diagonal angle.

4 Place tuna and squid nigiri pieces next. Position the tuna in front of the gizzard shad and the squid in front of the shrimp.

6 For the final row, line up salmon nigiri pieces at the same angle as the tuna and squid nigiri two rows back. Fan out the cut bamboo leaves and tuck them into the space between the salmon and omelette sushi. Add a mound of pickled ginger.

Mandala Arrangement Hosha Mori

This attractive concentric arrangement makes sushi easily accessible from all directions, so it's a suitable presentation for round tables. Decide what to place in the center first, and design the radiating rows so that the pieces intended for a single serving are easy to distinguish. Strive for variations in height and utilize cut bamboo leaves to create a pleasing balance. This celebratory presentation features a Kazari Roll in the center.

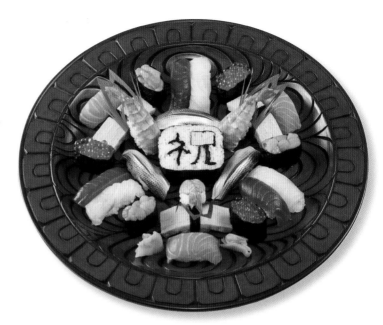

TIPS *Decide on the center elements and put them in place first. The more elaborate sushi should go near the center. • Create variety with the positioning of the sushi; don't have them all face the same direction. • Use cut bamboo leaves to indicate single servings or to add height. • Check from all directions to assess the balance of the entire presentation.*

1 Place the focal Kazari Roll in the center of the platter.

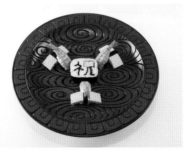

2 Combine Japanese Omelette nigiri and shrimp nigiri in a three-pronged formation. To give a sense of dimension, prop the shrimp on the Japanese Omelette with the tail facing outward.

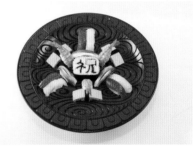

3 Place gizzard shad nigiri between the Japanese Omelette and shrimp nigiri. Arrange tuna and white-fleshed fish nigiri next. Alternate the red and white colors to symbolize celebration (this is also reinforced by the kanji character 祝 *iwai*, "celebration," in the central Kazari Roll).

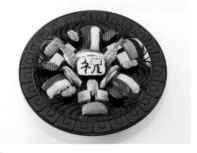

4 Round out the presentation with sea-urchin roe and salmon roe battleship rolls. Add salmon nigiri next to the Japanese Omelette. Slide cut bamboo leaves under the shrimp nigiri and add pickled ginger.

Fan Arrangement Ougimori

As its name indicates, this arrangement is shaped like a fan. It's a good presentation for events with a guest of honor or for buffet-style gatherings where tables are pushed against a wall. Like the Flowing Arrangement (page 114), it is assembled from back to front. Keep the focal point at the very front in mind, as the rows become narrower as the arrangement is filled in.

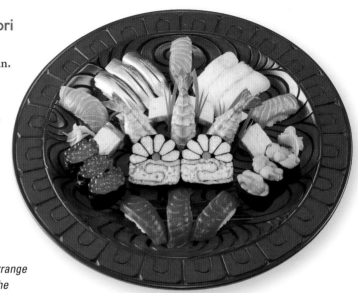

TIPS *Designate the focal point at the front of the platter and arrange the sushi pieces in a fan shape. • Pay attention to the angle of the sushi placement, as the rows become narrower toward the focal point. • Placing the focal point sushi first will make the overall composition easier to construct. • Add visual interest by varying heights and layering or propping one type of sushi on another. • Decorate with cut bamboo leaves, interspersing them within the fan shape. • Lastly, place a mound of pickled ginger on either side of the platter.*

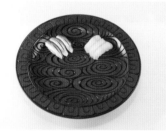

1 Arrange three pieces of gizzard shad nigiri in the upper left quadrant of the serving platter, angling them toward the center. Place three pieces of white-fleshed fish nigiri at the upper right, angling them toward the center as well. Make sure to point the tail end of the gizzard shad toward the center.

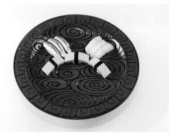

2 Form the Japanese Omelette nigiri into an arc underneath the nigiri.

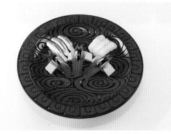

3 Prop a fan-shaped piece of decorative cut bamboo leaf against each omelette nigiri.

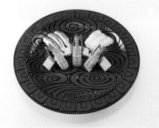

4 Place a piece of shrimp nigiri on top of each bamboo leaf, leaning it tail-end-up against the omelette sushi.

5 Place two pieces of Kazari Sushi against the shrimp, making sure that the design is facing the right side up.

6 Arrange three *ikura* salmon-roe battleship rolls on the left side of the Kazari rolls, and sea-urchin roe battleship rolls on the right. Place one piece of salmon nigiri on the left side of the gizzard shad, place another on the right side of the white-fleshed fish, and place a third one between the two. Arrange three pieces of tuna nigiri into a fan shape at the front.

Varying Your Sushi Presentations

Sometimes you want to break the mold and try unconventional presentations. Even if the sushi used is orthodox, modern and innovative designs can be achieved. The following section will help you flex your creativity for special occasions and celebratory arrangements. Note: it's important to quickly assemble the pieces and serve them for maximum freshness and to ensure food safety.

Arrangements for Special Occasions

Futomaki thick rolls, regular nigiri sushi, and thin rolls with tuna are staples at any sushi restaurant. Here's a way to present these typical sushi pieces in a fresh way to serve three to four people. Try using a simple plate instead of a traditional serving vessel for sushi; substitute herbs for cut bamboo leaves and add cut radishes and cherry tomatoes as accents.

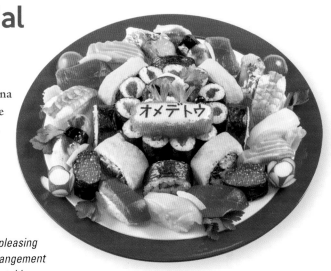

TIPS Giving a nod to cake decoration, arrange the sushi pieces in a circle with the center portion rising higher than the rest. • Create a pleasing color scheme with the sushi pieces, and position them so that the arrangement looks the same when viewed from any direction. • Embellish with vegetables that are decorative as well as edible, like radishes. • As a finishing touch, top with a piece of nigiri sushi bearing a word or message cut out of nori.

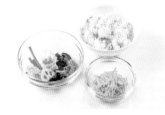

Even if you don't go out of your way to make special sushi, decorative arrangements are easy to create. Home cooks can simply purchase ready-made sushi as a starting point. Don't forget to use it before the expiration date, though!

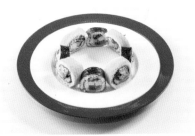

1 Arrange pieces of futomaki thick rolls in a ring with the contents facing outward. Try alternating nori-wrapped rolls with egg-wrapped ones for added vibrance and variety.

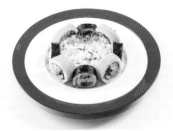

2 Fill the center of the ring with prepared sushi rice. Flatten the surface.

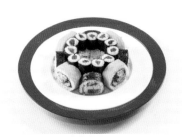

3 Arrange a ring of upright pieces of tuna roll along the inside of the futomaki ring.

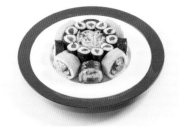

4 Scatter shredded Japanese Crêpe (see page 33) on top of the sushi rice.

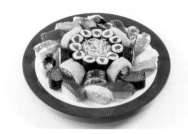

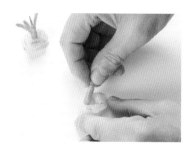

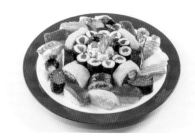

5 Surround the futomaki ring with pieces of nigiri sushi. Match the angles and avoid placing the same type of nigiri sushi next to each other.

6 Make a horizontal incision in the middle of the back of a raw *amaebi* sweet shrimp or other sashimi-grade raw shrimp. Curve the tail and slip it through the opening to make the tail stand straight up. Repeat with a second shrimp. Place in the center of the arrangement.

7 Decorate the platter with pickled ginger, and top with decoratively sliced radish, cherry tomato, lemon and herbs.

8 Make a rectangular squid nigiri and arrange thin pieces of nori to spell out words (the arrangement on page 117 says オメデトウ *omedetou*, "Congratulations"). Press *tobiko* on the sushi rice on all four sides. Place in the center of the arrangement next to the prawns.

Arrangement for Girls' Day or Doll's Festival
Hina Matsuri

The elements of this presentation are constructed from nigiri sushi, *inari-zushi* deep-fried tofu pouches and futomaki thick rolls. The emperor and empress figures sit prominently in the center and the other sushi are arranged around them in the fan style (page 116). This presentation, which features a lot of kid-friendly sushi such as tuna and salmon, can easily be made from store-bought sushi.

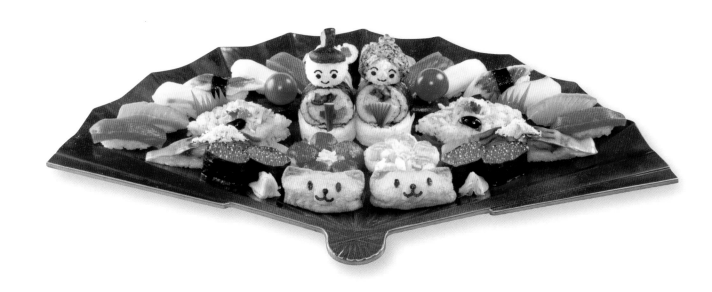

The bodies of the dolls are made from sushi rolls, and the heads are made of balls of sushi rice. • Position the doll figures in the center, as they are the stars of this arrangement. • Place shorter sushi pieces in front of the dolls so that they are not blocked from view. • Arrange the other sushi pieces into a fan shape. • Make sushi selections that will appeal to children, such as inari-zushi *fried-tofu pouches, tuna nigiri, salmon nigiri, and Japanese Omelette.*

1 Cut 3 pieces of tuna nigiri sushi in half. Cover one of the halves in plastic wrap and shape into a sphere (see page 101). Make 5 spheres in all. Repeat with 3 pieces of shrimp nigiri sushi.

2 Cut two 1-inch (2.5-cm) circles out of a strip of yellowtail. Use a punch or fine scissors to cut eyes, noses, and mouths out of nori. Pinch the upper left and upper right ends of an *inari-zushi* tofu pouch to form ears. Place a yellowtail piece in the center of the tofu pouch and decorate with the cut-out nori to create a bear face. Repeat with a second *inari-zushi* pouch.

3 Arrange ½ cup (100 g) prepared sushi rice into a cylinder shape (if using store-bought sushi, use the rice from a *chirashi* bowl). Place on a cutting board and cover with plastic wrap. Use a kitchen knife blade to flatten each side, making a rectangular bar. Continue flattening and shaping to form a parallelogram. Cut the parallelogram in half to form 2 diamond-shaped pieces.

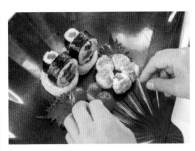

4 Arrange slices of futomaki thick roll and *tekka-maki* tuna thin roll to make the dolls' bodies as shown. Lay two green shiso leaves in front and arrange the sushi spheres from step 1 on top to make flowers. Fill the center of the flowers with shredded Japanese Crêpe.

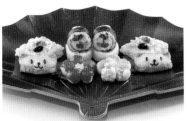

5 Place a diamond-shaped piece from step 3 on either side of the doll figures, and place an inari tofu pouch in front of each one, or in front of the flowers, as shown in the large photo on the opposite page.

6 Make the dolls' heads out of sushi rice. Decorate each head with nori, cooked shiitake mushrooms and cucumbers. Attach to the futomaki "body" with a skewer. Fill empty spaces on the platter with nigiri sushi, battleship rolls, and pressed mackerel sushi. Create two "lanterns" by placing a cherry tomato on top of a piece of cucumber. Place one next to each doll figure. Finish by adding two mounds of pickled ginger.

Mini Scattered Sushi for Children Chirashi

These arrangements have tons of kid appeal. Use a punch to create nori pieces for cute facial expressions.

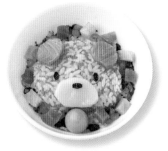

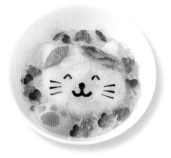

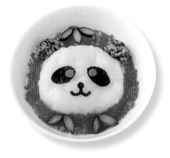

Dog

Scoop about ½ cup (100 g) of prepared sushi rice into a bowl and flatten the surface. Blend *tobiko* flying-fish roe with additional sushi rice and shape into a flattened circle. Place in the bowl of sushi rice. Slice salmon into thin circles for the ears and cut a scallop into an oval for the nose and mouth. Decorate with cut nori pieces. Fill the space around the dog with minced *nozawana* pickled mustard greens and small pieces of tuna and white-fleshed fish. Add a cherry tomato for the finishing touch.

Cat

Scoop about ½ cup (100 g) of prepared sushi rice into a bowl and flatten the surface. Shape additional sushi rice into a flattened circle. Layer thinly sliced white-fleshed fish on top for the face, then place in the middle of the bowl of rice. Make two small triangles and one oval out of sushi rice, then cover these with thinly sliced white-fleshed fish to make the ears and a paw. Decorate with salmon and soy-sauce glaze (for the pattern near the ears), tuna (paw pads), and nori (face). Fill the space around the cat's face with chopped Japanese Crêpe (see page 33) topped with pieces of *kaiware* daikon sprouts and *ikura* salmon roe.

Panda

Scoop about ½ cup (100 g) of prepared sushi rice into a bowl and flatten the surface. Shape additional sushi rice into a flattened circle. Cover with a circle of thinly sliced squid and place in the middle of the bowl. Mix sushi rice with black sesame seeds, form into two small rice balls, and attach as ears. Make the face out of nori and pickled burdock root. Fill the space around the panda with *tobiko* flying-fish roe and *ikura* salmon roe. Add cucumber pieces cut into the shape of bamboo leaves.

Bear

Scoop about ½ cup (100 g) of prepared sushi rice into a bowl and flatten the surface. Cut four leaves of green shiso in half along the center vein and arrange around the edge of the bowl. Form *ikura* salmon roe into the shape of a bear face on top of the rice. Cut a circle of Japanese Omelette (see page 10) for the nose and mouth and two half-circles for the ears. Arrange cut nori for the eyes, nose, and mouth. Scatter chopped imitation crab around the edges of the face.

Pig

Scoop about ½ cup (100 g) of prepared sushi rice into a bowl and flatten the surface. Place a flat circle of fatty tuna in the middle. Add thin slices of scallop for the nose and ears. Make the eyes and nostrils out of nori. Scatter thinly sliced green onions (both the green and white parts) around the edge of the face.

Mount Fuji Sushi Art

In sushi art, a variation on scattered sushi, the ingredients are arranged to look like a painting. Depending on the design, Kazari Rolls may be incorporated, as they are here. We encourage you to use your imagination when you create sushi paintings. Although a beautiful composition is the end goal, the interplay of flavors is important as well. Starting with a simple sketch is helpful. Featured here is a 14 x 8-inch (35 x 20-cm) piece that serves approximately 10 people.

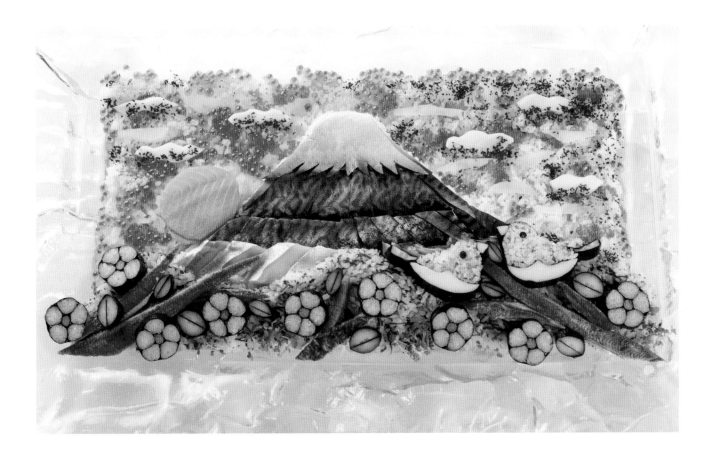

TIPS *Before starting, create an actual-size sketch. • Prepare all the necessary ingredients and Kazari Rolls. • To avoid running out of rice for the foundation, prepare and set aside the required amount in a bowl or container. • You will need about 6 cups (1.2 kg) of prepared sushi rice in all (not counting the rice needed for the Kazari Rolls). • Arrange the elements as rapidly as possible. • Take the overall balance into consideration as you arrange the sushi elements. • Make use of the variegated patterns in the mackerel skin when making the mountain. • You will need 2 or 3 Marinated Mackerel fillets (see page 39), depending on size. • Use* tobiko *flying-fish roe,* ikura *salmon roe,* oboro *flakes, chopped* takuan *pickled daikon and* yukari *dried shiso powder for the gradations in the sky. • Make the sky brighter on the sunrise side, and use* yukari *to darken it on the opposite side.*

Prepare the ingredients for the painting in the amounts needed: sushi pieces, *tobiko* flying-fish roe, *yukari* dried shiso powder, *oboro* flakes, vegetables, etc.

 1 Form the sushi rice base. Combine 4 cups / 800 g of sushi rice with 3 tablespoons each *oboro*, *tarako* and toasted white sesame seeds. Gently mix to incorporate.

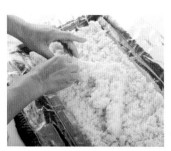 **2** Blend 2 teaspoons each minced pickled ginger and toasted white sesame seeds with 1 cup (200 g) of the sushi rice. Shape into a mountain on top of the rice base from step 1.

 3 The Mount Fuji base is now complete.

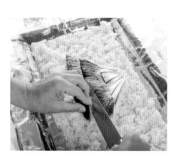 **4** Slice the Marinated Mackerel fillets into uniform thickness, and separate the white belly side from the patterned dorsal side. Use the part with white skin as the summit; cut the darker patterned pieces and arrange them into a mountain shape. Place on top of the mountain base.

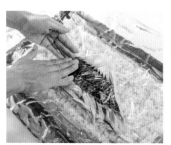 **5** Once the mackerel pieces are in place, cover with plastic wrap. Press on the plastic to adjust the shape and affix the mackerel to the sushi rice.

 6 Combine ½ cup (100 g) of sushi rice with 1 teaspoon *aonori* laver flakes and 2 teaspoons finely minced *nozawana* pickled mustard greens. Spread the green rice in an even layer underneath Mount Fuji.

 7 Cut a thin slice of salmon into a circle. Trim one edge off with a straight cut and form 1 tablespoon of sushi rice into a size and shape that matches the salmon piece. Place salmon on the rice and position it against the slope of the mountain.

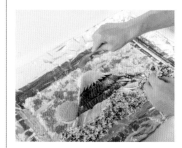 **8** Scatter *tobiko* flying-fish roe, slivered *takuan* pickled daikon and *ikura* salmon roe on the sushi-rice "sky" to create a sunset effect.

 9 Scatter *yukari* dried shiso powder and *oboro* flakes to add color gradation to the sky.

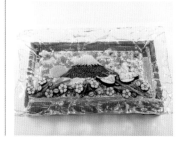 **10** Shape thin slices of broiled *anago* saltwater eel into "branches" and add Kazari Sushi flowers, leaves and birds in a balanced way. Cut thin slices of *kamaboko* fish cake into cloud shapes and place in the sky. Add sprouts on the bottom and decorate the birds with nori eyes.

Bamboo Leaf Cutting (Sasagiri) Variations

Bamboo leaves and *haran* (aspidistra) leaves are most commonly used for the classic craft of decorative leaf cutting known as *sasagiri*, though other leaves may be used as well. Considered an essential part of traditional sushi presentations, decorative leaves not only beautify the dish but also serve as partitions to separate groupings of sushi. Plus, their antibacterial properties make them ideal for use with raw fish. The more elaborate the leaf-cutting design, the more luxurious the sushi appears. As you become accustomed to the craft, try creating and layering multiple leaves for greater impact. We will cover the basics and representative designs in this section.

TIPS *Use a small-bladed knife or a paring knife to make detail work easier. • If possible, use a cutting mat specifically for* sasagiri. *• Wetting the bamboo leaf slightly makes it less slippery and easier to cut. • When cutting out intricate designs, hold the knife like a pencil, with your thumb near the base of the blade. • Use the hand that is not holding the knife to hold down the leaf securely. • Cut the leaf quickly, and if it will not be used right away, place it in water.*

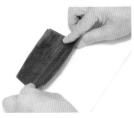 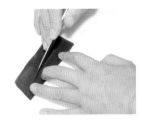

When cutting the leaf into a symmetrical shape, as for partitions, cut off the stem first and fold the leaf in half horizontally. Cut with the fold facing toward you.

For detailed work, hold the knife like a pencil and cut with the tip.

Barrier Leaves Kenzasa

Kenzasa leaves serve the same function as *sekisho* leaves. Because they combine straight lines to create pointed edges, they are relatively easy to cut out. By varying the width and angle of the pointed edges, you can create some visual interest. The *gosasa* pattern shown here started out as a thin, long piece of bamboo leaf cut in two and layered.

Gosasa Pattern

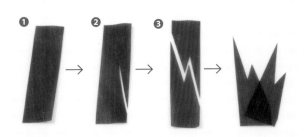

Partition Leaves Sekisho

Partition leaves are used to separate pieces of sushi with incompatible flavors so they don't mix, or to create sharp color contrasts. Their height also adds dimension and movement to the arrangement. Many partitions are created by keeping the leaf folded in half lengthwise as it is cut, which creates symmetrical designs.

Pine Tree

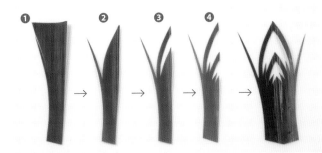

Shrimp

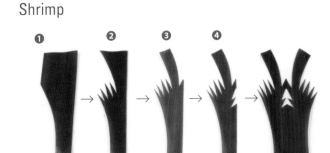

Base Leaves Shikizasa

A leaf cut in this pattern would be placed on the container or dish underneath the sushi arrangement. It can also be used under sashimi appetizers. Like the net pattern shown here, the entire leaf could consist of a single repeated pattern, or the center might have a crane or flower shape surrounded by other designs.

Net Pattern

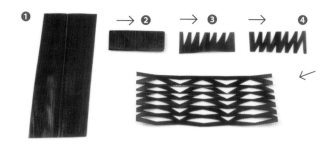

Decorative Leaves Keshozasa

These leaves are the final flourish of a traditional arrangement. They are not used as a partition; rather, their function is purely decorative. Common designs include shrimp, crane and family crests. The addition of a single *keshozasa* leaf can increase the splendor of the presentation exponentially.

Mount Fuji

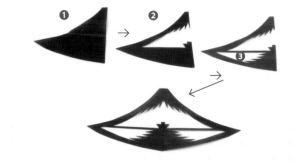

Crane

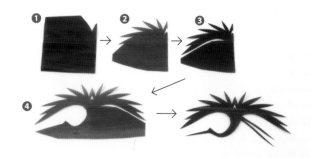

Butterfly

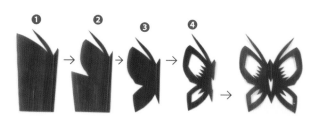

Shrimp

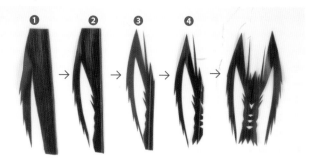

Decorative Vegetable Cutting

Vegetables come in colors that are not found in fish and other typical seafood ingredients. Even a simple decorative vegetable slice adds a distinctive sense of freshness to a sushi arrangement, and is pleasing to the eye. This section features easy ways to incorporate decorative vegetables into celebratory arrangements.

Wasabi Container: Version 1 (Balloon Flower)

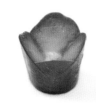

1 Cut off the end of a Japanese or English cucumber. About ⅝ inch (1.5 cm) from the cut end, insert the knife diagonally and slice up to the core of the cucumber.

2 Rotate the cucumber 90° and make another cut as in step 1. Repeat twice more.

Wasabi Container: Version 2 (Boat)

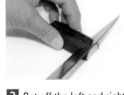

1 Cut a Japanese or English cucumber into a 2⅜-inch (6-cm) long piece and slice in half lengthwise. With the cut side facing down, hollow out a smaller section from the top by inserting the knife at an angle on all four sides.

2 Cut off the left and right ends at an angle to form the boat. Choose either the left or right side and make a small incision in the middle where the "sail" will be added. Cut a thin slice from the section removed in step 1. Insert into the incision.

Wasabi Container: Version 3 (Daisy)

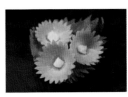

Lay a leaf of green shiso underneath and place a piece of minced *takuan* pickled daikon in the center to make a decorative flower.

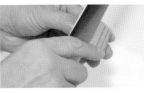

1 Cut a 1¼-inch (3-cm) long piece of carrot and thinly slice the peel off. Cut out small V shapes all around the edge of the carrot to create jagged edges.

2 Place the knife at a slight angle at one end. Thinly slice all around.

Pine Tree

1 Cut a 3⅛-inch (8-cm) long piece of cucumber and slice in half lengthwise. Place with cut side facing down and insert a bamboo skewer crosswise in the middle.

2 Make a series of parallel lengthwise cuts up to where the bamboo is inserted. Remove the bamboo skewer.

3 Cut a little off each side of the longer edges and place the piece horizontally. A few centimeters from the left edge, insert the knife at an angle and make a thin slice, but don't cut all the way through. Using the knife, shift the slice toward one side. Make another slice above the first one, then shift this slice to the other side. Repeat these back-and-forth steps as you add small cuts to the edge of the cucumber slices as you go.

Christmas Tree

1 Repeat steps 1 and 2 for the Pine Tree (page 125).

2 Trim the left and right edges at an angle, forming a long trapezoid.

3 Place horizontally with the pointed side facing to the left. Insert the knife at an angle on the left side and slice the peel without cutting all the way through, alternating the shifting and spreading of the sliced peels as with the Pine Tree. Add little cuts to the edges of the peels. Decorate with *ikura* salmon roe.

Butterfly

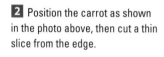

1 Cut a 3⅛-inch (8-cm) long piece of carrot and thinly slice off the peel. Trim one section off to create a straight edge. Perpendicular to that edge, trim off another section. On the rounded side, make a v-shaped cut and smooth the edge into a curve. Cut small notches in the middle of the first straight edge, directly opposite the rounded side.

2 Position the carrot as shown in the photo above, then cut a thin slice from the edge.

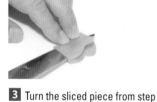 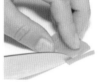

3 Turn the sliced piece from step 2 on its side, and insert the knife without cutting all the way through. These will become the wings.

4 Rotate the piece from step 3 so that the cut side is facing you. Leaving the corner intact, make a sliver incision in the edge. Rotate 180° and do the same with the inner section.

5 Open up the carrot from the center to form the wings. The slivers from step 4 will be the antennae; pull them out gently, then tuck them in between the wings.

Chrysanthemum

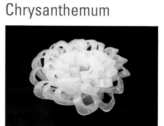

2 Cut a 1½-inch (4-cm) length of carrot and remove the peel. Use the same method to cut a paper-thin slice all the way around.

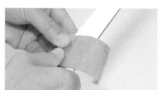

4 Fold the daikon sheet in half lengthwise. Make a series of closely spaced parallel cuts along the folded edge.

6 Secure with a toothpick. Place in water and watch the flower bloom!

Combining the butterfly with the chrysanthemum is charming, too.

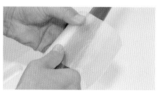

1 Cut a 3⅛-inch (8-cm) length of daikon and remove the peel. Rotate the resulting cylinder against the knife edge as shown in the photo, gently moving the knife up and down, to create a paper-thin sheet.

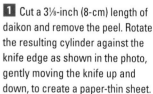

3 Make a series of closely spaced parallel cuts about halfway up the width of the carrot sheet. Roll the piece up from one edge.

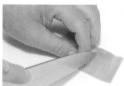

5 Roll together from the edge so that the cut edges of the carrot align with the folded edge of the daikon.

Coming Up with Ideas

The thrill of Kazari Sushi is how it lends itself to creative expression. As your skills develop, challenge yourself to come up with your own, original ideas. You'll be able to better respond to your customers' requests for flavorful dishes, and your ideas could lead to new and exciting menu offerings.

Create the Blueprint

The best of ideas will go nowhere if they are merely thoughts in your head. Start by sketching some ideas on paper. Sketches rendered in actual size will be enormously helpful in determining how much materials and ingredients will be necessary down the line. Avoid intricate designs and stick to simplified concepts.

Once the sketch is complete, think about the techniques you've practiced and how you can incorporate them into your own design. Take the time to decide on the ingredients and materials as well. As much as possible, you'll want to use what you have on hand or concentrate on supplies that are easily acquired. Try to avoid hard-to-find specialty foods.

The rough sketches for the Sparrow Rolls on page 80. The specific ingredient amounts and steps were then refined.

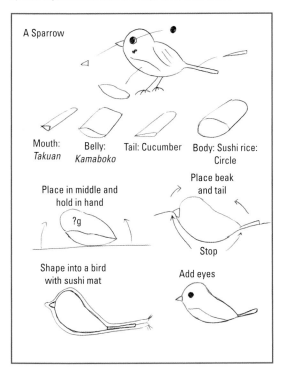

Prototyping

When you have a satisfactory blueprint and plan, the next step is to create a prototype. Keep a running list of the ingredients used, the amounts, the colors and overall shape. Taste it and track how long it takes to make each roll. As you test out your idea, tweak all the components as needed. You will probably need to create multiple prototypes until you hit on the right combination. But as you repeatedly test and modify, each round will become easier.

Tulip Prototypes (page 40)

 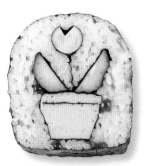

Compared to the final version, the nori in this prototype is touching the bottom of the planter and the cheese *kamaboko* tulip has three pointed edges.

More sushi rice has been added between the bottom of the planter and the outer nori. The flower design has been shifted upward which improves the overall balance. The flower itself has been simplified to two petals and is more tulip-like.

Published by Tuttle Publishing, an imprint of Periplus Editions (HK) Ltd.

www.tuttlepublishing.com

Kazari Sushi no Gijutsu
Copyright © 2014 by Ken Kawasumi
English translation rights arranged with ASAHIYA PUBLISHING CO., LTD.
through Japan UNI Agency, Inc., Tokyo
Translated from Japanese by Sanae Ishida

English translation © 2017 Periplus Editions (HK) ltd

Library of Congress cataloging in process.

ISBN: 978-4-8053-1437-1

Distributed by

North America, Latin America & Europe
Tuttle Publishing
364 Innovation Drive
North Clarendon, VT 05759-9436 U.S.A.
Tel: (802) 773-8930; Fax: (802) 773-6993
info@tuttlepublishing.com; www.tuttlepublishing.com

Japan
Tuttle Publishing
Yaekari Building, 3rd Floor
5-4-12 Osaki, Shinagawa-ku, Tokyo 141 0032
Tel: (81) 3 5437-0171; Fax: (81) 3 5437-0755
sales@tuttle.co.jp; www.tuttle.co.jp

Asia Pacific
Berkeley Books Pte. Ltd.
61 Tai Seng Avenue #02-12, Singapore 534167
Tel: (65) 6280-1330; Fax: (65) 6280-6290
inquiries@periplus.com.sg; www.periplus.com

20 19 18 17 10 9 8 7 6 5 4 3 2 1

Printed in China 1709RR

TUTTLE PUBLISHING® is a registered trademark of Tuttle Publishing, a division of Periplus Editions (HK) Ltd.

About Tuttle
"Books to Span the East and West"

Our core mission at Tuttle Publishing is to create books which bring people together one page at a time. Tuttle was founded in 1832 in the small New England town of Rutland, Vermont (USA). Our fundamental values remain as strong today as they were then—to publish best-in-class books informing the English-speaking world about the countries and peoples of Asia. The world has become a smaller place today and Asia's economic, cultural and political influence has expanded, yet the need for meaningful dialogue and information about this diverse region has never been greater. Since 1948, Tuttle has been a leader in publishing books on the cultures, arts, cuisines, languages and literatures of Asia. Our authors and photographers have won numerous awards and Tuttle has published thousands of books on subjects ranging from martial arts to paper crafts. We welcome you to explore the wealth of information available on Asia at **www.tuttlepublishing.com.**

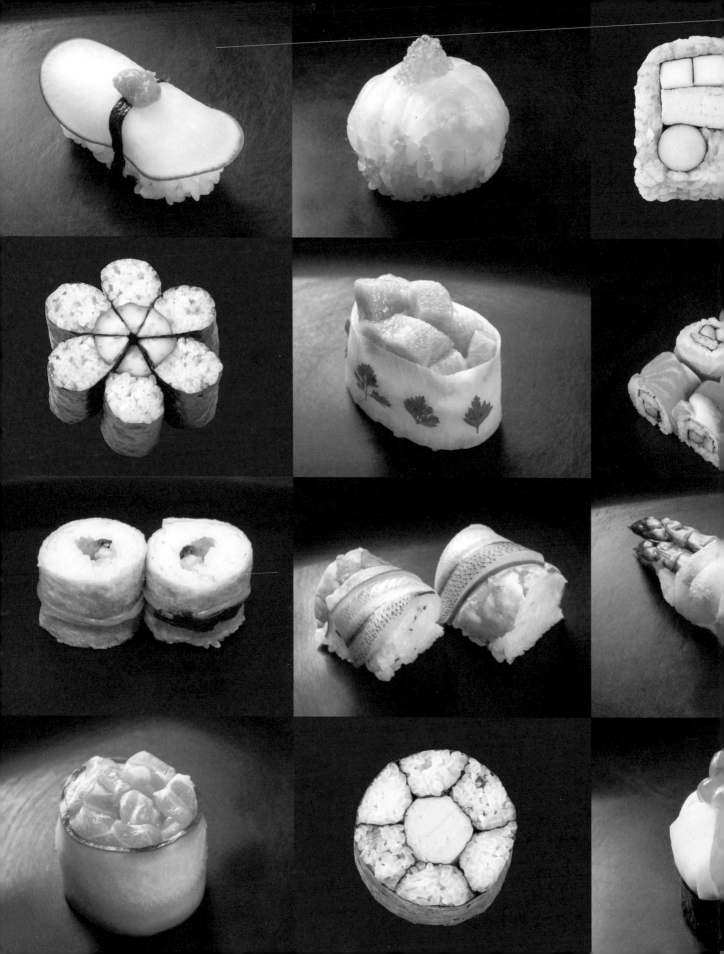